Fix It In Post

Solutions for Postproduction Problems

Jack James

Focal Press
Taylor & Francis Group

NEW YORK AND LONDON

First published 2009
by Focal Press

Published 2015
by Focal Press
70 Blanchard Road, Suite 402, Burlington, MA 01803

Published in the UK
by Focal Press
2 Park Square, Milton Park, Abingdon, Oxon OX14 4RN

Focal Press is an imprint of the Taylor & Francis Group, an informa business

Library of Congress Cataloging-in-Publication Data
Application submitted

British Library Cataloguing-in-Publication Data
A catalogue record for this book is available from the British Library

ISBN 13: 978-0-240-81124-6 (pbk)

Fix It In Post

Contents

Contents

Contents

Contents

Acknowledgments

It's self-evident to me that a film is a collaboration, in which, if anyone is the most important contributor, it's the writer.–Ken Loach

I'm now going to take the wind out of that bold sentiment and thank the following individuals for their direct and indirect contributions to this book:

To Andrew Francis (who also provided many of the wonderful images throughout), Aaron James, Luke Rainey, Jon Thompson, Mitch Mitchell, Aviv Yaron, Neil Robinson, Stuart Fyvie, Simon Cross, Gavin Burridge and Simon Burley; each of whom mentored me on many of the topics within.

To Claire McGrane, Mark Linfield, Alix Tidmarsh, Courtney Vanderslice, and Colin Brown for allowing me to play and experiment, even as they bore the brunt of a missed deadline.

To Rob Lingelbach and the members of the Telecine Internet Group (tig.colorist.org) for their great mine of knowledge, always just an email away.

To the numerous producers, artists, and photographers who generously provided the stunning imagery featured within these pages, helping to make this book aesthetically as well as intellectually stimulating.

To Dennis McGonagle for the inspiration and patience, Paul Temme, Carlin Reagan, and Paul Gottehrer for keeping the proverbial wheels turning.

To my family for their continuing support and encouragement, and to my friends, I promise I will spend more time with you all now …

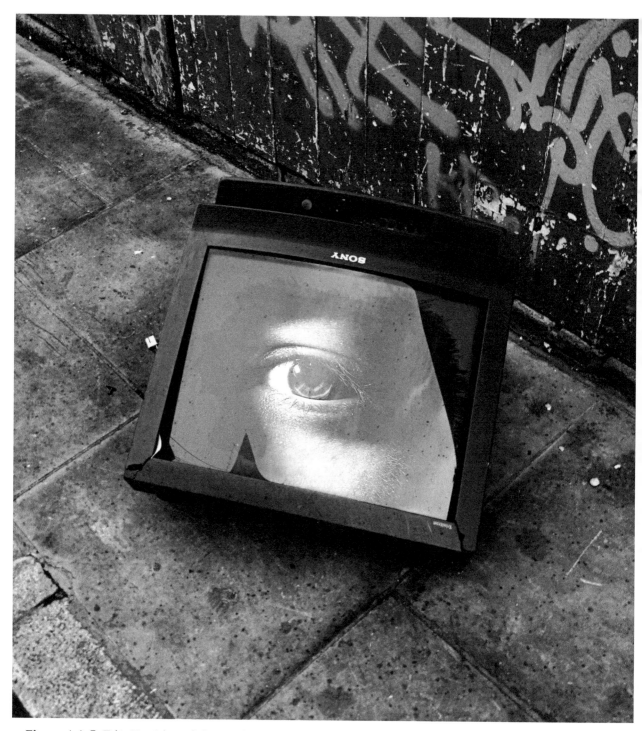

Figure 1.1 © *Fabio Venni (www.flickr.com/photos/fabiovenni/)*

Chapter 1

Introduction

The Beginning of the End

Postproduction is where a lot of the magic of moviemaking happens. The shoot's in the can and the actors, writers, and production crew are long gone, often leaving behind a director on the point of exhaustion and a producer trying to regain control of spiraling costs.

As with every other stage of production, nothing ever goes smoothly in post (despite what the DVD extras tell you). Piecing the film together can be a laborious, unglamorous, tedious, and wonderful roller coaster of a journey to deliver a unique experience to an insatiable audience.

Years ago, the hairiest moments of post involved damaged strips of film, missing footage, and sound sync problems. These are all but conquered in the digital age, giving rise to a brand new, yet hauntingly familiar set of problems, like corrupt data, dropped frames, and format compatibility issues. It seems that rather than providing a faster, more reliable way of completing a film, digital technology has just provided another outlet for venting our frustration.

But before depression sets in and a stream of tears renders the rest of this text a blurry mess, consider this: as a result of improvements to digital technology over the last few years, the overall standard of quality and control over a finished picture is much, much higher than was ever possible before.

There are several imperfections with the film-making process that were so difficult to fix that until very recently, they were considered an innate part of the process. Almost every frame of 35 mm film ever produced is subject to dust and scratches of varying impact; cameras inherently contain some amount of "weave" as they pull that film across the lens; and fine control over the color of the images was impossible. In a relatively short period of time, correcting these things has become such a routine process that we are probably more likely to notice what hasn't been fixed than what has.

The Myth of Digital Magic

The adage that pretty much everything can be fixed in post has become something of an inside joke among postproduction professionals over the years. While it's true to some degree, the reality is that

certain fixes can be provided only through the use of heavy-duty visual effects. For instance, while bumpy camera movement can be smoothed reasonably easily, replacing one actor with another cannot.

There is a romanticized view of digital image processing that believes it can somehow "undo" degradation, restoring detail to areas where there was none. Although most people intuitively understand that the ability to pan around inside a digital photo (as portrayed in the film *Blade Runner*, for instance) is not possible, there does seem to be a widespread misconception that all high-end postproduction systems contain an "enhance" button that can magically bring blurred objects into focus, or allow the viewer to glimpse into deep shadows, revealing someone hidden in the gloom.

The reality is that detail cannot be created where it does not exist. That requires artistry and imagination, not software and mice. That's not to say that it's impossible to highlight areas of an image that were previously invisible; on the contrary, much of the day-to-day "enhancement" that is done simply involves changing the viewers' perception—that the person in the gloom was in fact visible all the time, just difficult to make out among all the dark tones and colorful noise.

Some of this magic is surprisingly easy to perform. Much like adjusting the brightness and contrast settings on a television set, anyone with the most basic tools and knowledge can make improvements to their material, given a little time (not to mention a degree of taste). On the other hand, certain improvements, even those that may at first seem trivial, can prove to require a great deal of time and energy, with no clear solution.

This area of production requires a blend of technical and artistic sensibilities: you have to understand the technical limitations you face, and then you have to be creative about how you get around them. This is not a field of number-crunching, like accountancy, where there is a definitive "correct" result; nor is it a pure art form like paint on canvas or poetry on paper.

Definition of a Visual Effect

There is a great deal of overlap between the practices, and certainly the toolset, of the techniques in this book and those used for creating visual effects. Indeed, it can be difficult to determine where restoration and enhancement becomes compositing and effects. I consider visual effects to be a much more intense process, often requiring the artist in question to spend weeks working on a single shot. In contrast, you won't find much in this book that will take longer than an hour or so to complete on a typical shot. Although it's easy to define visual effects shots as "in-your-face, dinosaurs rampaging around cities"-type shots, the reality is that most visual effects are meant to be invisible, such as duplicating extras to form massive crowds. My working definition of a visual effect is anything that involves *reconstructing* a scene in some way, whereas the techniques featured throughout this book are about *enhancing* a scene in some way.

The Substitute Time Machine

There isn't a hard and fast rule for determining which types of fixes can be accomplished easily—that tends to come with experience. The only real way to be certain of anything working as expected in a finished production is to try and get it in-camera.

That said, the limited availability of time machines for producers means that on many occasions it is just not possible to anticipate or notice problems that occur. Similarly, many of these problems only present themselves in the editing suite, when they can become glaringly apparent through the veil of context.

In these situations, recognizing the easy fix before having to resort to paying for costly visual effects, or worse, reshoots, will make everyone more comfortable.

The Bottom Line

Having worked on productions of all sorts of budgets, I've come to realize that in postproduction, quality and expense tend to be unrelated. Spending more money gets it done faster, but not better (sadly, this does not seem to be the case with preproduction, production, distribution, or marketing). That's not to say that postproduction is the best place to tighten the purse strings; after all, good postproduction requires an experienced team and robust tools, and these tend to cost money. What it means is that you're not faced with dilemmas like whether to pocket some cash and shoot 16 mm while taking a hit in quality compared to 35 mm.

About This Book
Who This Book Is For

This book is designed to appeal to anyone looking to improve footage after it's been shot, whether it's someone gainfully employed in postproduction, a producer or director who likes to take more of a hands-on approach to completing a production they've been working on, or someone simply looking to learn more about the process.

Throughout the book, I'll assume you know what pixels are and basic computer stuff like moving files and folders about, and that you're not put off by the occasional bit of film production jargon.

I should also point out that this book makes no effort at all to cover two of the most important areas of postproduction: editing and visual effects. As deeply fascinating as those topics are, they are also far too broad for me to do any sort of justice to them here.

All of the techniques in this book are ones that are used regularly on commercial productions. Although it was tempting to put a lot of gratuitous, eye-candy-style tutorials in here, such as how to create the effect of film burning in a projector, in the end I felt that they were best left for a different book.

How This Book Is Organized

This book provides a collection of the most common production issues that occur and methods for correcting them in post, from those that are caused by the camera lens to those that can be caused by the nature of working in a digital environment.

> **TIP**
>
> To learn more about editing, I highly recommend *In the Blink of an Eye* by Walter Murch; on the subject of visual effects, look no further than *Digital Compositing for Film and Video* by Steve Wright.

Some of these issues will have very simple solutions, some will have more involved, time-consuming fixes (the bean counters among you are free to substitute *expensive* for *time-consuming* throughout this book), but all of them are field-tested and work in a variety of situations.

The techniques covered are organized into categories by the type of problem that requires them. If you're so inclined, you can read the chapters in order, or you use the book as a reference, dipping into it when you come up against a problem.

Contacting the Author

I can be reached at post@surrealroad.com if you want to provide feedback about the book (which is always welcome), or about any of the techniques I discuss.

Figure 2.1 © *Jack James.*

Chapter 2
Essential Techniques

"If it looks like it works and it feels like it works, then it works."
—Snow Patrol

Although there are plenty of sales teams who will tell you otherwise, the best solution for any image or audio problem will depend on finding the right blend of hardware, software, and skills for the specific problem.

There are a lot of great options available for tackling different tasks, some of which are useful for a single specific purpose, and others that are the less glamorous workhorses that no one likes to show off, but that no one can do without.

This chapter will cover the types of different tools that you'll need in order to perform the corrections throughout the rest of the book.

The Software Toolbox

In the digital age, the vast majority of manipulation of picture and audio for postproduction is done with software. It used to be that video engineers would have to familiarize themselves with all manner of signal processor boxes. Likewise, film technicians would have a vast knowledge of chemical processes, but these requirements are gradually getting phased out, relinquished to specific and, perhaps, archaic practices. The rest of us can get almost everything we need done through the use of different software packages in one form or another. With all-digital productions gradually becoming more popular, it's not uncommon to be able to do without devices such as tape decks altogether.

Though this can be liberating (software tends to be easier and cheaper to learn and implement than its former counterparts), it can also become the source of much confusion. There are many different software packages that claim to do the same thing. Some are designed specifically to tackle

a single problem, others are postproduction generalists, and yet still others have a large following even though it's not entirely clear what exactly they do.

Most good books on photography concentrate on technique rather than equipment. Rather than recommending a specific brand or camera, they emphasize specific capabilities, such as manual focus or spot metering. In a similar spirit, I don't want to evangelize a particular product or manufacturer in this book. Instead, I'll focus on the underlying techniques needed to get the job done.

The rest of this section will look at the specific digital tools that you'll need to achieve many of the corrections discussed throughout this book. There are several applications that provide all of these tools, or you may prefer to use different software for different situations. Each of the tools requires practice with real-world examples to get the best results, and I highly encourage you to experiment with any of the tools on this list that you're not familiar with.

Figure 2.2 © *Jenny Downing* (*www.flickr.com/photos/jenny-pics/*).

Picture Manipulation

The most basic tool to master, picture manipulation refers to changing an image's properties in some way. These changes can be anything from modifying the pixel resolution to repositioning or rotating the picture. Almost every video editing software (including several Web-based ones) will allow you to modify movie files in this way to some extent.

> **TIP**
>
> Whatever software you use, you should aim to learn all of its capabilities. You'll soon find that the application you rely on for digital paint also doubles up as a format conversion system with a bit of tweaking. This can save you a great deal of time in the long run. By the same token, be aware of any of the limitations of the software you use. If a specific application is not particularly effective at scaling footage, use something else for that purpose.

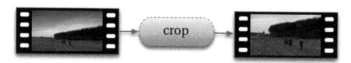

Figure 2.3

Any of the techniques featured in this book that require some form of picture manipulation will include the icon shown in Figure 2.4.

Figure 2.4

Number Crunching

Digital media can be manipulated at a mathematical level: because digital media are essentially just data files, and because data files are essentially just strings of digits, it's possible to perform all sorts of calculations on them. Although at first this may not seem very useful, it forms the basis of almost every other process that can be applied to images and audio. For instance, to brighten an image, you can increase the values of all the pixels, effectively just adding a number to the image.

In the context of this book, number-crunching operations are those that process the source data at its numeric level. This includes processes such as adding, subtracting, dividing, or multiplying data in some way. It also includes processes that separate the source into its basic components, for example, splitting an image into separate red, green, and blue channels.

> **TIP**
>
> Many picture manipulation processes don't require dedicated video software to get the job done. In many cases you can use a digital image editor such as Photoshop to make changes. To do so, refer to the guidelines in Appendix 1 for converting movies to and from image sequences. The catch is that you can process only one frame at a time using this technique, but a lot of image editors allow you to "batch" process many images at the same time.

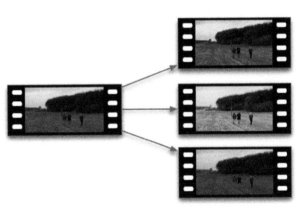

Figure 2.5

Painting

The paint tool, which allows pixels to be added directly to a picture through strokes or dabs, is ubiquitous within image-editing applications and yet strangely absent from the majority of video-editing software. Where it is available, it tends to be an intuitive process, though (as with real painting) it can take time to master. It can be implemented in a variety of ways, allowing either solid colors or predefined patterns or, in some cases, strokes that mimic the properties of real-life paintbrushes to be painted

> **TIP**
>
> Some applications may not provide a direct method for performing calculations on the source media. In this case, it may be possible to achieve the same results by using layers with blending modes. See the section "Layering" for more on this process.

onto the picture. Some applications apply paint strokes to single frames only, while others also have the option of applying a single stroke across all frames.

Figure 2.6

Cloning

The clone tool is similar to the paint tool, except that instead of painting solid colors or patterns, it copies pixels from elsewhere in the picture (even from a different frame). This tool is incredibly useful and, with a little skill, can be used to correct almost any type of picture defect, from film scratches to video dropout.

TIP

A workaround to making painted pixels last across multiple frames is to export a reference frame to an image-editing application and create the paint stroke in a new layer. You can then export just that layer, along with its transparency (alpha channel), and layer that on top of the original footage as a freeze frame.

Figure 2.7

Figure 2.8

Any of the techniques featured in this book that require some form of cloning will have the icon shown in Figure 2.8.

Layering

The ability to combine two or more audio tracks or multiple images in some way is crucial to postproduction. A well-placed soundtrack can hide audio defects, while a combination of images may be necessary to add fluffy clouds to a scene with a clear sky.

Although this is a simple idea, many applications offer some very sophisticated methods for its implementation. Several systems have the ability to blend layered images together in a variety of ways (often called blending or

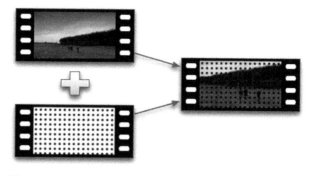

Figure 2.9

transfer modes). For example, it may be possible to blend two images in such a way that you only see the "differences" between the two. If one of the two images is just a solid color (for example, a shade of gray), you can also do things like add them together (in this case, increasing the brightness of the original image).

Compositing Semantics

The word "composition" unfortunately has many different meanings, even in the context of this book. It can be a generic term for a digital visual effect, typically done by a visual effects artist (or compositor), or it can refer more specifically to a combination of multiple media elements (such as a composite of two different sound effects played at the same time, or one image superimposed over another). It can also refer to a completed work of audio or video (or both), or it can refer to the arrangement of individual visual or aural elements relative to each other.

To make things work, certain tools also use the word composition with abandon to refer to any number of things. In order to ease this situation a little, throughout the book I'll use the word "layering" to refer to a combination of media elements, and reserve the use of the word "composition" for its artistic context.

Masking

Masks are used to define regions in an image. Masks can be used either to limit the effect of a tool or to remove unwanted regions completely. For example, if you want to blur a license plate on a car, you would first mask the license plate, then apply the blur. The blur would then affect only the pixels inside the mask. Alternately, you might want to use a mask to exclude the car from the image completely. Some applications use an "inside/outside" paradigm, allowing you to choose whether to affect areas inside or outside of the mask independently.

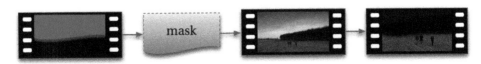

Figure 2.10

Masks can be simple shapes like ellipses or rectangles created as resolution-independent vectors, or they can be applied to each pixel of the image individually. They may also vary in strength or transparency, for example, with different parts of the mask affecting the image by a different amount. Many applications provide a way to view the mask as a grayscale image, with the brightness of each pixel corresponding to the strength of the mask at that point. This sounds complicated, but is in fact a

Figure 2.11 *A mask can be used to remove unwanted areas...*

Figure 2.12 *... or to single them out for further enhancement.*

Figure 2.13 *Viewing the grayscale representation of the mask (note the soft edge).*

Figure 2.14 *The masked area shown as an overlay on the original image.*

Figure 2.15 *The mask used to restrict which parts of the image are blurred.*

very convenient way to see how the mask will affect the image. Other systems can display masked areas as an overlay on the original image, for example, desaturating masked areas.

Figure 2.16

Any of the techniques featured in this book that require some form of masking will have the icon shown in Figure 2.16.

Selection Semantics

Many applications make a distinction between masks that are vector-based shapes and masks that are selections (or mattes or even alpha), which are pixel-based and traditionally drawn as "marching ants" to show the boundaries. In practice, the difference is largely due to the way the software works, and ultimately can be meaningless (not to mention confusing) to the artist. In this book, the term "mask" refers to both pixel-based and vector-based variants, as either approach may be appropriate, depending upon the particular footage.

Keying

Keys are also used to define regions in an image, but they work by looking for characteristics based upon chroma or luminance (or some combination of both). The implementation (and resulting accuracy) of keying tends to vary greatly from system to system, but it usually boils down to picking a point in the image with the color you want to isolate, and then tweaking a bunch of settings to get the desired result.

Although keys can be used for individual images, they are particularly useful for their ability to work across an entire sequence. With a little bit of practice, creating a key of a person's lime green sweater over a few seconds, regardless of the person's movement, should be very simple, allowing you to change it to a more tasteful color.

Keys and masks are often considered to be two separate tools. It may be helpful to think of a key as simply a method for generating a mask automatically.

Figure 2.17 *A keyed region (shown with overlay).*

Figure 2.18 *The corresponding mask.*

Figure 2.19 *The result of a color change on the keyed region.*

Any of the techniques featured in this book that require some form of keying will have the icon shown in Figure 2.20.

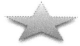

Tracking

Figure 2.20

Tracking tools are a fairly modern development. They are so useful, though, that it's amazing that anything ever got done without them. The purpose of tracking is to follow the movement of a particular feature in a video sequence. These tools usually work by selecting a region containing the feature to track, and then a region in which to search for the feature on subsequent frames. The position of the feature on each frame is then interpolated to determine its motion within the frame. This data can then be used for a lot of things, such as synchronizing the motion of images on different layers. Most applications that have tracking tools will also allow two or three points of an object to be tracked, which means that additional information, such as changes in size (or the relative distance of the object from the camera) or

> **TIP**
>
> Most tracking algorithms use some form of edge detection. In order to get the best results, try to track features that have distinctive shapes and lots of contrast.

rotation, can also be inferred. You'll also want something that allows you to manipulate the tracking data in different ways for some techniques.

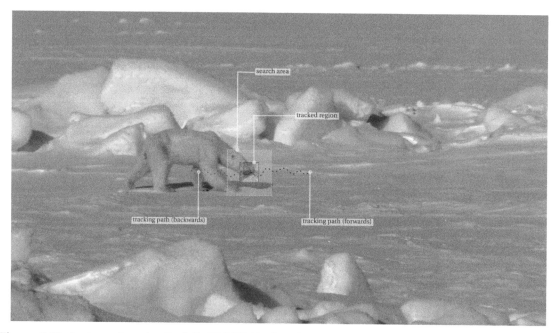

Figure 2.21 *Anatomy of a tracker. Earth © BBC Worldwide Ltd 2007.*

The great thing about most tracking software is that it often produces better (not to mention faster) results than if you were to attempt to track the features yourself. Good tracking algorithms also work at the sub-pixel level, measuring changes in position at the level of a fraction of a pixel, which gives smoother results, and which would prove nearly impossible to do manually.

Any of the techniques featured in this book that require some form of tracking will have the icon shown in Figure 2.22.

Figure 2.22

Color Correcting

Color correction tools come in many different flavors. The most basic allow you to affect the brightness, contrast, and hues of an image, while the more sophisticated will allow colors to be adjusted using curve graphs or even 3D color cubes. There are entire systems exclusively devoted to the color correction of footage (many of which are not at all modestly priced, either), and the creative process itself can take many years to master. However, even basic color correction skills are essential when working to improve footage, no matter how good it might look to begin with.

In conjunction with the tools for modifying colors in an image, many systems also have tools for measuring the colors, which can give more objective feedback than the typical approach of judging the color by how it looks. The most common measurement tool is the histogram, which shows the distribution of brightness values of the pixels. If there are a lot of pure white pixels, this will show as a tall bar at the edge of the histogram. This is indicative of clipped highlights, or areas where certain pixels have reached maximum brightness and have become a single color, something that may be difficult to determine by eye.

TIP

A great way to practice and improve color correction skills is to experiment with using whichever tools you have at your disposal on some digital photos.

Table 2.1

	Operation	Description
	Brightness	Increasing or decreasing pixel values to raise or lower image brightness respectively
	Contrast	Increasing contrast makes light areas lighter and dark areas darker, decreasing contrast does the opposite

(Continued)

Table 2.1 (*Continued*)

	Operation	Description
	Hue	Changing the hue of footage changes the color component while keeping brightness and other properties the same
	Saturation	Increasing saturation increases the purity of colors, while decreasing (desaturating) makes them grey
	Lift	Increasing or decreasing the lift (or pedestal) raises or lowers the black level respectively
	Gamma	Increasing or decreasing the gamma raises or lowers the mid-point respectively
	Gain	Increasing or decreasing the gain raises or lowers the white level respectively
	Exposure	Simulates changing exposure as it would happen in-camera
	Replace	Substitutes one color for another
	Color correct	A combination of techniques to change the colors to stylize or match other footage

Any of the techniques featured in this book that require some form of color correction will have the icon shown in Figure 2.23.

Figure 2.23

How to Create a Difference Matte

A very useful way to compare images, difference mattes have practical applications, too.

A difference matte is an image that contains information about the differences between two images. Difference mattes are normally used to find differences between images for use in creating masks, but they can also be used to prove that there are *no* significant differences between two images (for example, when testing different compression methods).

TIP

Some applications allow absolute subtraction, such that pixels can have negative values. If your application supports this feature, it is usually sufficient to subtract one image from the other.

1. Subtract the first image from the second.
2. Subtract the second image from the first.
3. Add the two results together.
4. If necessary, adjust the gamma of the resulting image to increase the visibility of the differences.

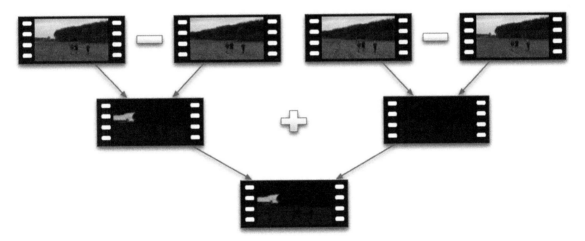

Figure 2.24

Audio Manipulation

Like color correction tools for working with the picture, there are a number of tools for working with the audio, depending upon which application you happen to be using. The most basic of these allows the pitch and volume of an audio track to be adjusted, while more advanced systems might offer 3D equalizers.

Also like color correction, there are tools for measuring aspects of an audio clip, though audio manipulation can take a long time to master. One of the most common of these is the waveform, which displays the amplitude of the audio over time, which is handy for easily identifying extraneous

Table 2.2

Operation	Description
Expand	Stretches the dynamic range of a sample, making loud noises louder and quiet noises quieter
Compress	Squeezes the dynamic range of a sample, making loud noises quieter and quiet noises louder
Pitch-shift	Changes the frequencies of a sample, making the wavelengths longer or shorter
Resample	Recalculates the sound wave based upon a different sampling frequency
Draw	Replaces part of the sound wave with a curve drawn by hand
Gain	Adjusts the overall volume by a percentage or a fixed amount
Cross-fade	Gradually blends one sample into another
Pan	Increases the volume of one channel while decreasing the other
Phase-shift	Adjusts the timing of one channel with respect to another
Surround pan	Increases the volume of one or more channels while decreasing the others proportionately

noises in a recording, as well as audio peaks (where the volume is at or approaching the maximum value).

Sequencing

Whenever you work with more than one audio or video clip, their order and position in time relative to each other become critical. Ensuring the correct placement of these elements requires the use of some form of sequencing system. The majority of these use a timeline paradigm, with the sequence running from left to right to represent the passage of time. These generally provide an intuitive (if slightly unmanageable) interface to understanding the order and timing of each audio or video clip. Many systems also combine the timeline interface with a layering system, such that each layer has its own timeline (this is sometimes referred to as "vertical editing").

The capabilities of each system vary, but generally speaking it is possible to rearrange, lengthen, shorten, or divide individual clips on the timeline. Most sequencers also provide for transitions, which control how adjacent clips merge together. For instance, the most simple transition, the "cut," ends one clip and starts another. Dissolves and wipes, on the other hand, progress from one clip to the next by blending and using a pattern, respectively.

Timeline Semantics

Although the term "sequencing" is an appropriate one for positioning audio recordings (as the applications that work with audio in this way are commonly referred to as "sequencers"), in the video industry, the term "editing" is preferred. However, editing is an incredibly vague term in the context of this book (potentially referring to the editing application itself, or the process of changing a parameter within any application, or even the process of modifying something in some way), and so I will use the term "sequencing" throughout this book to refer to both audio and video.

Any of the techniques featured in this book that require some form of audio or video sequencing will have the icon shown in Figure 2.25. Also note that while transitions fall into this category, they can also be created using a combination of layering and dynamics tools.

Figure 2.25

Table 2.3

	Operation	Description
	Cut	Split a clip into two
	Trim	Shorten a clip by removing frame from the start or end
	Extend	Lengthen a clip by adding frames to the start or end
	Replace	Substitute one clip for another, retaining the length and position in a sequence
	Insert	Adds a clip to a sequence, increasing the sequence's overall duration
	Overwrite	Adds a clip to a sequence, replacing other footage in order to maintain the sequence's overall duration
	Delete	Removes a clip from a sequence, leaving a gap

(*Continued*)

Table 2.3 *Continued*

Image	Operation	Description
	Ripple	In combination with other operations, affects the position of clips in the sequence after the current one
	Slide	Moves a clip along in a sequence
	Slip	Changes the start and end point of a clip's footage without affecting its position in the sequence
	Speed up	Makes the clip run faster
	Slow down	Makes the clip run slower

Filtering

One of the fundamental benefits of working digitally is that you get to use all manner of signal processors on the material. Audio and video engineers have long been able to process analogue signals in a variety of weird and wonderful ways, such as reducing noise, but these inevitably required dedicated (and often costly) hardware to perform the task. In the digital realm, these processes can be reduced to their mathematical form and applied directly to the picture or audio data to get the same effect.

> **TIP**
>
> Many editors have gotten into a mess by making ripple edits when they didn't mean to (and vice versa), which can lead to all sorts of sync problems.

Table 2.4

Filter	Description
Equalization (EQ)	A filter that selectively applies gain to audio
High pass	A type of EQ that removes low-frequency sound
Low Pass	A type of EQ that removes high-frequency sound
Shelving	A type of EQ that restricts changes to a range of frequencies, affecting them with a "falloff"
Peaking	A type of EQ that restricts changes to specific frequency bands

(Continued)

Table 2.4 (Continued)

Filter	Description
De-click	A filter that reduces audio segments with characteristics similar to clicks and pops
Delay	A filter that delays audio segments, typically feeding them back to the original
Modulation	A filter that modifies the volume, timing, and frequency of an audio segment, typically combining it with a low frequency oscillation (LFO)
Reverberation	A filter that simulates the effect of sound reflecting off of multiple surfaces
Comb	A filter that combines an audio segment with a delayed copy of itself
Limiter	A filter that limits audio peaks to a specific volume

Table 2.5

	Filter	Description
	Blur	Blurs pixels together
	Sharpen	Increases the definition of details
	Add noise	Adds random noise to footage
	Median	Averages pixels together
	Edge detection	Replaces the footage with detected edges

Any of the techniques featured in this book that require some form of filtering will have the icon shown in Figure 2.26. All the filters referred to are ones that are available in most applications as standard.

Figure 2.26

A Filter for Every Occasion

Many systems employ the use of filters through a "plug-in" infrastructure, meaning that other companies can create filters to perform very specific tasks, to the extent that there is probably a filter somewhere that addresses every single technique covered in this book. The problem with using filters for solving specific problems (other than their expense) is that they tend to be designed to be as generic as possible, which means that you have to either dig into the guts of the interface and do a lot of tweaking, or combine them with other filters in order to get a suitable result. Although I've found several filters that work really well for certain specific tasks, I think in many cases it's much easier to build the same effect manually.

Dynamic Adjustment

Most of the tools mentioned so far modify the entire audio or video clip, which is great if you want to resize all your footage in one go, but not so good for trying to increase the volume of a sound at a particular point in a sequence without affecting the entire audio track. Dynamic adjustments allow tools to use different settings at different points in the timeline (the term "dynamic" in this context comes from color correction, but can be applied to any process). For example, you could create a fadeout on a sequence by increasingly darkening the image on each frame, eventually going to black by the end of the sequence. The possibilities are endless.

Figure 2.27 *Apple's Motion software provides the capability to apply dynamic adjustment gesturally, by telling the system what you want to happen.*

Most systems allow the use of dynamics through a key-framing paradigm, where you set two or more values at different points in time, and the system smoothly interpolates between the two. More advanced interfaces allow for some form of scripted behaviors, for example, allowing a brightness parameter to react to a zoom parameter. Still others allow for dynamics to be recorded live. For example, you might play an audio track and adjust the pitch while it's playing.

Figure 2.28 *Key-framed adjustments are the most common form of dynamic adjustment and are often viewed graphically.*

Figure 2.29 *Adobe's After Effects software caters to advanced dynamic adjustment through a script-based interface.*

Nondynamic Applications

Almost all of the video-based techniques featured in this book that *don't* require dynamic adjustment (or tracking) can typically be carried out using digital image applications (such as Photoshop), which have all the other requisite tools and some method for batch processing. To do so, convert the sequence to images using the procedure outlined in Appendix 1, and then apply the technique as a batch process to all images. In Photoshop, you can even save the process as an action for later use.

Rotoscoping

Rotoscoping is a technique inherited from animation, in which the animator would trace over each frame of a film sequence, producing very realistic motion. A similar technique is employed on a large scale in the visual effects industry, in which the roto artist will adjust a mask on a frame-by-frame basis to conform to the object in question. It can be a tediously slow process, but it produces incredibly accurate results.

For the purposes of this book, rotoscoping is treated as a dynamic effect, albeit one that is made on every frame in a clip.

Any of the techniques featured in this book that require some form of dynamic adjustment will have the icon shown in Figure 2.30. Note that painting and cloning techniques are always assumed to be applied to individual frames (unless stated otherwise), but are not considered to be dynamic.

Figure 2.30

Transcoding

One of the weaknesses (or strengths, depending upon your perspective) of working digitally is the vast number of competing formats. For audio there are formats such as MP3 and FLAC, for images, JPEG and TIFF, and for video it gets even more complicated, with formats such as Windows Media and QuickTime, each of which have multiple different "codecs" (compression and decompression algorithms).

> **TIP**
> For a list of popular digital formats and comparisons between them, refer to Appendix 2.

Some of these formats are functionally identical to each other and yet are completely incompatible (such as the AIFF and Wave audio file formats), while others are completely different (such as MPEG and RealMovie video formats). Some of them are proprietary and can be used only in conjunction with specific hardware, or are designed only as an intermediate format. Some are more suited to broadcast transmission, some are designed for Internet streaming, and others are designed for archival purposes, which means that on any digital production, there will likely be a good deal of transcoding, converting from one digital format to another.

Transcoding can be accomplished in a number of different ways and can introduce quality loss to the source as part of the process, so it's important to be careful about which formats you use and how you perform the transcoding process. This situation is made worse because most transcoding applications are notoriously unintuitive. The good ones seem to be overly technical, while the simpler ones simply don't provide the means to get the best quality

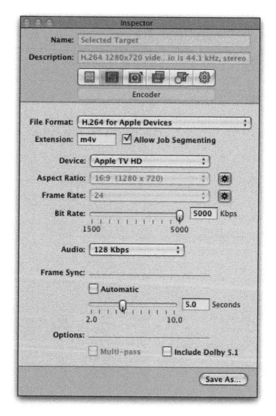

Figure 2.31 *Apple's Compressor, a typical transcoding application, with a huge number of parameters to change.*

results. Chapter 6 contains more information on finding your way around this minefield.

The Hardware Toolbox

Although we don't rely on specific hardware to work with digital media very much anymore, we do still rely on the hardware that runs the software that we do use. Using different hardware won't directly produce different end results, but better equipment will allow you to work more efficiently, which means you get more time to experiment inside the software.

Input Devices

Input devices, such as mice and keyboards, are the main way in which you interact with computer systems. You can see that even a minute improvement in comfort, precision, or speed will add up greatly over the course of a day when you consider just how much time you actually spend pressing keys or dragging and dropping.

Hotkeys are available in almost every major application, and learning them for the applications you use regularly will result in a dramatic improvement in speed. After all, it is much quicker to press a couple of keys than it is to move a mouse to a specific menu item, especially if you do it repeatedly. The more visually minded can take advantage of a keyboard such as Artlebedev's Optimus Maximus, which actually changes the display of each key depending upon the application you're using, meaning that you don't need to commit the hotkeys to memory.

Figure 2.32 *The Optimus Maximus keyboard (www.artlebedev.com).*

Graphics tablets are an alternative approach to mice. These devices, in which the location of the stylus on the tablet's surface corresponds to the location of the mouse pointer on the screen, are popular among digital artists as they have a much more natural feel than using a mouse. They can

take a while to get used to if you've been using a mouse for a long time, but it's well worth it. I find it both more comfortable and faster to use a tablet, even for mundane tasks like dragging and dropping files. The only drawback is that some applications can be a little awkward to work with; for example, certain sliders can be difficult to control with any sort of precision. Tablets such as the Cintiq present an altogether different paradigm, by integrating a monitor into the display, allowing you to feel as though you're reaching into the screen.

Figure 2.33 *The Cintiq 12WX graphics tablet (www.wacom.com).*

Output Devices

From the ubiquitous LCD monitor to the digital cinema projector, there are several choices available for viewing output. These will vary in terms of resolution and color response, and it's sensible to use a device that is at least close to your target output, which means having a monitor with a resolution of at least 1920 × 1080 pixels if you work with a lot of high-definition footage.

Whichever type of device you use, it is always worthwhile to have a secondary display, so that the application's interface along with other windows can be confined to a single screen, allowing the second to be entirely devoted to the image. It's also important to note that if you're doing color work, the monitor needs to be calibrated on a regular basis, and the ambient lighting needs to be very strictly controlled.

On the audio side, a good set of powered speakers (or at the very least, broadcast-quality headphones) are essential. It goes without saying that if you're working with surround sound, you should have a speaker system to match.

Storage

The cost of data storage has dropped dramatically over the past few years. Where it was once a struggle to store a few megabytes of files, it is now almost not an issue to plug in a disk drive with space for several *terabytes* of files. There are many different types of storage on offer, from disk-based to optical media.

> **TIP**
>
> It's worth noting that printers are largely useless for output in this context. Not only are they intended for still images, but the huge differences in color space between the display and the printed page mean that what you see printed out is not necessarily a good representation of what you see on the screen.

On the disk-based side, there are both internal and external varieties. Internal disks tend to boast better performance and lower cost, while the external ones can be conveniently relocated to another system. It's also possible to combine multiple disks to appear as a single large disk (this can also result in an increase in performance). There are also systems such as network attached storage (NAS) and storage area network (SAN), which allow you to separate the data into their own independent system.

Optical media (such as CD, DVD, Blu-ray, and even holographic storage methods) and tape-based media are more useful for distribution or long-term storage of data. Although some variants of these are rewritable, in general the idea is that you record a "snapshot" of your data at a particular moment in time onto them, and they are not useful for storing files that are in constant use.

There are also Internet-based storage systems, such as Amazon S3, which provide unlimited capacity with a high level of reliability and are paid for on a subscription basis, making them ideal for long-term archiving. However, the relatively slow speed of Internet-based data transfer makes them less useful for storing a large volume of data in the short term.

There are many pitfalls regarding data storage. The most common issue is the lack of compatibility of file structures between different systems. For example, disks formatted in Windows won't necessarily be readable by Linux or Mac-based systems. (I have found that using the FAT32 disk format seems to provide the best cross-platform compatibility, although individual files must be less than 2GB each.) Alternatively, you could use software such as Google's Fuse to try to access foreign disks.

> **TIP**
>
> Appendix 1 contains several strategies for organizing and protecting data.

Performance

The amount and type of RAM, the speed and number of CPU cores, and various other factors all add up to the overall performance of the system. However, in the real world it can be difficult to determine exactly what the benefit of installing more RAM is while you're working. There seem to be two main areas of postproduction where greater performance has a direct impact on your efficiency: rendering and responsiveness.

Rendering processes are the most hardware-intensive processes you can run on a computer. If you do a lot of rendering, then it can add up to a great saving of time if you increase the speed of the renders. However, many people don't hit the render button all that often, or when they do, it's usually set to run overnight anyway.

The responsiveness of an application is slightly more esoteric; there are so many variables involved that you can sometimes drastically improve it just by tweaking the settings of the operating system. However, there's no doubt that the less time you spend waiting for projects to load and save, or blur previews to update, the quicker you'll be able to get things done. In particular, the performance of the disk system can have a direct impact on how you work. With fast-enough disks, it's possible to get real-time playback of uncompressed footage, whereas with lower performance systems it may be necessary to transcode media in order to get real-time playback.

Operating Systems

In the postproduction industry, it is more common for the need to use a specific application to determine the operating system to use rather than the other way around. Having said that, the difference between each is staggering in the way it affects how efficiently you can work. If you're comfortable messing around with source code, you may find that Linux can coax the ultimate performance out of your system, while Windows advocates prefer the huge user base and wealth of software options it provides. On the other hand, because of its selective hardware base, using Apple's Mac OS X means you'll probably spend less time troubleshooting computer problems, while the built-in AppleScript caters for a decent amount of automation.

The Visual Toolbox

Probably the most important skill to learn to get good results is the ability to evaluate the media you're presented with, in addition to the fixes you apply to them. It may seem obvious, but identifying the problems is the first step toward fixing them. Certain problems are only seen under certain conditions. For example, certain compression errors can only be seen during playback, while others can only be detected on single frames. The same thing is true when you apply fixes. For instance, a fix using the clone tool looks great on the frame it's applied to, but pops out when played back if you're not careful.

There are a lot of tools that can be used throughout the process, such as waveform monitors and vectorscopes, which can be incredibly useful if you know how to use them properly.

Figure 2.34 *The Icon Factory's xScope software provides several tools to analyze image content on screen (www.iconfactory.com).*

Gamma Slamming

One handy technique for checking for problems is to use software such as the free DarkAdapted (available for Mac and Windows from www.aquiladigital.us/darkadapted) that can change the display gamma interactively. Doing so can reveal problems in shadow or highlight areas that were previously undetectable, but that might otherwise be seen on an uncalibrated monitor (the type of monitor absolutely everyone else in the world uses).

Above all else, it's important to be pragmatic. You can end up agonizing over getting one particular fix absolutely perfect, when in fact you could have stopped working on it an hour before and no one would have noticed the difference. It can help to ask someone to look over something you're working on. If they can't even tell what the problem is supposed to be, then you've done your job.

TIP

Understanding the *cause* of a problem can be the most important step to fixing it.

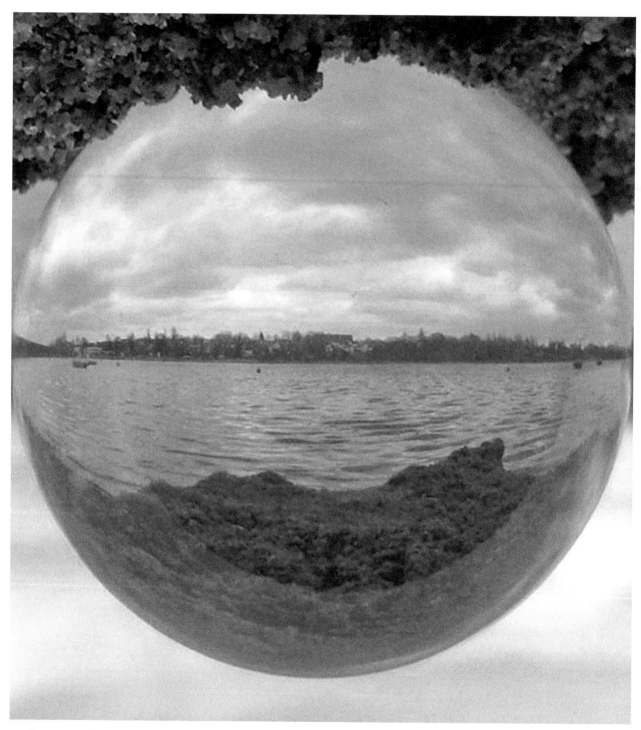

Figure 3.1 © *Lee Jordan (www.flickr.com/people/leejordan).*

Chapter 3
Fixing Lens Problems

"So distorted and thin, where will it end?"
—Joy Division

Postproduction begins with the lens. While aspects such as set design, lighting, and wardrobe all combine to create the overall mood of a shot, the camera lens determines what will actually be seen, discarding everything that doesn't come under its gaze. This process of culling is repeated throughout the postproduction chain, most notably through editing, and is irreversible—you can't recover detail that wasn't originally shot.

The lens itself introduces its own compendium of problems. Lenses are precision instruments, but at the level of detail required by film and video photography, no lens is perfect.

This chapter will provide ways to fix common problems introduced by lenses and the handling of the camera itself.

Lens Distortion

Imperfections in the camera lens can distort the photographed scenes in several ways. Because it's impossible to manufacture a lens to have perfect curvature, the images that are recorded can be squashed or stretched in some way.

The two most common types of distortion are barrel and pincushion. With barrel distortion, the image appears to bulge outward, whereas pincushion is the opposite, almost sucking the picture into its center.

Barrel and pincushion distortion can be detected by examining vertical and horizontal lines in the image. If lines that should be straight (such as the edge of a building) curve toward the picture's center, that is usually evidence of pincushion distortion. Lines that curve outward, on the other hand, are indicative of barrel distortion.

Figure 3.2 *Barrel distortion makes lines bulge outward.*

Figure 3.3 *Pincushion distortion makes lines bend inward.*

Figure 3.4 *Using a fisheye lens usually leads to barrel distortion. © Joel Meulemans, Exothermic Photography (www.flickr.com/ people/Exothermic).*

How to Correct Barrel or Pincushion Distortion
Barrel distortion is very simple and quick to fix, using the right filters.

1. Pick a reference frame, and then identify a line or edge in the image that appears curved but that should be perfectly straight, either horizontally or vertically. For best results, choose something toward the edge of the picture.

2. If the reference line curves outward (implying barrel distortion), apply a pinch filter to the footage; otherwise, apply a punch filter (for pincushion distortion).

3. Adjust the parameters of the filter until the distortion goes away. If possible, use an on-screen guide line (or just use the edge of this book) for the most accurate results. Be careful not to go too far or you will end up with the opposite type of distortion.

4. You may need to crop or resize the fixed version if the filter changes the picture size as part of this process.

Figure 3.5

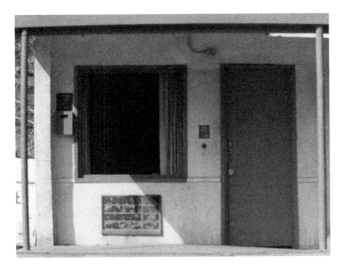

Figure 3.6 *Barrel distortion can be seen along the edge.*

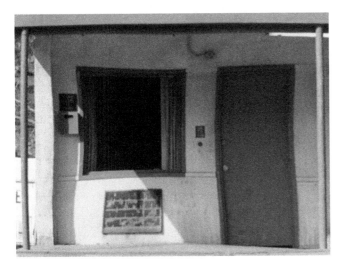

Figure 3.7 *Pushing the filter too far causes pincushion distortion.*

The good thing about lens distortions is that they are consistent. If you work out the exact parameters needed to fix lens distortion for a specific shot, then you can usually apply exactly the same parameters to any footage that used that particular lens. Be careful, though, as zoom lenses can exhibit different distortions at different focal lengths.

Warping

If you find that the lens has distorted the image in such a way that a simple application of pinch or punch filters doesn't eliminate the problem, you will need to invest in more exotic tools. These are typically classed as "warping" tools, and they typically work by creating a grid of points on the image that can be moved around, stretching the pixels underneath.

Figure 3.8 *Warping software, such as After Effects's Mesh Warp (www.adobe.com), can be used for more sophisticated lens distortion correction.*

Vignettes

Vignetting, which is when there is more light at the center of an image than at the edges, may be caused by a number of factors. The most common is a lens with multiple elements (or even a single lens element with multiple filters). Light striking the edge of the front-most element is

Figure 3.9 *Vignettes can ruin a shot or enhance it.* © *Paul Hart (www.flickr.com/photos/atomicjeep).*

not refracted enough to pass through the last element and is diminished by the time it reaches the recording medium (i.e., the film or CCD element). The resulting image tends to fade out from the center, occasionally reaching black at the corners. A reduction of brightness is typically seen, as well as a corresponding reduction of saturation.

Figure 3.10 *A vignette shown on a simple pattern.*

From an aesthetic perspective, vignettes may not necessarily be undesirable, as they can draw the viewer's eyes to focus on the center of the frame. From a technical standing, though, it is generally best to avoid producing images with vignettes in-camera, as they degrade the image and can reduce options for color correction later on.

How to Add a Vignette
Digitally adding a vignette to footage is easy, and the results can approximate "real" vignettes very well.

1. Load the footage and create a very small circular mask centered on the image.
2. Adjust the mask so that the edge softness extends toward the corners of the frame.
3. You may need to invert the mask to affect just the region outside of the mask.
4. Apply a saturation color correction to the masked region, and reduce the saturation to 0.
5. Apply a brightness color correction to the masked region, and reduce the brightness to 0.
6. Adjust the size and softness of the mask, and increase the saturation and brightness parameters to get the desired result.
7. Render out the sequence.

Figure 3.11

TIP

If you are using a system that uses a pixel-based masking system (such as Photoshop) you can recreate the soft edge either by "feathering" the mask several times, or by heavily blurring it. An alternative approach is to create an alpha channel using a circular gradient from black at the center to white at the edges.

How to Remove a Vignette
Vignettes are destructive to an image, but in some cases it's possible to undo the damage.

Removing vignetting from footage can be tricky. The main problem is that detail toward the dark regions of the vignette can be lost, making it impossible to recover.

1. Load the footage and examine the pixel values in the vignette areas.
2. Create a very small circular mask centered on the image.
3. Adjust the mask so that the edge softness extends toward the corners of the frame.
4. You may need to invert the mask to affect just the region outside of the mask.
5. Apply a brightness color correction to the masked region, and increase the brightness until the image has the same brightness at the edges as it does in the center.

6. Apply a saturation color correction to the masked region, and increase the saturation until the image has the same saturation at the edges as it does in the center.

7. Adjust the size and softness of the mask, and tweak the color settings until the vignette cannot be seen.

8. You may need to crop and resize the image if there is substantial loss of detail at the corners.

9. Render out the sequence.

Figure 3.12

Camera Shake

Although it may not always be noticeable, camera shake happens all the time. Small tremors in the position of the lens, either from mechanical vibration of the lens elements or camera body or from less-than-smooth camera moves (or both), translate into displacement of the image across a sequence. The longer the focal length of the lens, the more exaggerated the effect tends to be.

Digital compositors have had to deal with this problem for years, and the result is that it is fairly easy to correct with modern digital tools.

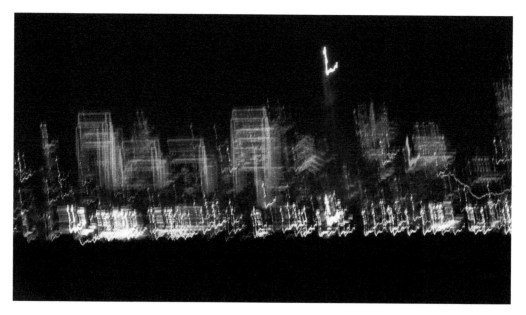

Figure 3.13 *Movement of the camera over the course of a single exposure can cause extreme blurriness.* © *Jessica Merz.*

Film Shake

One of the oddities about camera shake in film cameras is that even though it can be much more pronounced than with other media (the movement of the film itself in relation to the lens compounds the motion of the shaky camera), it isn't really noticeable when viewed in a theater. The reason for this is that film projectors have an inherent shake to some degree, which the audience subconsciously compensates for. When you watch projected film, it is only when scrutinizing the edge of the frame, or looking at something that should have a fixed position (such as captions or titles), that you really notice the erratic motion.

Once you view such footage on a monitor or screen, the unsteady motion becomes much more obvious, largely because the edge of the screen is much more prominent and provides a stronger point of reference.

How to Remove Camera Shake
This is a common compositing technique, known as "stabilization."

Removing camera shake from (or "stabilizing") a sequence successfully takes a bit of time to master, but can be done quickly with practice. It involves two stages: calculating how the camera moves in relation to the scene, and then reversing that motion.

1. Load the footage into a tracking system.

2. Pick a point in the image that should be completely still and track its motion across the entire shot.

3. You may need to tweak the results or add more points, for example, if something moves in front of the point you've tracked at any time during the shot. The resulting tracking data give the motion of the camera during the shot.

4. This tracking data can now be applied to the original footage (you may need to invert the data to get the desired result, depending upon your software).

5. Zoom and crop the image (if necessary) so that the edge of the frame doesn't encroach on the footage, and render the sequence out.

Figure 3.14

Picking the right point to track can make all the difference to the success of the final result, so it may be worth experimenting with different points. Ideal points will vary depending upon the specific tracking software you use, but as a rule, try to pick something close to the center, with strong, high-contrast vertical and horizontal edges. For static camera shots, features such as the corners of windows or items of furniture make excellent candidates.

Sometimes there may be an area outside of the picture area that is known to be stable and can serve as an excellent tracking point. For instance, some film cameras burn a reference marker at the edge of the frame independently from the position of the film itself, which can be used to at least eliminate the motion of the film weaving as it passes across the camera's gate.

Although not ideal from the point of view of quality loss, it may be necessary to repeat the process several times on the rendered output to ensure perfectly smooth motion.

> **TIP**
>
> Camera shake typically implies a loss of softness due to motion blur as well as the more apparent motion problems. For the best results, it may be necessary to apply some form of motion blur reduction after removing the shake. See Chapter 10 for more information.

How to Add Camera Shake

Camera shake can be added to footage to imbue it with energy, to add drama, or simply for the sake of continuity.

The secret to adding believable camera shake to a more stable shot is to use footage that naturally has the shaky motion that you're after.

1. Locate some reference footage that already has the characteristics of camera shake (in terms of frequency and amount) that you want to add to the stable footage.

2. Pick a point in the image that should be completely still and track its motion across the entire shot.

3. You may need to tweak the results or add more points, for example, if something moves in front of the point you've tracked at any time during the shot. The resulting data give the motion of the camera during the shot.

4. Save the tracking data.

5. Load the stable shot into the tracking system.

6. Apply the saved tracking data to the shot (you may need to split up the shot or loop the data if the reference shot was shorter than the stable one).

7. Zoom and crop the image (if necessary) so that the edge of the frame doesn't encroach on the footage, and render the sequence out.

Figure 3.15

How to Smooth Unsteady Shots
Even the infamous steadicam camera can produce results that leave a lot to be desired.

1. Load the footage into a tracking system.

2. Pick a point in the image that should be completely still and track its motion across the entire shot.

3. You may need to tweak the results or add more points, for example, if something moves in front of the point you've tracked at any time during the shot. The resulting tracking data give the motion of the camera during the shot.

4. You now need to separate the shake from the desired motion. There are a couple of ways to do this.

 a. If your tracking software has the capability, you can duplicate the tracking data you've just collected, smooth (or blur) it, and then subtract that from the original tracking data.

 b. The other option is to completely remove all camera motion and then manually recreate the original camera move (using the pan-and-scan technique in chapter 9) afterward. If you opt for this approach, make sure that you don't crop the footage at any point (you may need to increase the rendering region of your workspace to prevent this from happening).

Figure 3.16

5. You should now be left with tracking data that contain just the motion that needs to be removed. Apply it to the original footage (you may need to invert the data to get the desired result, depending upon your software).

6. If necessary, apply a pan-and-scan to recreate additional motion.

7. Zoom and crop the image (if necessary) so that the edge of the frame doesn't encroach on the footage, and render the sequence out.

> **TIP**
>
> A very common problem with shot footage, especially for film shoots (which tend to involve a lot of swapping camera parts), is for a hair to get caught in the gate and then make a cameo appearance in the resulting image. This can have several side effects, such as causing scratches, but all of these are generally fixable. See Chapter 4 for more information on film damage.

Focus

Getting good focus during a shoot involves so much skill that an entire profession (focus pulling) is devoted to it. Because of this, it's inevitable that sometimes shots are not quite as focused as they should be, resulting in images that may be "soft" (lacking sharpness). Sharpness may be most noticeably lost at the lens, but it is also diminished during the process of digitization (or analog-to-digital conversion).

It is not possible to digitally refocus images, because there is an inherent loss of quality that can never be recovered, short of a reshoot. The easiest way to visualize why this happens is to think

Figure 3.17 © *Keven Law (www.flickr.com/people/66164549@N00/).*

about nighttime photographs that have distant lights in them. The lights that are close to the focal plane will appear as tiny points in the image. The farther the lights are from the focal plane, the more they start to look like circles of color (and the bigger those circles get). Well, that's actually

true of any single point of anything ever photographed, whether it's a streetlight or the edge of a table. The farther away from the focal plane that point is, the more distorted it becomes. In the same way that it might be impossible to shrink those large circles of lights back down into points, it might be impossible to recover detail for any part of an image that is not on the focal plane. Things become a little more complicated when you also account for the fact that the brighter those points of light are, the more they overpower the rest of the image.

Figure 3.18 *The farther from the focal plane, the less defined the edges. The recorded size of a single point is known as the circle of confusion.*

Having said that, it is possible to use digital tools to at least fake sharpness in a convincing way. The sharpening process (which is often called "aperture correction" when it applies to analog-to-digital conversions) basically finds and then increases the prominence of edges in an image. It requires a delicate balance, though—too much sharpening and telltale problems such as ringing or aliasing can appear.

Digital Sharpening

Anyone who has dabbled with digital photography is probably aware of the range of sharpening tools available. To get the greatest benefit from them, it is important to be aware of two things: how we perceive edges and how sharpening algorithms work.

> **TIP**
>
> Although Chapters 5 and 6 relate to video and digital footage respectively, they contain techniques that are useful for fixing problems caused by too much sharpening, such as ringing and aliasing.

Perceived sharpness is incredibly subjective. It depends on how good your eyesight is as well as things like how bright the subject is, how much motion there is, and how close you are to the subject. Most importantly, it depends on contrast. Images with high-contrast edges will almost always appear to have better definition. Therefore, one of the most important things to do when analyzing footage is to optimize your viewing conditions. This means that you need to make sure that the screen you view the footage on is bright, that there is little ambient light in the room, and that what you're viewing is set at 100%, thus ensuring that it is not being resized by the software to fit

the screen. You should also check that your screen itself doesn't apply any sharpening to what you're looking at—unfortunately, many modern screens do this by default.

Another subtle issue is that we are much more sensitive to changes in luminance than we are to chroma. In terms of sharpness, this means that sharpening luminance is much more important than sharpening chroma.

The other key to mastering this process involves understanding how the sharpening algorithms work. Sharpening processes come in a variety of flavors, but are mostly based upon a simple premise: they exaggerate edges. Imagine an edge in an image as a see-saw, with the height of one side compared to the other as the relative sharpness of the edge. A sharpening algorithm adds a little bit of weight to the see-saw, so that the height difference becomes greater. At its most basic, this will result in every edge in the image appearing more pronounced (which isn't necessarily a good thing). Some algorithms can be a little better behaved than that, only affecting edges that already have a minimum degree of sharpness, for example. Others actually overexaggerate the sharpness of pixels on an edge—imagine that someone dug a hole in the ground underneath the see-saw to coax a bit more of an incline out of it.

Figure 3.19 *Looking at the edge profile of a blurred edge, a sharp edge, and an oversharpened edge reveals digital artifacts that might otherwise be difficult to spot.*

There are significant problems with just applying a stock sharpening algorithm to a piece of footage, even though it is often a quick and easy fix. First of all, they almost always affect the footage in a uniform way. This means that every pixel of every frame is treated as a potential edge, with little regard to where it is with respect to the focal plane. Secondly, they tend to analyze the RGB values to determine where there are edges, which ignores the fact that we are more interested in luminance values than chroma values, and also ignores the fact that different amounts of sharpening may be required for the shadows than for the highlights. And, finally, they can lead to destructive artifacts within the footage, particularly if there is a lot of fast motion in the image.

How to Repair Out-of-Focus Shots
The following technique works well in most situations, and at a minimum will give you much better results than just applying a stock sharpening filter.

1. Load in the footage, and make sure it is set to be viewed at 100%.
2. Separate the luminance channel from the color channel. This will form the basic mask (separating into L, A, B channels is the preferred method for doing this, but it is not available in all software packages, in which case you may have to make do with splitting it into H, S, B and working with the B channel).
3. Duplicate the luminance channel a couple of times so that you have three copies.
4. Key each of the luminance channel copies so that one contains just shadow information, one has just mid-tones, and the last just highlights. These will form your three main masks to apply to the original footage.
 a. If there are specific regions in the images that need extra sharpening, such as an object or character the audience will be paying attention to, it will be worth creating additional masks to isolate those areas.
 b. If the focal point changes significantly during the shot, create a circular mask with a very soft edge and apply a dynamic move on it to roughly track the focal point of the lens throughout the shot.
5. Apply an edge detection filter to the three main masks, and then blur the results by about 200–300%. This will focus the sharpening effects on just the edges.
6. Apply a series of sharpen filters to the original image, using each of the masks in turn. If your software "bakes in" the sharpening operations to the original image as you apply them, be sure to set the sharpening strength to a very low value in each case, and then repeat this step until you get the desired result.
7. Render out the sequence.

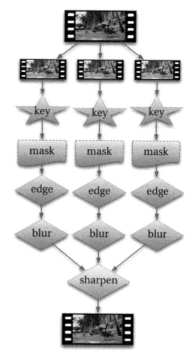

Figure 3.20

> **TIP**
>
> Generally, if you're going to be performing a lot of other fixes to a piece of footage, you should leave the sharpening part until the end.

Sharpness from Noise

You can increase the perception of sharpness in footage by adding a small amount of noise. To exploit this fact, mask any regions representing the focal points, and then add some noise to the luminance channel.

Figure 3.21 *Detail of the slightly out-of-focus shot.*

Figure 3.22 *The final mask.*

Figure 3.23 *After sharpening.*

Figure 3.24 *Adding a small amount of noise can increase the apparent sharpness.*

Color Fringing

Color fringes are halos or bands of color around objects in images. There's a ton of debate as to what exactly is the cause of color fringing in any given situation, but it can usually be attributed to either a lens or recording medium imperfection.

The good news is that they are largely geometric in nature—you won't often see large fringing in one part of an image and not in another—and thus fairly simple to fix.

Figure 3.25 © Josef F. Stuefer (www.flickr. com/photos/josefstuefer).

How to Remove Color Fringes
Most color fringes can be removed by shrinking them down.

1. Load the footage and identify the primary RGB colors of the fringe. For example, purple fringes are a combination of red and blue.
2. Separate the red, green, and blue channels.
3. Scale the channels containing the fringe slightly (red and blue channels for a purple fringe), until the fringe cannot be seen.
4. Crop the image, if necessary, to remove any borders at the edge of the frame.
5. Render out the sequence.

Figure 3.26

Figure 3.27 Close-up of a color fringe. © Andrew Francis (www. xlargeworks.com).

Figure 3.28 *After removing the color fringe.*

Lens Flare

Love them or hate them, lens flares are everywhere. They are the result of light reflecting off the surface of individual lens elements. Traditionally, they would be seen when pointing the lens directly at a bright light source (such as the sun), but the effect is easy to simulate digitally through filters. Ironically, lens flares are now so synonymous with computer-generated images that many cinematographers try to avoid them wherever possible just for this reason.

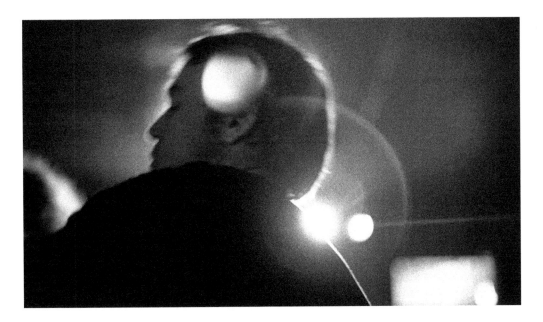

Figure 3.29 © *Andrew Francis (www.xlargeworks.com).*

Lens flare can also be more subtle, with a small but noticeable amount of stray light falling on the lens and contaminating the shot, which may not be noticed until long after the shot is in the can. Lens flares distort the contrast, luminance, saturation, and hues of the areas they fall on, sometimes so much so that even color-correcting the affected areas cannot recover the original detail. They also have a tendency to move around a lot over the course of a shot, but as we'll see, this actually helps in the process of trying to remove them.

How to Remove Lens Flare
Removing lens flare from footage is a laborious process, but the results can be worth it.

1. Load the footage.
2. First examine how the lens flare moves in relation to everything else in the shot. Because the most common source of lens flare is the sun, footage with lens flare tends to contain a lot of sky.
3. Create a "clean plate" to use throughout the shot. Identify a frame that contains most of the imagery in the shot (you may need to pick several frames at regular intervals to fulfill this function) and clone from them to create a single frame with no discernable lens flare.
 a. Where possible, mask parts of the lens flare and color-correct them so that they match the surrounding image.
 b. For the rest of the image, clone areas from adjacent frames or from elsewhere in the current frame until the lens flare has been completely removed from the image.
4. Step through each frame, cloning areas from the clean plate on that frame until traces of the flare have gone.
5. Once you reach the end, play through the cloned result in real time, looking for inconsistencies and cloning artifacts that may have arisen. Fix these by using more cloning (you may also need to clone from the original footage if you get into a bit of a mess) until the lens flare is removed and there are no cloning artifacts.
6. Render out the sequence.

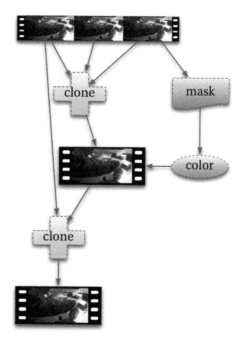

Figure 3.30

Figure 3.31 *Close-up of lens flare on a frame.*

Figure 3.32 *Cloning out the lens flare.*

Simulating Camera Filters

One of the benefits of working in the digital realm is that it's very easy to simulate certain effects (with an unprecedented degree of control) that would otherwise need additional filters attached to the lens during a shoot (at additional expense and limitations).

Table 3.1 describes how to replicate some of the most popular camera filters easily (where possible) using generic digital processes (note that these are intended as starting points rather than definitive recipes).

Table 3.1

Photographic Filter	*Digital Equivalent*
Neutral density	Brightness + contrast
Polariser	None
Colour	Tint
Starfactor	Starburst filter
Soft focus/diffusion	Blur with soft circular mask
UV	None

Figure 4.1 © *Escobar Studios (www.escobarstudios.com).*

Chapter 4
Fixing Video Problems

"I'm just a cross-hair, I'm just a shot away from you."
—Franz Ferdinand

Probably the most ubiquitous shooting format on the planet, video is loved by many, and loathed by a few. It's cheap, disposable, and easily obtainable. In the last decade, broadcast-quality video impregnated the consumer market, and today, even at the high end, high-definition video standards can be used with ease on even a modest desktop editing system.

The level of quality of video varies dramatically, from the (almost obsolete) standard definition formats such as PAL and NTSC, through high definition, to emerging formats such as RED, which offer an approximately twenty-fold increase in picture size of the acceptable broadcast specification.

Video Semantics

Technically speaking, "video" refers to a clearly defined set of specifications (standard and high-definition formats). Most digital video we are exposed to (such as those videos on YouTube or cell phones) does not fall into these categories, and are instead some proprietary digital format. However, the vast majority of what would be considered broadcast video cameras are digital in some way or another, and with formats such as Sony's XDCAM or Panasonic's P2 (which store footage in a completely digital format on computer-compatible media), this line is being blurred even further.

To avoid getting overwhelmed in technicalities, "video" in the context of this book will generally mean anything that is not originated on film, and "broadcast video" will be used to specifically refer to video formats used by broadcast television, such as NTSC, PAL, and 1080p.

Frames, Fields, and GOPs

Figure 4.2 © *Mikael Altemark (www.flickr.com/people/altemark).*

Video gives the illusion of motion by showing a sequence of images in rapid succession. Each image, or frame, is shown for a fraction of a second, typically such a short time that you don't consciously perceive it (the exact number of frames shown in a second is referred to as the frame rate). Most of the time, you can look at an individual frame from a sequence and it will appear indistinguishable from any other digital image (although it may differ in terms of quality). This is one of the reasons why it is often convenient in postproduction to split footage into its constituent frames before doing any processing.

Video isn't just made from frames, though. A single frame can be subdivided into fields, and a sequence of frames can be combined into a group of pictures (GOPs). Each of these can be further subdivided into various components as well (at which point that knowledge stops having any real practical application and serves only to make it all seem unnecessarily complicated).

GOPs define frames into a predictable pattern and are mainly used in digital compression technologies (a notable example being the MPEG standard for digital video compression), and therefore aren't really relevant most of the time, unless you run into compression artifacts (which is covered in Chapter 6).

Fields, on the other hand, are a much more common source of problems. A field is half a frame, and exists to solve a problem of bandwidth. During recording, many video cameras cannot process a complete frame fast enough to capture it in its entirety. Many video cameras process frames line by line from top to bottom, but by the time they get to the end, the image has changed slightly, leading to streaks in footage of fast-moving subjects. To compensate for this, the frame is divided into two fields, which are processed separately. For the first field, the camera records only every other line from top to bottom, and for the second field, records the other set of lines. The two fields are then stored as a single frame (the overlapping field lines are said to be interlaced).

You may already be able to see some of the problems this can cause. First of all, there is the delay between each field being photographed, which means that fast-moving subjects look distorted when seen as a still frame. (They may look fine during playback, however; this is usually because the display itself is showing one field at a time rather than a frame, or it may be that the frame rate is high enough that individual frames are imperceptible.)

Another potential sticking point is the order of the fields. The specification for each video format defines the order differently. The result is that some video formats record the first, third, fifth (and so on) lines first (this is known as "odd" or "upper first"), and others record the second, fourth, sixth (and so on) lines first (known as "even" or "lower first"). This can lead to a whole heap of mess, mostly because there is nothing in the video itself to determine which system is being used—you just have to be aware of it based on the type of video you're working with. If you process video thinking it has even field order when it actually has odd field order (or if it's not interlaced at all), you might not notice until you start to spot problems down the line.

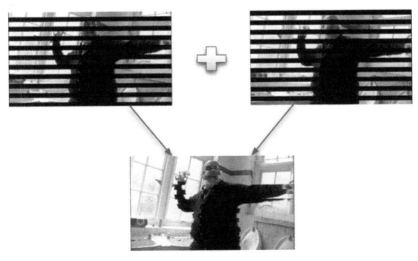

Figure 4.3 *Frames are made up from two interlaced fields.*

Figure 4.4 *Each field is recorded at a different point in time.*

> **TIP**
>
> Videos that are recorded with frames in their entirety (without using interlacing) are known as progressive scan. Both progressive and interlaced video can be stored as either type, though: it's not unusual to find progressive video on a tape that traditionally carries interlaced video.

Figure 4.5 *Progressive scan records each frame in its entirety.*

How to De-interlace Footage

If you plan on mixing interlaced footage with other types of media, you will need to de-interlace it to get the best results.

There are lots of reasons for de-interlacing video, but they ultimately boil down to either trying to squeeze as much image quality out of the footage as possible or reducing artifacts (such as those experienced when resizing or reframing interlaced footage).

1. Resize the footage to 50% of its original height, without using any interpolation (for example, use the nearest neighbor method). Then resize it again back to its original size, this time with interpolation (for example, using one of the techniques in Chapter 9).
 a. At this point, you can stop here and you'll be left with a quick and dirty de-interlaced version.
 b. Otherwise, save this version as the de-interlaced upper field.
2. Return to the original footage and crop out the top line. Then repeat step 1, which will leave you with the de-interlaced lower field.
3. Layer one of the two newly created versions on top of the other and set them to blend at 50%. This will produce your de-interlaced blended version.

4. Return to the original footage and go to the first frame. Create a mask by subtracting the current frame from the next frame.

5. Repeat this process until you have a mask for all the frames in the sequence (to generate a mask for the final frame, subtract it from the previous frame). This mask sequence roughly represents the areas of motion between frames.

6. Layer the de-interlaced blended version on top of the original footage, using the mask you just generated to confine it to regions of motion.

7. Render out the final sequence.

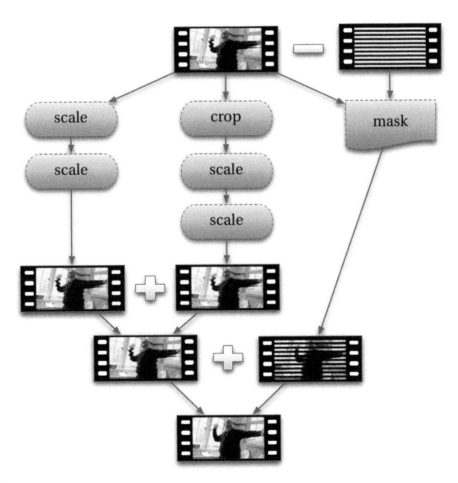

Figure 4.6

Figure 4.7 *Close-up, the teeth of interlacing can be seen.*

Figure 4.8 *After de-interlacing.*

TIP

Most video editing applications include a method for de-interlacing video auto-matically, and this is one of the few instances where I'd advocate using them, if for no other reason than it makes the process much faster. Some software, such as the de-interlace plug-ins by Nattress (www.nattress.com), can achieve results that just aren't possible even with hours of labor.

How to Interlace Footage
Though not a particularly common process, interlacing progressive footage is simple to do (see Figure 4.9).

The most likely reason for wanting to deliberately interlace footage is that you plan to mix it with other interlaced footage, and/or you are outputting to a device that expects to see an interlaced source.

1. Load the footage into an editing system.
2. Retime it to 50% of its original speed (so that it runs twice as fast), using an interpolative method (if your system can't do this, refer to the techniques in Chapter 10). This will generate intermediate frames, but they will be sandwiched between the originals.
3. Remove the first frame from the new sequence, and then retime it to 200% of its current speed (so that the duration matches the original), but this time, make sure it doesn't interpolate the frames. This should leave you with just the interpolated frames (if not, try again, this time without removing the first frame).
4. Create a mask that includes every alternate row of pixels in the frame, starting with the first line.
5. Layer the original footage with the interpolated version in the following way:
 a. If you want to create upper-first interlacing, put the original on top of the interpolated version.
 b. If you want to create lower-first interlacing, put the interpolated version on top of the original.
 Refer to Appendix 2 for a list of the field orders of the most popular video formats.

6. Apply your mask to the top layer.
7. Render the sequence.

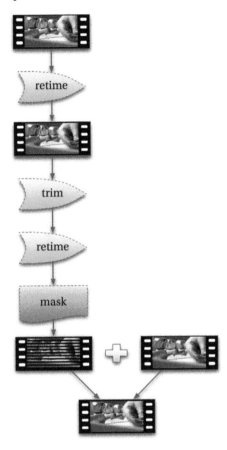

Figure 4.9

Note that this approach may cause the very last frame of the new sequence to not be interlaced, so it is advisable to use footage that is overlong (has handle frames) where possible.

> **TIP**
>
> Even if you're only going to be working with interlaced footage, you should still strive to de-interlace it before doing any postproduction work. In fact, this is crucial if you plan to resize or reposition interlaced images, or do any sort of painting or layering (for example, adding text). Furthermore, you will greatly reduce artifacts that may be caused by operations such as keying or tracking if you first de-interlace. Even though it leads to a slight loss in the original picture quality, de-interlacing, then processing, then re-interlacing it provides substantial benefits overall.

How to Correct Field Dominance

The field order of a sequence can break for several reasons, making playback appear distorted.

Sometimes interlaced footage looks wrong during playback. The "mice teeth" telltale signs of interlacing may become very prominent, or motion in the footage may appear to vibrate. If you can rule out any faults in the display device, then the mostly likely explanation is that the field dominance in the footage—the order in which each field appears—is wrong. The first stage to fixing this problem is to do a little detective work to find out how exactly the dominance is wrong.

1. Load the footage, and make sure that your system isn't set to de-interlace the display automatically.

2. You will first need to determine what the field order should be from the format type (refer to Appendix 2 for a list of the field orders of the most popular video formats), and then compare it to what it currently is by inspecting the first few frames of the footage itself. To do this, look for motion that goes from left to right across a few frames. Examine one of the frames where the motion is quite pronounced, and you should see the "mice teeth" over the areas of motion.

 a. If you don't see any interlace patterns, then this indicates that the frame is actually progressive, and the problem can be fixed by using the interlace technique described above.

 b. Lines where the teeth extend to the right side were recorded as the second field. Teeth extending to the left are the first field. From the very top of the frame, count the number of lines until you can identify one of the lines as field one or field two. If you find that field one occurs on an odd-numbered line (or that field two occurs on an even-numbered frame) then your footage is currently set to upper-first. Otherwise, it is set to lower-first.

3. Compare the current field order to what the definition of the format is (in other words, what it should be).

 a. If the field orders don't match, then the fields need to be reversed.

 b. If the field orders are the same, then either the cadence (the order in which the fields appear within the frame sequence) is wrong, or it is being interpreted incorrectly. To determine whether the cadence is to blame, check the motion between adjacent frames. If the motion looks unnatural or appears to vibrate, then the cadence is wrong, and the fields are appearing on the wrong frame.

 c. If you find that the footage is being interpreted incorrectly, you will need to check the metadata of the footage file and correct it as needed. Typically, there will be a setting somewhere within the file itself to denote the field order, and the chances are that this has been set incorrectly.

4. In the case of needing to fix the cadence or reversing the fields, the next thing to do is separate the fields. To do so, create a mask that includes every alternate row of pixels in the frame, starting with the first line. This will be your upper field.

5. Layer the upper field version on top of the original (this will cause the lower layer to become the lower field). You must now offset the relative position in time of one of the layers to the other by one frame. If your footage should be upper field first, then you will probably need to ripple-delete the first frame of the top layer (and delete the last frame of the lower layer) or vice versa. Resolving cadence issues might take a little more trial and error, but usually trimming one or two frames from the start of one of the layers will do the trick (in really problematic cases, it may be necessary to re-edit the frame sequence of one layer to get the desired result, but bear in mind that cadence-related problems always have a pattern to them).

6. Render out the sequence.

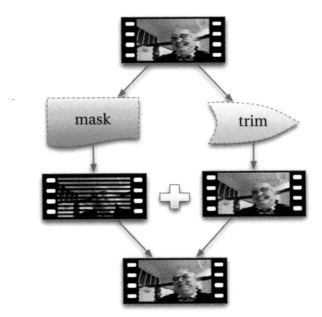

Figure 4.10

Figure 4.11 *Footage with reversed dominance, where the frames are in the correct order, but the fields are in the wrong order.*

Figure 4.12 *Footage with incorrect cadence, where the fields are out of sync with the frames.*

Figure 4.13 *Footage with incorrect cadence, where the fields are out of sync with the frames.*

> **TIP**
>
> Incorrect cadence might be an indication that the footage has undergone a pull-down process, in which case additional work may be required to restore the footage correctly. See Chapter 11 for more on this topic.

How to Remove Stretched Fields
Removing fields is one thing, but when the fields themselves have been modified, it can be a bit trickier (see Figure 4.14).

With a little experience, de-interlacing footage can become a routine process, especially if you use plug-ins to do most of the work for you. On occasion, though, you may be faced with video that has the hallmarks of being interlaced, but traditional de-interlacing approaches seem to make the situation worse. On closer inspection, you find that the field lines are more than 1 pixel in height—larger than all de-interlacing processes expect them to be.

This is usually the result of interlaced footage being resized without first being de-interlaced, or it could be the result of an interlacing process gone awry.

1. Load the footage and zoom in so that you can see individual pixels. The first thing to note is how many pixels in height each of the "mice teeth" are. If you're lucky, the mice teeth will have hard edges, indicating that they are an exact number of pixels high. If the teeth appear to blur slightly across the rows of pixels, you will need to work out the height by counting a number of rows and calculating the average height.
2. The next thing to note is whether each field line contains any vertical detail, but the teeth sections are hard-edged (not blurry).

a. If it does, then this is a sure sign of an interlacing process gone wrong. You can fix it by following the procedure for correcting field dominance above, but create the mask to match the height of each field line rather than setting it to 1 pixel. The chances are that this will result in a de-interlaced sequence.

3. Resize the footage so that each field line is 1 pixel in height. For example, if you found that each field line was exactly 3 pixels in height, resize it to 33.3% of its original height; if it was 2.5 pixels, then resize to 40%. Make sure not to use any interpolation (for example, use the nearest neighbor filter). If the teeth are still vertically blurred, you can try using a vertical sharpening filter.

4. You can now de-interlace using the procedure above. If you couldn't successfully produce a version at the right size with hard-edged teeth, you will also need to apply a slight vertical blur to the upper and lower fields you create as part of the process to prevent artifacts.

5. Finally, resize the footage to its original height, if necessary, and render.

Figure 4.14

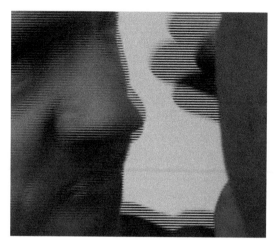

Figure 4.16 *After resizing, the field lines are now each a single pixel high.*

Figure 4.15 *Here, each field is 2 pixels in height.*

How to Remove Drop-out
Drop-out is fairly common, but very quick and easy to remove (see Figure 4.17).

"Drop-out" is the term given to a type of damage that video can suffer. It can be recognized as blocks in the image (these could be blocks of color or even other parts of the image) in one or more places on individual frames. In the days of videotape, drop-out was caused by tiny pieces of the tape's surface breaking off or getting damaged in some way. In the digital world, data corruption can lead to a similar effect.

1. Load the footage.
2. On frames that exhibit signs of drop-out, clone areas from adjacent frames, or from elsewhere in the current frame until all the damage has been removed completely from the image.
3. Render out the sequence.

Figure 4.17

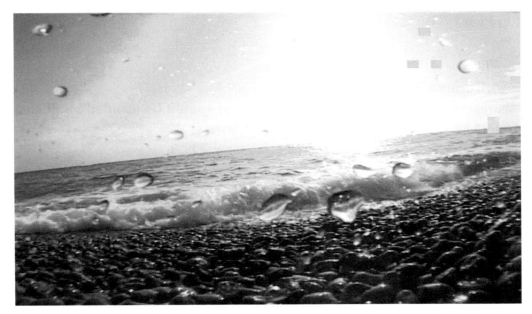

Figure 4.18 *A frame exhibiting drop-out.* © *Jack James.*

Figure 4.19 *The corrected frame.*

TIP

Although digital corruption can exhibit similar effects to drop-out, it can be a little more complicated to fix because damaged digitally compressed videos can have additional problems. Refer to the techniques in Chapter 6 for more information.

How to Reduce Ringing
Oversharpening is destructive to the image, and should be avoided at all costs. If it's too late for that though, all is not lost....

Ringing (also referred to as haloing, or occasionally (and incorrectly) as ghosting) is caused by excessive digital sharpening. Since there are many ways that footage can undergo digital sharpening (such as in the camera itself or as part of some digital postprocessing operation), it is not unusual for multiple sharpening processes to stack together, resulting in footage that actually becomes damaged as a result.

The effect of ringing is normally seen on edges in an image: the edge appears sharp, but there appear to be outlines on either side of the edge. It's one of the most destructive things that could happen to an image. The following technique can help reduce the apparent effects of ringing, but cannot recover detail that has been lost (see Figure 4.20).

1. Load the footage.
2. Apply an edge detection filter across all frames. This will isolate the edges in the original. Now we need to isolate the regions next to the edges, where the oversharpening effects are.
3. Apply a second edge detection to the result. This will outline the previously found edges.
4. Blur the result a little. This will form the mask for the next step.
 a. You may need to color-correct the mask to focus on the appropriate region.
5. Blur the original footage, constraining the blur to the mask you just created.
6. Render out the result.

Figure 4.20

Figure 4.21 *Close-up of footage with ringing. © Andrew Francis (www.xlargeworks.com).*

Figure 4.22 *The footage with reduced ringing.*

> **TIP**
>
> This technique can be tweaked to produce better results by separating the image into shadows, mid-tones, and highlights. Our eyes are more sensitive to the effects of ringing in the highlight regions, less so in the shadow regions, and hardly at all in the mid-tones, so you can adjust the effects of the technique in each of those regions separately to avoid reducing the image quality too much. You can also experiment with separating the luminosity from the color, and constraining the effects to just the luminosity.

Ghosting and Cross-talk

Ghosting and cross-talk are problems created by transmission or circuitry errors in analogue video. What happens is that the signal gets duplicated in some way, adding to the original and interfering with it. In the case of ghosting, this is seen as a visual echo throughout the video. The complexity of the resulting footage means that it can't be fixed using digital means; instead, the only option is to produce a new copy from the original video source.

How to Convert Video Formats

Converting video between different formats requires a combination of several techniques.

Because there are so many different video formats in popular use, it becomes somewhat inevitable that at some point you're going to need to convert from one format to another. There are many applications that promise the ability to convert between the formats effortlessly, but in practice even these require a great deal of trial and error to get perfect results and are therefore more suited to situations where you need to automate the process of converting one specific format to another several times.

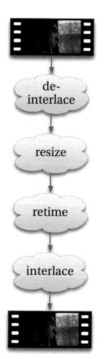

1. First, get the specifications for the format you're converting from, and the format you're converting to, in terms of the frame size, aspect ratio, frame rate, compression, bit depth, and field order (refer to Appendix 2 for the specifications of the most popular video formats). For the source video file, you can take advantage of tools such as the freely available MediaInfo (mediainfo.sourceforge.net) or VideoInspector (www.kcsoftwares.com) to retrieve most of what you need from the file itself.

2. If the source is interlaced, use the process outlined on page 58 to de-interlace it (you should do this regardless of whether or not the target format is interlaced, as it will improve the results from all other steps in this technique).

3. If the source resolution (or aspect ratio, or pixel aspect ratio) is different from the target resolution, then it will need to be resized, using the techniques in Chapter 9.

4. If the frame rate in the source and target formats is different, use one of the techniques in Chapter 10 to retime it.

Figure 4.23

5. If the target format is interlaced, use the procedure on page 60 to interlace it.

6. Render out the sequence. Be sure to render to a file format that supports the compression type and bit depth of the target format (alternatively, render to an uncompressed format and then transcode it into the desired format later).

Scaling Video

The nature of digital video means that the need to resize it in some way is very common. The most obvious cause for resizing video is when converting formats, such as when you want to get an HD video source onto a regular DVD (which expect standard definition picture size), or when scaling lower-quality video sources for output to high definition, but there are many other situations where scaling plays an important role.

The problem is actually two-fold; first you must recompose it to match the aspect ratio (the shape of the frame) of the desired format, and then you must resize it. Resizing any digital image is not as simple as it might seem. Different methods give results of varying quality, and some approaches take much more time than others. The topic of resizing and repositioning digital footage is discussed in greater detail in Chapter 9.

How to Make Video Look Like Film
Trying to emulate the "film look" is something that is often attempted; here is one way of doing it.

First of all, a disclaimer: it's not really possible to make something shot on video look like it was shot on film. Film has many properties that give it a unique look that can be difficult, even impossible, to emulate with pixels. Trying to mimic different film stocks requires radically different approaches.

Now that that's out of the way, the "film look" is an incredibly desirable technique to master. Although it's rarely necessary (trying to mix video footage with film footage not withstanding), it's something I'm asked about on a regular basis. The following approach isn't necessarily going to produce the most realistic results, but it provides a structured approach that's well suited to different types of footage.

1. Load the video (ideally, you'd also have at least a reference image of the scene shot with a disposable film-based camera, but this is unlikely).

2. De-interlace the footage if necessary, using the technique on page 58 (interlacing is only exhibited by video footage).

3. Inspect the footage for any signs of oversharpening and use the technique on page 67 to eliminate it if necessary (digital sharpening is a telltale sign of video-sourced images).

4. Reduce any noise in the footage, using the techniques in Chapter 6.

5. Stabilize the footage using the method in Chapter 3 (the complexity of shooting film encourages steadier footage than video, and steady footage is thus synonymous with the format).

6. Resize the footage so that the pixel dimensions match those of the chosen film format (refer to Appendix 2 for the specifications of the most popular film formats), using the techniques in Chapter 9. Make sure you match the aspect ratio as well.

7. Use the technique in Chapter 10 to add motion blur (film tends to be shot with the shutter open longer than in video, and so exhibits more motion blur).

8. Use the technique in Chapter 5 to add grain to the footage.

9. If you want to emulate film damage, you'll need some scanned film that doesn't have any picture content. Then create a mask based upon the dust and scratches and use that in a new layer.

10. Color-correct the image to make the shadow regions a bit deeper, increase contrast in the mid-tones, and reduce the saturation of the reds and blues a little.

 a. Different film stocks have slightly different color responses. For example, 8 mm footage tends to have stronger yellows, so saturating the yellow regions will help to emulate 8 mm film.

 b. You may find that adding a small amount of glow to the footage gives it a more film-like quality.

11. Render the sequence out, if necessary resizing it back to the original resolution.

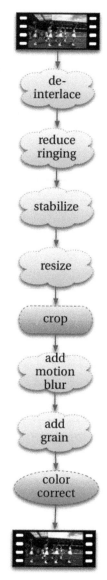

Figure 4.24

Figure 4.25 *A frame of footage shot on video. © The Cheerleading Company (www.cheerleadingcompany.co.uk).*

Figure 4.26 *The resulting film-look frame.*

Figure 5.1 © *Andrew Francis (www.xlargeworks.com).*

Chapter 5

Fixing Film Problems

"Grant me this final wish, I want to put you in a trance."
—Soho Dolls

There's something about film. It's a fragile, expensive, complicated, and elitist medium in today's digital world, but it has a certain quality to it. No other medium can evoke a dreamlike state the way that projected film can.

The days of film as a shooting format have been numbered for an extraordinarily long time now, but it is still going strong, with billions of feet of film being shot each year for commercial productions. Despite a tedious amount of technical discussions within the film industry as to its tangible value compared to digital formats, it is very common to end up working with digital footage that originated on film.

The process of digitizing film is best left for another book, but even so, there are some characteristics of film that remain problematic, even in digital postproduction. Thankfully, the vast majority of them are fixable, but have a big tub of elbow grease standing by....

Film Damage

One of the most recognizable characteristics of film footage is the damage. It's something of a visual cliché that in order to make footage look like actual film (especially old film), there needs to be dust sparkles and scratches all over it. The reality is that film (even modern film) does exhibit these types of damage, albeit (one would hope) in smaller quantities.

The damage is caused by the fact that film images exist as physically very small pieces of material that are projected to many times their actual size. Due to

> **TIP**
>
> There are lots of techniques that claim to be able to capture the look of film using video footage (even I present a technique for doing this, in Chapter 4). The truth is that no other medium can completely match film visually, which is one of the reasons it remains so popular today.

Figure 5.2 © *Andrew Francis (www.xlargeworks.com).*

the extreme degree of magnification that occurs, even a microscopic strand of hair can become as pronounced as a length of rope.

By the time the film has been scanned and is in a digital form, any of this kind of damage forms part of the image, and as such turns into pixels, leaving behind no trace of the image underneath.

Figure 5.3 *A frame of film with dust and scratch damage.* © *Andrew Francis (www.xlargeworks.com).*

Figure 5.4 *A frame of film with watermark and mold damage. © Andrew Francis (www.xlargeworks.com).*

How to Bust Dust
Dust on scanned film is by far the most common issue to deal with in postproduction.

Dust that happens to be on the surface of each frame of film scanned will become a permanent part of the image. Fortunately, each speck of dust translates to being only a few pixels in size in the digital image, and they are distributed randomly across the frame, so the following technique will work for the vast majority of cases.

> **TIP**
>
> There are a number of options available during the scanning stage that can help reduce the amount of film damage that makes its way into the digital realm. First of all, the film should be cleaned, using either chemical processes (also known as a wet-gate), or ultrasound. Secondly, some modern film scanners have the capability to use infrared to determine the locations of defects on the surface of the film, typically creating mattes that can then be used as part of an automated process to digitally correct them later.

1. Load the dusty footage into a paint system.
2. On a frame with dust, clone from an adjacent frame onto the pixels containing the dust. Use a soft brush, just slightly larger than the dust in question, and use an offset if the area in question moves between the source and target frames.
3. Repeat for any other dust in the frame.
4. Repeat for other frames.
5. Render out the sequence.

On the surface, this is a very simple approach, but the real trick to this technique is speed. There will doubtless be plenty of dusty frames to correct (numbering in the thousands on a typical 90-minute

Figure 5.5

feature) and so the key is not to agonize over any of them. After all, no hairdresser would cut hair a strand at a time, no matter how good he or she is.

As a rule of thumb, the less noticeable the dust speck is during playback, the less time you should spend trying to fix it.

How to Remove Mold and Watermarks
Fixing these larger types of film damage requires a slightly different tact from fixing dust, though the approach is similar.

TIP

One of the trickiest parts of removing film dust is finding the stuff in the first place. The best way I've found to spot dust is to adjust the display so that highlights stand out a lot more in comparison to the rest of the image (dust tends to get scanned as pure white, or close to it). Then play through the footage at a speed slower than real speed, and the dust should be highly visible.

Mold and watermarks are both types of damage specific to film. They form either as part of the processing and development of the film or during storage. In addition to obscuring the original image, they may also distort part of it in some way. Like dust, they tend to be randomly distributed across the frames, which means that cloning is usually a great way to get rid of them. However, the drawback to cloning in this way is that very slight differences in motion in the image between frames can cause the picture to shift very slightly between frames, and this becomes noticeable only during playback.

Because of the high volume of this type of damage, it must be fixed using a rapid method, which normally means using the same method used for dust. However, the larger size of this type of damage calls for a variation of the simple dust-busting technique above.

1. Load the footage, and identify the frame with the damage.
2. Clone over the damaged area from an adjacent frame.

a. For damage that covers a reasonably large area (in other words, is very noticeable), clone from both the frame before and the frame after the current frame. This will help reduce the perceptual impact of the cloning operation.

b. Some watermarks appear as rings on the image. In some cases it is acceptable to just fix the actual rings, but bear in mind that the areas enclosed by the rings may be subject to some distortion.

3. Repeat for other watermarks or mold in the footage.

4. Render the sequence.

Figure 5.6

How to Remove Tramlines
Tramlines are a staple characteristic of old film. One hundred years later, they're still tough to get rid of.

Tramlines are scratches, so named because they run the length of a piece of film (almost always from top to bottom of every frame). When you watch projected film that has tramlines, the effect is similar to watching the rails from the front of a tram. The common cause of a tramline on a strip of film is a small bit of dirt getting trapped in the path of the film; as the film is pulled across it, it scrapes the surface in much the same way an ice skater makes a distinct path across a frozen lake.

There are two kinds of tramlines: those that move, and those that don't. The ones that move are difficult to repair; those that don't are really difficult.

1. Load the footage.

2. Mask the scratch. If it moves, you will have to adjust the mask dynamically to follow the motion.

3. Use cloning techniques to repair as much of it as possible. This can be very tedious, especially for long sequences, but will result in much better results than using any other method.

a. Clone to a new layer if possible. This will allow you to fix the footage using multiple passes of the clone tool and mix and match results.

b. If the scratch is quite wide and doesn't move, it may be possible to construct a clean plate, particularly if there is a lot of motion in the scene (or if the camera itself pans), which can then be used as a base to repair most of (if not all) the damage.

c. If all else fails, duplicate the footage twice to get two new layers. Shift one layer left and the other right by half the width of the scratch in each case, and then blend them together.

> **TIP**
>
> Tramlines are a great candidate for using automated software designed specifically for the purpose. Additionally, if you have access to a high-end compositing system, tools for performing wire removals can work wonders on eliminating most film scratches.

4. Use the mask created earlier to constrain the fix to the scratch itself (you may need to soften the mask to make the fix blend well).

5. Review the fix so far (you may need to render out an intermediate version to see the changes). Then go back and fix anything that screams of digital manipulation.

6. When satisfied, render out the new footage.

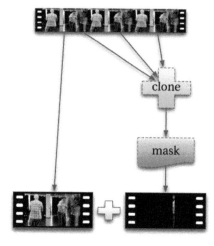

Figure 5.7

How to Correct Frame Registration
When frame registration takes a turn for the worse, fixing the resulting images can become quite a chore.

Even though film consists of individual frames, sometimes the exact positioning along the length of a piece of film (the registration) may not be consistent for various reasons. Just as paychecks are not

always evenly spaced throughout a calendar year, sometimes the positioning of each frame along the film may not be exact. This can lead to the picture appearing to oscillate up and down during projection or, in extreme cases, one frame creeping up into the previous one.

This doesn't just affect projection. Bad registration can easily translate to the scanned images, meaning it's possible to end up with scanned frames that vibrate during playback, or even images that contain parts from two adjacent film frames. The ideal method is to fix the problem at the source and rescan the film, although this isn't always possible. The following solution should work for even the most troublesome frame registration issues.

1. Load the footage and scrub through it slowly to determine the extent of the damage.
2. If the picture oscillates in some way but each frame is intact, you can treat the footage as if it is suffering from camera shake, and follow the instructions in Chapter 3 to remove it.
3. If the film frames run across two image frames, first rebuild the sequence. To do that, mask the bottom portion of the first frame with the problem, from the top edge of the picture to the bottom of the frame, and paste that into a new file.
 a. If the top part of the first frame is incomplete, you can try cloning it from the next frame after you fix it, or just discard it.
4. Mask the top portion of the next frame, and paste that into the bottom of the new frame, taking care to line up the edges.
 a. If you're lucky, the join will be seamless. If not, you will need to use cloning techniques to fix the seam later (referring to the technique in Chapter 10 for extending framing might help in this case).
5. Save the new frame, if possible with each section on a separate layer.
6. Repeat the process for the remaining frames.
7. Take the new frames and sequence them together. If possible, retain separate layers for the top and bottom of each image (this will make it easier to tweak the positioning later).
8. Play the sequence through to make sure there is no disparity between the motion of the top and bottom sections.

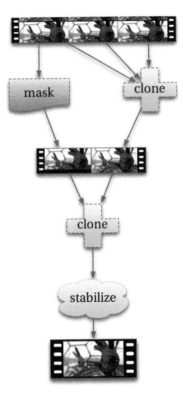

Figure 5.8

a. If there is, use stabilization techniques on the top and bottom parts of each frame (if they are not on separate layers, you will need to create new masks and adjust them dynamically to separate the sections).

9. If necessary, use cloning techniques to remove any visible seams from the image.

10. Finally, ensure the finished sequence is steady; if it isn't, use the technique in Chapter 3 for removing camera shake.

11. Render out the sequence.

How to Repair Splice Damage
Splice damage can be devastating, but in the long run, usually only a single frame suffers.

A splice is a method of joining two pieces of film together (the actual process for doing this varies, but there always seems to be some sort of glue involved). Before nonlinear digital editing (before linear video editing, for that matter) splicing film was an integral part of the editing process. Films were quite literally cut and pasted together. Today, splicing film is still necessary in certain situations, even in digital postproduction. For example, if a piece of film snaps, it must be spliced back together in order for it to be scanned.

Figure 5.9

Usually a splice occurs outside of the picture area. Though in theory this means that film splices shouldn't affect the image, in reality they can cause any (or all) of the following side effects:

- Changes to frame registration, such that the footage suddenly (and noticeably) jumps in some way when played back
- Missing frames, if the nature of the splice meant that one or more frames were discarded as part of the process
- Visible glue or other gunk finding its way into the picture area
- In some instances, the splice itself is visible in the picture area.

Each of these issues must be fixed independently of the others, using a combination of techniques.

1. Load the footage into a timeline. First, identify where in the sequence the splice occurs. This should be easy; it will almost always be on the first frame where the damage makes an appearance.

2. Make a cut in the sequence. If there is a shift in frame registration, you can usually fix it by repositioning the part of the sequence after you cut vertically to remove the jump.

a. Sometimes the splice can cause the shift to occur across several frames, as a result of causing the film to bounce slightly during scanning. If that is the case, refer to the technique above for correcting frame registration.

3. If there are missing frames in the sequence, use the technique in Chapter 10 for replacing dropped frames to smooth the sequence.

 a. Use this technique if there is extensive damage to any individual frame caused by splice damage; it may be easier to just cut out the bad frame and treat it as if it didn't exist.

4. Use cloning techniques similar to treating mold and watermark damage to clear up any visible stains, glue, or anything else that has found its way into the image.

 a. In some cases, this can also be used to recover any part of the picture where the splice is visible.

5. Render out the sequence.

How to Remove Film Gates
No one wants to see film gates creeping into the edge of the picture, especially when removing them is so trivial.

Film gates, the film equivalent of a picture frame mount, can sometimes make an unwanted cameo in a shot, either due to misaligned camera elements during a shoot or perhaps due to miscalibration during the film scan.

Figure 5.10

1. Load the footage and scrub through it to see the extent of the problem (it might help to use whatever visual guides are available in your chosen application).

2. If the gate is steady throughout the sequence, crop the image so that the gate is outside of the safe area for the desired output format, then scale it using the technique in Chapter 9 to get it back to the correct resolution if necessary. When you crop the image, make sure that you retain the same aspect ratio as the original.

3. If the gate gradually creeps into view, it may be possible to use cloning techniques to remove it (this is preferable, as it won't affect the quality of the rest of the image). Otherwise, use the cropping approach, using the frame where the gate is at its most visible as a reference.

4. Render out the sequence.

TIP

If the gate is visible in the frame but outside of the safe area for its intended output format, there's very little point in fixing it, as no one will ever see the difference. The main exception is if you plan on scaling it downward in some way. Most cinematographers will routinely shoot a line-up chart reference to identify the safe regions for the particular aperture they are shooting for; it's wise to refer to a scanned image of the line-up chart to determine whether the gate is indeed inside the intended safe area.

Film Grain

Grains are to film what pixels are to digital images, or what bricks are to the Great Wall of China: not much to look at close-up, but necessary to make the bigger picture.

Figure 5.11 *An example of a 3-perf line-up chart (courtesy of colorist Jim Mann).*

The most unique aspect of film grains (at least, when compared to pixels) is that they are randomly shaped and sized. This is part of the reason why film looks the way it does, but it also means that trying to simulate (or reduce) grain digitally is problematic.

Figure 5.12 *Grain is a key characteristic of film and can degrade an image or enhance it aesthetically. © Andrew Francis (www.xlargeworks.com).*

The film grain characteristics also vary depending upon the film stock used. For example, fast film (being more sensitive to light) has comparatively large grains, which give it the impression of being "grainy"; in other words, the grains are highly visible during playback. This is not the whole story, though, because 8 mm slow stock film footage (having comparatively small grains) tends to appear more grainy than 35 mm fast stock film footage. The reason for this is that the 8 mm frame is enlarged much more than the 35 mm frame, so the actual size of the grains in the image on screen might end up being much bigger in comparison.

How to Reduce Film Grain
Grain is a big part of what gives film its look, but sometimes it gets in the way of other processes.

The primary reason for wanting to reduce the visibility of film grains from a shot is to make it sit comfortably in a sequence with video footage on either side of it. The second reason is to perform some other operation that would suffer if you left the film grain in (much like you'd want to de-interlace video before scaling it).

The absolute worst reason for trying to reduce grain from a shot is to improve the image quality. Every grain reduction method will compromise the image quality in some way. The only way this could ever be justified is if the grain is so prominent that it is painful to watch the sequence play—to the extent that you'd be willing to blur it a little to remove the distraction and take the pressure off your eyeballs.

1. Load the footage, and zoom into it. Find the average width of a grain (in pixels) on any frame.
2. Apply a median filter, setting the size to slightly higher than the width you just measured, and increase the strength of the filter until the grain is reduced to a satisfactory amount.
3. For a more advanced variation of this technique, you can key the shadows, mid-tones, and highlights separately and apply the median filter to each in turn. The shadow areas will exhibit stronger grain patterns than the mid-tones, with the highlights needing the least correction of all.
4. Render out the sequence.

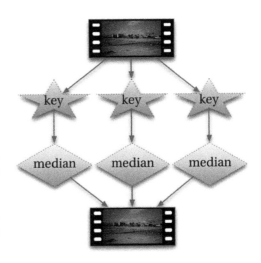

Figure 5.13

How to Add Grain

For the occasions when it's necessary to reduce film grain, adding it back afterward can make doctored footage look more natural.

1. Load some film footage that has no picture content (for example, scanned film leader).

2. If necessary, use the techniques outlined earlier in this chapter to remove signs of film damage.

3. Duplicate the resulting footage and use the grain reduction technique described above on one of the copies to completely remove the grain structure.

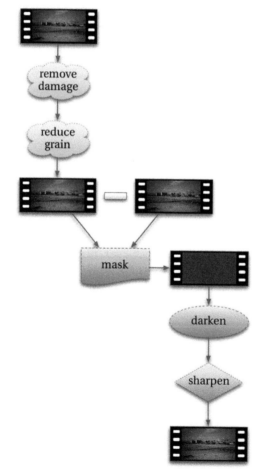

Figure 5.14

4. Generate a difference matte from the two versions, using the technique in Chapter 2.

5. Load the footage to apply the grain to.

6. Color-correct the footage to darken it. Use the difference matte as a mask to limit the extent of the correction.

 a. You can further limit the effect by keying the shadows, mid-tones, and highlight regions and applying different color corrections to each. The shadow areas should receive the lion's share of darkening, with the highlights receiving almost no changes at all.

7. You can also try applying a sharpen filter to the footage, using the difference matte to limit the effect. Depending upon the type of footage, this can work well (alternately, invert the mask and use a blur filter on the footage).

8. Render out the finished sequence.

Emulating Video

Even though there have been thousands of articles written on the topic of making video look like film, there are very few that discuss making film look like video, which is strange considering that it's a much more common postproduction technique.

Traditionally, film offers superior quality images over its video counterparts, so it makes sense to shoot film if you're unsure whether you want the end result to look like film or video (the flipside is that film is more expensive to shoot, so it can be in the best interests of the producer to shoot video if there's some uncertainty). The desire to turn film footage into something

Figure 5.15 © *Paul Noël Brakmann (www.flickr.com/photos/stallkerl).*

> **TIP**
>
> Although these techniques are from the perspective of film-sourced material, with a little bit of modification, they can also be used to make video footage (for example, HD video) look like a lower quality video source (such as a security camera video).

that resembles video can be motivated by the storyline, by artistic license, or by continuity (needing to mix film footage into a sequence of video), and is easily done, given the right tools. Although people tend to think of the "film look," with video there are actually several different looks, some of which will be covered below.

How to Make Film Look Like HD Video
35 mm film, and even good-quality 16 mm film, has better color rendition and even higher definition than HD video, so it's a good candidate for video emulation.

1. Load the film footage.
2. Remove any film damage, using the techniques discussed earlier in this chapter.
3. Use the technique given above for reducing grain.
4. Follow the process in Chapter 3 for adding camera shake (film footage tends to be steadier than video, purely because of the infrastructure required during a shoot).
5. Scale the footage down to match the resolution of your chosen HD format (refer to Appendix 2 for a list of resolutions for common HD formats).
6. Use a sharpening filter on the footage until signs of ringing (oversharpening) just start to appear (refer to Chapter 4 for a discussion of oversharpening).
7. Add noise to the footage (all HD video will exhibit some amount of noise).
 a. For a more convincing application of noise, separate the highlight and shadow areas, and be sure to add more noise to the shadow regions than the highlights.
8. Color-correct the footage (if possible, use similar footage shot on an HD camera for reference).
 a. Increase the brightness of the highlight regions so they clip (max out at white), paying particular attention to skies in the footage (video cameras are notoriously bad at reproducing sky detail).
 b. Darken and slightly desaturate reds, and desaturate greens in the footage (film is much better at reproducing deep reds and greens than video).
 c. Lower the contrast of the overall image, especially in the mid-tone regions (video has a linear response to light, and so it looks slightly muddier than film).
9. Retime the footage to match the frame rate of the chosen HD format, using the techniques in Chapter 10.

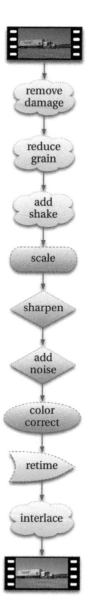

Figure 5.16

10. If the target HD format is interlaced, use the method in Chapter 4 to interlace the footage.
11. Render out the sequence.
 a. If your chosen video format uses some form of compression, make sure you render using the same compression type, as this will subtly affect the overall look of the finished footage.

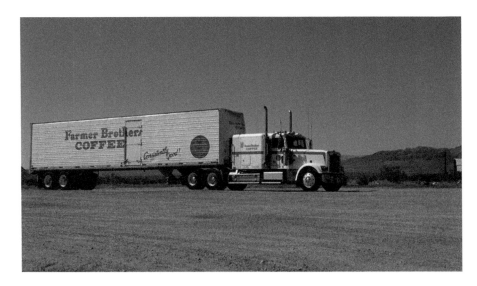

Figure 5.17 *An image shot on film. © Andrew Francis (www. xlargeworks.com).*

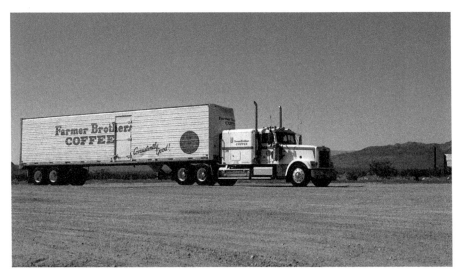

Figure 5.18 *The image made to look like video.*

How to Emulate Cell Phone Video

Shooting on a cell phone may be cheap, but that doesn't mean it's desirable, even if you want to capture the look.

The proliferation of video camera-enabled cell phones means that it is increasingly necessary to mimic the footage produced by these kinds of devices. At the same time, the cameras themselves do not lend themselves particularly well for shooting in the first place, and so shooting normally and postprocessing the footage later to look like the chosen format becomes a much more flexible option.

1. Load the film footage.
2. Remove any film damage, using the techniques outlined earlier in this chapter.
 a. It's probably not worth removing small dust sparkles, as these will likely be removed as part of the process anyway.
3. Follow the process in Chapter 3 for adding camera shake. You can add quite a lot of camera shake here, because cell phone video is rarely steady, and the reduction of the picture size will diminish the overall effect.
4. Blur the image until the fine details are barely distinguishable (this will mimic the inferior quality lenses that cell phone cameras tend to have).
5. Scale the footage down to match the resolution of your chosen format (refer to Appendix 2 for a list of resolutions for common mobile formats).
6. Use a sharpening filter on the footage until signs of ringing (over-sharpening) just start to appear (refer to Chapter 4 for a discussion of oversharpening).
7. Add noise to the footage.
 a. For a more convincing application of noise, separate the highlight and shadow areas, and be sure to add more noise to the shadow regions than the highlights.
8. Color-correct the footage to match the look of your chosen format (using reference video if possible).
 a. Completely clip the highlights so that anything resembling white becomes pure white.
 b. Completely crush the shadows so that anything resembling black becomes pure black.
 c. Lower the contrast of the overall image.

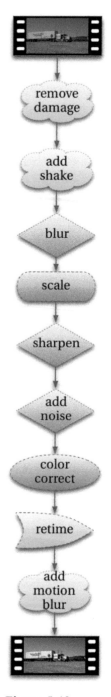

Figure 5.19

 d. Desaturate the footage (you want colors to be distinguishable, just not very pronounced).

 e. For enhanced realism, apply dynamic color correction so that whenever the camera points toward a light source, the brightness of the image increases, depending upon how close to the center of the image the light source is (this will mimic the automatic exposure that many cell phone cameras use).

9. Use the technique in Chapter 10 for adding motion blur (cell phone cameras shoot at a much slower frame rate, and so exhibit much more motion blur).

10. Retime the footage as per the instructions in Chapter 10 to match the frame rate of your chosen format.

11. Render out the sequence.

 a. If your chosen video format uses some form of compression, make sure you render using the same compression type, as this will subtly affect the overall look of the finished footage.

 b. If you are aiming to use this in a sequence with a higher resolution, you should still render it out at the format's native resolution, and then use the techniques in Chapter 9 to scale it up to the desired resolution later.

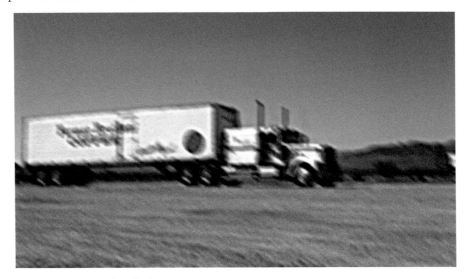

Figure 5.20 *Film frame given the cell phone treatment.*

How to Emulate Security Camera Video

Security cameras use a very low frame rate, making them more like time-lapse cameras than video cameras.

Security cameras typically have different properties than other types of video cameras. Because they are constantly recording, the number of frames captured is reduced dramatically in order to save

storage space. Consequently, the frame rate tends to be very low, and there is usually a great deal of motion blur. Furthermore, they are usually monochrome (especially if they are used at night), or at least have greatly reduced color saturation.

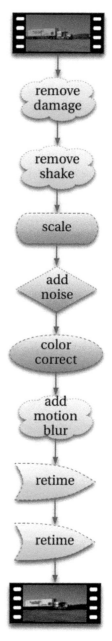

1. Load the film footage.
2. Remove any film damage, using the techniques from earlier in this chapter.
 a. Don't remove all dust or watermarks, as these can appear as things like bugs on the lens, which will actually increase the realism of the effect (unless the camera is supposed to be in a bug-free area).
3. Follow the process in Chapter 3 for removing any camera shake. The resulting footage needs to be completely still to match the fact that security cameras have fixed positions.
4. Scale the footage to the target resolution (use an SD format resolution if in doubt).
5. Add noise to the footage.
 a. For a more convincing application of noise, separate the highlight and shadow areas, and be sure to add more noise to the shadow regions than the highlights.
6. Color-correct the footage to match the look of your chosen format (using reference video if possible).
 a. Completely clip the highlights so that anything resembling white becomes pure white.
 b. Completely crush the shadows so that anything resembling black becomes pure black.
 c. Increase the contrast of the overall image.
 d. Desaturate the footage (if you want to mimic a black-and-white video camera, desaturate the footage completely).
7. Use the technique in Chapter 10 for adding motion blur (security cameras shoot at a much slower frame rate, and so exhibit much more motion blur).
8. Retime the footage as per the instructions in Chapter 10 to around 1 frame per second.

Figure 5.21

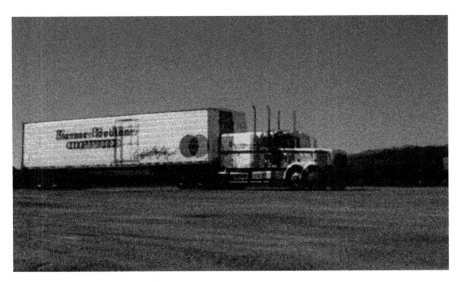

Figure 5.22 *Image made to look like it's from a security camera.*

9. Retime the result without using any temporal interpolation (in other words, so that the newly created frames are just repeats of the existing frames) to match the frame rate of the final sequence.

10. Render out the sequence at the desired resolution.

Figure 6.1 © Maria Lorenzo (www.flickr.com/photos/eme06).

Chapter 6
Fixing Digital Problems

"Come with me, you will see, it's easy."
—Chungking

During the course of about a decade, the digital image went from being a medium for scientists and specialists to the most popular method for creating and sharing pictures on the planet. The pace of technological advance in this field has been astounding; the hardware required to process and store film-quality images is readily available on the average home computer, and it is almost effortless to work with digital images, given the abundance of free, intuitive software packages, and the same is becoming true of file-based video formats.

On the aural side of things, most people are at least accustomed to the idea of file formats such as MP3 as a means for storing music, and many professional audio institutions have completely done away with analogue recording methods, relying completely on storing uncompressed sound as files on hard disks.

It is natural to assume, therefore, that all the issues related to digital media would have been completely ironed out by now, or at least well documented. The reality of working with any sort of digital material is that it is not quite as painless as we might like to think.

The single greatest benefit of any digital format is the ability to make a perfect copy. The second benefit is the ability to process the data in a variety of ways. However, each of these situations can be a source of potential problems. In the first instance, copying data can fail due to any number of reasons, resulting in incomplete or in some way corrupted data. And by the very nature of digital processing, media can be altered incorrectly in a variety of ways. In both cases, a problem may not be spotted until it is not possible to return to the original and try again.

Digital Corruption

For all their different flavors and glamour, digital files are just strings of numbers. What may be a digital image in one instance is a text file full of gibberish, or an audio clip of screaming static, in the next. The difference between the two may be as small as just a few digits. Once you factor larger structures into the mix (for example, a digital video file that consists of multiple digital image frames, or a digital audio file that consists of multiple audio channels), you may start to realize how fragile the foundations of all these conventions really are.

Figure 6.2 © *Louise Docker (www.flickr.com/photos/aussiegall, texture www.flickr.com/people/nesster).*

It might take only a single bit of askew data for a digital file to become corrupted. Examples of digital corruption can be found in everyday life, from the iPod that mysteriously skips a beat to the digital television picture that freezes from time to time. (And as a rule, the more complex the data, the more likely it is to suffer—when was the last time you received a partially scrambled email message?)

The thing about corruption is that it manages to find its way into data, in spite of (or perhaps even because of) your best efforts to prevent it, in much the same way that anything organic will eventually decay (this is not a perfect analogy; in most cases, simply leaving files untouched is the best way to protect them).

Assuming you can't just go back to an uncorrupted source file, there are ways to fix most of the common side effects of corruption. In fact, it is sometimes more convenient to perform a quick fix than to search through backups for a pristine copy.

> **TIP**
>
> Corrupted digital audio will usually manifest in the form of pops and clicks (assuming that the file hasn't been rendered completely useless). For techniques to fix these sorts of problems, refer to Chapter 7.

How to Fix Pixel Corruption

Pixel corruption can be so quick and simple to fix that it might be faster to fix this form of corruption than to replace the file.

Pixel corruption can manifest in different ways. It might be that a single pixel on a single frame is the wrong color. Or a group of pixels might be corrupted, perhaps over several frames.

1. Load the footage.
2. Scrub through the footage to identify the extent of the damage.
 a. If the corruption occurs on only a single frame (or sporadically across a few frames), clone from adjacent frames to remove it.
 b. If the corruption persists across several frames, follow the procedure for removing tramlines covered in Chapter 4.
 c. If the corruption covers a significant part of a single frame, follow the procedure in Chapter 10 to remove the frame from the sequence and then regenerate the missing frame.
3. Render out the sequence.

Figure 6.3

Digital Artifacts

Many digital problems arise because of the inherent limitations of digital systems. These limitations can be mathematical (for example, color values exist as discrete steps in digital systems, rather than as continuous spectra as in nature) or geometric (for example, pixels are always rectangular), and can be the cause of a wide variety of different defects, or artifacts.

Some of these defects can be very subtle, and some very much in your face. Because most people don't bother to fix these faults when they arise, and because digital images are so prolific, you see them everywhere. This, in turn, has the effect of making the problems more subliminal.

> **TIP**
>
> In my experience, the process of undeleting files is one of the best ways to end up with a lot of corrupt files. Deleted files recovered by a utility may appear to be intact at first glance—the file sizes may check out, and the files may even appear to open normally—but when the time comes to process them, an abundance of problems may reveal themselves. Attempting to undelete files is therefore best used only if there are no alternatives, rather than as a shortcut to restoring from a backup.

There are two main reasons for removing artifacts from digital media: to improve the quality and to make it look less digital.

How to Anti-Alias Pixels
Aliasing is the most noticeable of the digital artifacts, and the easiest to cure.

Aliasing (also known informally as the "jaggies") occurs because the square shape of pixels can't reproduce curved or diagonal edges very well. When coupled with the digital sharpening techniques present in most imaging devices, moving footage with aliasing can be very distracting to watch.

1. Load the aliased footage.
2. Scale it to around 170% of its original size, using the techniques in Chapter 10 (err on the side of smoother rather than sharper edges in this case).
3. Render out the resulting sequence.
4. Load the new footage, and scale it back down to its original size (around 59% of the new render), again using smooth interpolative techniques.

How to Reduce Noise
Noise is rampant in most digital media, and too much of it can make the footage painful to watch.

Figure 6.4

1. Load the footage.
2. Separate the channels, so you can work on just the luminance channel.
3. Key the luminance to obtain masks for shadows, mid-tones, and highlights.
4. Apply a median filter three times to the luminance channel, using each of the masks in turn. You will likely want to use stronger filter settings for the shadows, with the highlights receiving the least of all.
5. Render out the sequence.

The median filter has an effect similar to using a blur filter, but rather than blending pixels together evenly, it analyzes each group of pixels and eliminates the least popular one. The net result is that any pixels that are seemingly random (in other words, noise) are replaced with a more likely result.

> **TIP**
>
> One of the most common cases of aliasing that causes problems is with credit rollers. As they typically consist of white text on a black background, they have lots of high contrast curves and the aliasing can be very prominent. However, the benefit of this situation is that the credit rollers are usually computer-generated, so the text elements (and hence the edges) are resolution-independent. Therefore, the trick to getting high-quality, unaliased credit rollers is to first render them out at a higher-than-necessary resolution, then scale them down to the desired resolution. If you aim for twice the desired resolution before reducing, you usually won't see any aliasing in the final output.

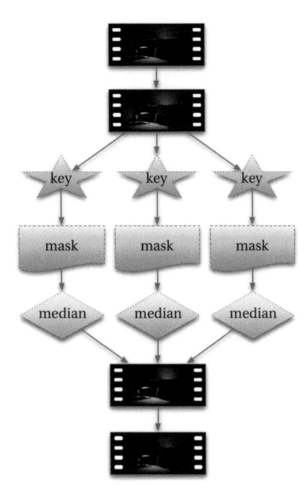

Figure 6.5

The problem with this approach is that it can also remove actual detail to some degree. There are specific noise-reducing plug-ins available that analyze frames on either side of each group of pixels as well to better calculate which pixels are likely to be noise in each case, making it less likely that you remove details. If you have such plug-ins at your disposal, make use of them.

How to Reduce Banding
Banding is seen in digital media as steps in color graduations.

While aliasing is a side effect of the relative size of each pixel, banding is a side effect of the relative color of each pixel. The problem is fairly common; however, it's usually not very noticeable. Where you see it is in regions of graduated colors, such as a sky that smoothly blends from a deep blue at

the top to a lighter blue at the bottom. When banding occurs, you can actually see the steps where one color becomes another.

The following technique takes advantage of the fact that we're more sensitive to details in luminance than in color, which allows the banding to be reduced without seeming to lose any quality.

1. Load the footage.
2. Separate the channels so you can work on just the color channels leaving the luminance channel untouched.
3. If the problem is confined to a specific range of color, mask the affected areas by creating a key to cover that range.
4. Apply a blur filter to the isolated color channels.
5. Add some noise to the sequence and preview the result.
6. If there are still signs of banding at this point, this is an indication that the banding resides primarily within the luminance channel. In this case, add some noise to the luminance channel as well.

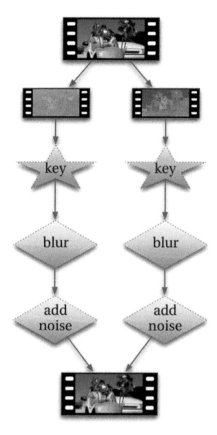

Figure 6.6

Compression

It's probably worth restating this point here: digital media are made up of a bunch of digits. The more detail you have in your footage, the more numbers you need in your files, and that means more disk space. An hour of film-resolution footage, for instance, can require one or more terabytes of storage space. This is not as much of a problem as it used to be, but keep in mind that not only do you need to store your data, but you'll also want to manipulate and move it around quite a lot, which in turn means that not only do you need extra storage space for higher detail, you also need extra time, perhaps the most valuable commodity in post.

Figure 6.7 © *Steven Fernandez (www.flickr.com/photos/stevenfernandez)*.

One of the solutions to this problem is to change the way the data are represented to use a more efficient structure. Without delving into a technical dissertation on the subject, consider that in the world of instant messaging, the phrase "be right back" can be reduced to "brb" without losing its meaning. Similarly, digital files can be compressed to save space.

Lossless compression is a form of compression in which the file size is reduced by storing the data more efficiently, but which doesn't compromise the quality of the data at all. Lossless compression can typically reduce file size by up to 50%, but it is not used very often because it can be argued that the net gain of the reduction in size is offset by the additional processing required to decompress it (there is also the argument that data errors in lossless-compressed media are harder to correct than in uncompressed media).

On the other hand, lossy compression reduces file size by reducing quality. The reduction in file size can be so great that it becomes beneficial to do so. Many lossy compression methods reduce

quality in an intelligent manner. For example, JPEG compression, which can reduce file size by a factor of 90%, is designed to discard details that are imperceptible to the human eye. But there's the rub: in postproduction, just because we can't see the extra detail doesn't necessarily mean it is useless. For example, consider a shot of a tree in bright sunlight. As it is, we cannot see the blades of grass in the deep shadow, or the clouds in the bright sky, so JPEG compression would discard these hidden details, which is fine, because we wouldn't be able to see them anyway. But if we wanted to take the JPEG version and brighten the shadows or darken the sky, the lack of detail in those areas would become immediately apparent. On the other hand, if we tried the same procedure on a non-compressed version, those hidden details would become visible.

Lossless Conversion

Knowing which formats use compression (as well as the properties of the compression they use) is very important when rendering or converting footage. It can be very tempting to save disk usage by rendering to a lossy-compressed format, but every time you do this, your footage loses quality.

The ideal situation is to use formats that use lossless compression (or even better, not to use any form of compression at all), although as a rule of thumb, if you stick to rendering everything to the format your source media is in (or even to your output format), you shouldn't end up with any serious problems down the line.

In digital video, there are also other types of compression. In intraframe compression, each frame is compressed independently from the others. Interframe compression, on the other hand, uses differences between frames in order to compress the video (this is the method used by MPEG compression, for example). This results in much smaller file sizes, but is less desirable prior to final output, as it becomes difficult to alter aspects such as color (as well as potentially introducing various artifacts into the footage), let alone the devastating loss in quality (meaning, it's advisable to avoid this type of compression wherever possible).

TIP

Certain compression methods use bitrates to determine the degree of compression. The point of these is to limit the throughput (bandwidth) of data during transmission. While this may be of importance during distribution and exhibition (and for certain output formats that have a maximum allowable bitrate), it is not usually a concern during postproduction, and so the bitrate should be kept as high as is feasible.

Color Sampling

Certain video formats use a form of compression known as a sampling ratio. These discard information from each color component at the specified ratio. For example, YUV 4:2:2 compression discards half of the color values from the U and V components compared to the luminance (Y), whereas YUV 4:2:1 discards half of the U component and three-quarters of the V component.

Most of the time this happens at the recording stage, so if you have footage that was shot on a format that uses color sampling, there is no way for you to retrieve the missing detail (on the plus side, it does mean you can keep the file sizes down throughout the majority of the postproduction process). However, you should aim to use formats that maximize the sampling ratio as often as possible, particularly if you plan to do any color correction.

Essence and Metadata

Digital media tends to consist of two components. The data related to the actual content, such as the image or audio data, are known as the essence. The data related to the subsidiary properties of the essence are known as the metadata (literally, data about data). Depending upon the specific media format, the metadata might contain, for example, the frame rate (for video), print size (for images), and the volume level (for audio).

The distinction can be important, as these types of data can be modified independently of each other. Modifying the metadata alone will almost never result in a loss of quality of the essence, and can usually be done very quickly in comparison to modifying the essence.

Compression Damage

Because compression methods are so destructive, they often produce artifacts that cannot be easily removed. The most common of these are block-level artifacts, where the individual blocks of pixels used as part of the compression algorithm become clearly visible to the viewer. There are other types of errors, many of which become pronounced during further processing (for example, through color correction).

Unfortunately, there is no simple way to reverse the majority of damage caused by compression errors. For some simple problems, it may be possible to treat them as if they were other, more common problems, using techniques discussed earlier in this chapter. Even generic approaches such as noise reduction and cloning techniques can sometimes heal a lot of the damage. Alternatively, there

Figure 6.8 © *Andrew Francis (www.xlargeworks.com).*

is software that is specifically designed to combat certain forms of compression damage, which can work well in the right situation. Usually, though, your options will be to return to a precompressed (or at least, a slightly less compressed) version or just live with the damage.

Audio Compression

Although the term compression in the audio world can refer to the process of changing the properties of an audio sample, there are also algorithms that reduce the size of an audio file (most notably MP3). Many of these are lossy, like JPEG and MPEG, and are therefore destructive processes.

Because audio requires comparatively little disk space, however, in the vast majority of situations, you should avoid using any sort of compression altogether.

How to Work with Multiple Formats
One of the great benefits of working in a digital environment is that it enables lots of different media to be combined.

It's typical for any modern production to combine media sourced from different places, and which therefore must combine material in different formats. More than this, it is very likely that multiple output formats will be produced from a single final master.

Depending on the system you're using, you may be able to simply load all the footage and have the system convert the formats as and when it needs to. If it can't (or if it can't do it reliably), you'll need to follow these steps to convert it all into a common format:

1. Assemble all the different media together and make a note of the properties of each. Based on this information, as well as the properties of the formats you'll eventually be outputting to, decide upon a mastering format to use.
 a. When deciding upon the mastering format, ideally you'll choose one that preserves the highest quality aspects of each of the source and output formats.
2. Follow the techniques in Chapter 9 for resizing footage to the mastering format.
3. Follow the techniques in Chapter 11 for ensuring continuity between the different source formats.
4. At this stage it may be worth outputting to the highest-quality destination format (if it's practical and economical to do so) to preview how it will look.

Intermediate Formats

The digital intermediate paradigm, where the source footage for a production is converted to a single digital format before output to various other formats, was originally pioneered for film production but is valid for many other production pipelines and can ensure a high degree of quality and flexibility throughout the postproduction process.

See *Digital Intermediates for Film & Video* (Focal Press) for more about the entire workflow.

Outputting to Different Formats

When planning to output a production to different formats, you should make a list of the differences between the mastering format that you're going to be generating the output from and the target format (also see Appendix 2 for details of the most popular formats). Pay particular attention to

- Differences in resolution
- Differences in aspect ratio
- Differences in frame rate

TIP

In order to save yourself a lot of aggravation later on, you should try to work with footage that has a pixel aspect ratio of 1.0 as much as possible, at least until you render your output format at the end. To do this, calculate the resolution based on a pixel aspect ratio of 1.0 and render a copy of the footage using these new dimensions to work with. When you're finished you can output to the resolution and pixel aspect ratio of your chosen format.

Figure 6.9 © *www.flickr.com/wonderferret.*

- Differences in pixel aspect ratio
- Differences in color space
- Differences in compression, if applicable (such as different bitrates)

Each one of these issues must be addressed independently for the best possible results. For example, when outputting from HD material to an SD format, there are differences in resolution and aspect ratio, as well as color space and compression. If you follow the techniques found in Chapter 9 to tackle the aspect ratio and scaling differences, you'll be in a good position to get maximum quality results. Similarly, refer to Chapter 10 for information on dealing with changes in frame rates and Chapter 8 for information on different color spaces.

How to Produce Stills for Print
Producing stills for print from digital media is so easily done that it's often overlooked as an essential part of postproduction.
1. Load the footage into an editor.
2. If necessary, de-interlace the footage to make the footage progressive.
3. Mark the individual frames and render them out.

4. Load the rendered frames in an image editor.
5. Convert to CMYK color space.
6. Color-correct the stills as needed.
7. Save the stills.

Figure 6.10

Figure 7.1 © *Andrew Magil (www.ominoushum.com).*

Chapter 7
Fixing Audio Problems

"This is what it sounds like when doves cry."
—Prince

In many ways, dealing with the audio content is much easier than dealing with the picture content of a production. There are fewer concerns: after all, humans are primarily visual, and ultimately our perception of a TV show or movie is driven more by what we see than what we hear. Structurally, constructing audio involves much less complexity than constructing moving images. Simply put, there is less that can go wrong.

However, there are also fewer tools available for working with audio. There's nothing to compare with the suite of color correction processes available when working with images, and certainly no real equivalent to the ubiquitous clone tool, used for hiding a multitude of visual glitches. On the other hand, there are lots and lots of filters for doing different things, but just as you wouldn't simply use a sketch video filter to make an animated feature, the vast majority of audio filters are best kept at arm's length.

I also don't want to give the impression that dealing with postproduction audio is in any way easy. There are a number of skilled people who are involved with audio on a typical production—the dialogue editors who painstakingly build fluid speech from salvaged scraps of vowels and consonants, the sound effects editors responsible for all the sounds that you'd miss if they weren't there, the mixers who take everything and make it all work together harmoniously. In fact, the process of producing great audio goes far beyond the scope of this book, let alone this chapter, which will limit itself to dealing with some of the more common audio-related problems that can arise during the mastering phase of postproduction.

Digital and Analogue Audio

Audio consists of a number of overlapping wavelengths (or sound waves, if you prefer) at different frequencies. The frequencies combine to form the unique sounds that you hear (different instruments, for instance, are said to primarily occupy specific frequency bands). Audio is primarily an analogue

format, much more so than images. Unlike digital video, which can be both created and displayed on digital devices, audio must be created in an analogue form, and must be transmitted as analogue in order for us to hear it (no matter how expensive your MP3 player is, by the time the sound reaches your ear, it is just vibrating air).

Digital audio is therefore problematic for a couple of reasons. First, it potentially contains all the same problems as its analogue counterpart, and second, the fact that it has been digitized opens up a whole new set of problems.

The analogue issues are usually due to something having gone wrong during recording, such as the volume being too low or the microphone popping. The digital issues are similar to those faced on the picture side, such as aliasing (undersampling), noise, and corruption.

Anatomy of Digital Audio

Digital audio is created by sampling an analogue waveform. These samples are taken at regular intervals across a time period (determined by the sampling frequency, which is typically measured in kilohertz, or thousands of times per second). The amplitude of each sample is then quantized at a specific bit resolution. If it helps to think of it in digital imaging terms, the sampling frequency is analogous to the pixels (and the corresponding resolution of the image), while the bit resolution is like the bit depth (and the corresponding color range). The combination of these two parameters can be broadly classified as the fidelity of the audio.

Digital audio can also comprise multiple channels. For example, stereo sound consists of a left channel and a right channel. Surround sound can consist of more, and in certain formats and workflows, extra channels are often used to store additional audio for other purposes (though in general, it's considered good practice to always store each channel in separate files, even for stereo recordings).

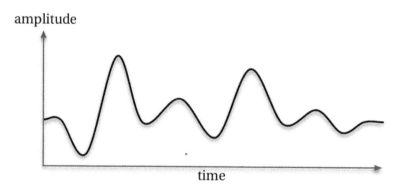

Figure 7.2 *An analogue waveform.*

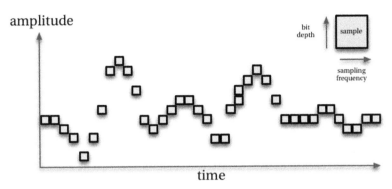

Figure 7.3 *Anatomy of digital audio.*

Decibels and Dynamic Range

Our ears have a nonlinear response to sound. That means that a sound that is measurably twice as loud as another one will not be perceived as being twice as loud. To make things simple, therefore, we measure audio level on a logarithmic scale, typically using decibels (dB). A bel is a unit of loudness; each unit is ten times louder than the previous one (a decibel is one-tenth of a bel).

In the digital realm, loudness is measured in decibels full scale (dBFS). Confusingly, this scale (as with most audio scales) is measured in reverse, with 0 being the maximum allowable value (anything above 0 will clip, becoming irreparably distorted). Audio engineers usually try to keep 3–6 dB of headroom clear (allowing for sudden peaks in the signal to exceed the expected levels without distortion), so the typical acceptible working range for digital audio centers around −6 dBFS.

The dynamic range of an audio sample is the ratio of the loudest part to the quietest part. For example, operatic music (which can go from a silent whisper to a glass-shattering shriek) has a very high dynamic range, while a jet engine, although very loud, would have a much narrower dynamic range by comparison.

High dynamic range is not necessarily preferable to low dynamic range in audio. For example, the high dynamic range of operatic music works well in the controlled environment of an opera house, but would not work so well against the backdrop of a busy street, for example. Using compression and expansion processes on digital audio can decrease and increase the dynamic range of the sample accordingly.

Figure 7.4 *A digital dBFS meter.*

How to Get Consistent Volume
Volume inconsistency is the most basic audio problem to solve, as it can be noticed by even the most untrained listener.

There are two parts to the problem of audio volume. The first is technical: the first step to any aspect of consistent audio is to properly meter it. The second is more subjective: the perception of audio is determined to a large degree by its context.

1. Load the audio sequence.
 a. If there is just a single clip with inconsistent volume, then the problem is almost certainly a technical one.
2. First play through the sequence, carefully monitoring the audio levels as you go.

 a. You'll need to rely on your ears as well as any visual aids, such as dBFS meters (volume levels should peak at around −6 dBFS and should never reach 0 dBFS).

 b. If there is more than one audio track, you should check them independently of each other for any obvious problems first.

3. If the levels vary greatly between clips, adjust the volume of each clip so they are consistent.

 a. Try not to exceed −6 dBFS, where possible, and never peak at 0 or the sample will distort.

4. If the levels vary within specific clips, you will need to dynamically adjust the volume within the clip itself. Displaying the waveform of the clip at this point can help identify the areas of volume shift.

5. If the volume is still inconsistent, it is probably a perceptual shift caused by surrounding audio clips.

6. Check that all the clips in the sequence have the same bit resolution, as higher bit resolutions can produce perceptually higher volume output, even though the meters may not register a change.

7. If all else fails, you can reduce the perceptual volume of the affected area by increasing the volume of the audio immediately preceding it, or vice versa (this can be especially effective with sequences using multiple tracks, as changing the volume of one of the other tracks can soften the perception of a volume shift).

8. Save the changes.

Audio Monitoring and Calibration

With experience, your ears will prove to be your most reliable equipment for monitoring audio. That said, your ears can only be as reliable as the sound you feed into them, which means it's vital that you provide them with accurate audio in the first place. Good-quality speakers are important, but there are many other factors that have to be considered. The sound you hear comprises the sound coming out of the speakers and the acoustics of the room, as well as any ambient noise.

All of these aspects need to be kept in check, if not directly controlled. It's also advisable to listen to audio in an environment similar to the one in which the audience will hear it. For theatrical productions, this means going into a dedicated screening room or dubbing stage whenever possible, rather than relying on the output of an editing system. Once there, you may discover new problems that simply weren't detectable before.

How to Retime Audio
Retiming audio is fairly simple to do with the right tools.

1. Load the audio into a sequencer.

2. If the audio does not need to sync to the accompanying picture (such as atmospheric sound), then you may be able to just trim or loop portions of the audio to get the desired duration. This may be preferable, as there will be no degradation when using this approach.

3. If your editing system has the capability to time-stretch the audio, then this is probably the best option to use, particularly with dialogue, as it will change the speed without also adjusting the pitch. Some systems timewarp audio in addition to time-stretching it, which will give you greater control over the process. Set the desired amount of stretching to get the new duration, and save the new audio clip.

 a. If your system does not have the means to time-stretch audio, then you must pitch-shift the audio in order to retime it. This will, of course, also result in changing the pitch of the audio, but it may not be noticeable for very small changes.

How to Correct Sync Issues
Follow these steps to correct many types of sync issues.

Getting correct audio sync is simple in theory—you simply line up the audio with the corresponding picture. In practice, though, dealing with sync problems can be a very frustrating experience. Spotting sync problems in the first place is a bit of an art form in itself, and is something that gets easier with experience. The good news is that the really bad sync problems will be very noticeable. The other point to bear in mind is that you need to pay attention to the sync of all audio elements, dialogue, foley, and atmosphere.

1. Load the conformed sequence into a sequencer.
2. Play through it, identifying where the sync issue occurs.
 a. Make note of the difference (in frames) between the audio and the picture.
 b. If the audio sync gets progressively worse over the course of a single shot, this is a good indication that the speed of the audio track doesn't match the picture content. This may mean that the picture is at the wrong frame rate or that the audio sampling frequency is wrong for the project. If changing the sampling frequency doesn't work, you'll need to either retime the picture or adjust the audio pitch.
 c. If the sync is fine on some shots but out on others, split the audio tracks into individual clips to separate the good ones from the bad. You'll then be able to leave the good ones unmodified while fixing the others.
3. First ensure that the conform itself is correct.
 a. Check the conform against any reference material available, such as an EDL or offline cut. Make sure that the cut points all line up correctly and that the timecodes match the edit.
 b. If the conform is found to be wrong, address the issue and see if there is still a sync problem.
4. Now you must decide whether to adjust the picture or the audio. Make this decision by factoring in what's possible: for example, you might not have access to the original picture footage;

and by what's least destructive: for example, it makes more sense to change the audio speed slightly than to retime an image sequence.

5. To adjust the sync, you have several options (modifying either the video or audio as necessary):
 a. You can slip the problem shots by the required number of frames to get them in sync.
 b. You can ripple-edit (trim or extend) the start of the first shot with the issue by the required number of frames (and if need be, ripple-edit the end of the last problem shot so that the overall duration remains unchanged).
 c. You can retime the shot (pitch-shift if modifying the audio) so as not to affect the position of cuts or change the overall duration of the sequence (for information on retiming shots, refer to Chapter 10).

6. After making changes, verify that the entire sequence is in sync. Sometimes when fixing sync problems, you can indirectly affect the sync of other shots in the sequence, so it's important to check everything again before outputting the result.

How to Reduce Audible Noise
There are several methods available for reducing noise in audio.

Electronic noise is one of the biggest problems encountered in audio postproduction. It's caused by any of a number of factors, such as the cables and tapes used during recording, imperfections in the components used for recording or digitizing audio, or even data corruption. As with digital image noise, it cannot be completely removed, but you can take steps to reduce the audible impact. Bear in mind that the whole process of noise reduction can easily be taken too far; you should never sacrifice audio detail in your mission to remove noise.

> **TIP**
> When dealing with audio sync problems (as with many other problems covered in this book), you should apply Occam's razor: the simplest solution is usually the correct one. The less you modify the original, the better the end result will be (and the less work you'll have to do).

1. Load the audio into a sequencer.
 a. Also load alternate takes, if possible, to see whether there are less noisy sections from other audio clips you can scavenge (and clean audio segments, such as room tone, ambient sound recorded on location).
2. Identify the properties of the noise. Is it fairly consistent? Does it overpower the main recording, or is it only audible over silent portions of the audio? Is it high-pitched (like hiss) or low-pitched (like rumble)?
3. For noise that you can only detect over silence, consider just lowering the volume of the silent regions. You'll probably need to cross-fade these volume changes so that the transition is not so brutal. It may be that this process will only draw more attention to the noise within the non-silent portions, but sometimes this simple approach can work very well.

a. An even better solution is to replace the silent portions with clean room tone rather than dipping the volume.

4. To reduce high-pitched noise, you can use a low-pass filter. Adjust the settings until the filter only just removes the majority of the noise. If it also affects other sounds in the recording, you will have to use a different approach.

5. Similarly, to reduce low-pitched noise, use a high-pass filter. As with the low-pass filter, adjust it until it only just affects the noise, and don't use it at all if it interferes with other sounds in the recording.

6. If at all possible, ultimately the best option is to try to rebuild the audio by cutting together fragments from alternate recordings that don't have the same degree of noise. This can be hard work, and probably is not possible with audio that has been completely mixed when supplied to you, but this option should always be strongly considered.

7. If all else fails, the only other method is to use dedicated noise reduction software.

a. You'll probably get the best results by applying the noise reduction process incrementally, fixing the noise in stages, rather than using a single application.

8. Save the resulting audio clip.

How to Remove Pops and Clicks
Removal of pops and clicks is best done manually.

Pops and clicks embedded in a soundtrack may be the result of a glitch during recording or some other postprocess, or part of the soundtrack itself (such as if the actor speaking dialogue has dentures). Most of the time, such noises are distractions, and so it's advisable to remove them, provided of course that doing so results in an overall improvement to the scene (on odd occasions, the noises can add atmosphere, and so can be left alone). If the noise is particularly bad and there are no suitable alternate takes you can use, your only recourse may be to get it remixed (or if it's on a dialogue track, to use ADR).

TIP

Noise is probably the single best reason to keep analogue recordings for future reference. Although the convenience of digital audio for archiving purposes cannot be understated, the continuous improvements in analogue-to-digital conversion mean that the ability to make better-sounding digital versions from analogue recordings is always just around the corner.

1. Load the audio into a sequencer and identify the point where the noise to be removed can be heard.

2. Display the waveform for the audio, zooming in as close as possible. You want to find the point where the noise can be seen as part of the waveform. Typically, this will appear as a dip or a peak in an otherwise smooth region (with experience, these points will become much easier to spot).

3. If the affected region is quite small, you should be able to fix the problem using a pen, or similar audio editing tool, by drawing over the region of the waveform where the noise occurs, smoothing it out. Depending upon the type of noise you're removing and the content of the

recording itself, the noise may now be completely removed without a trace, and you're done. Sometimes, though, this process can make the situation worse, in which case you can revert back to the unmodified version.

> **TIP**
>
> Many audio editing applications have filters for automatic pop and click removal. However, even the most sophisticated algorithms are no match for a human with the pen tool. Such filters are best left for the occasions when time is limited and the damage is severe.

4. In all other cases, the noise can usually be removed by replacing it with similar-sounding material—much in the same way you'd use the cloning tool to remove dust from a film frame (although with a little bit more effort on your part).

5. Identify a section of matching sound without the distracting noise, and copy it. If the noise occurs on an otherwise silent section (for example, between two words of dialogue), you can probably just copy some recorded room tone (or some other silent portions you can salvage from the track).

6. Paste the copied audio onto the affected area. You'll probably need to cross-fade either side of the edited section so there is no audible transition.

7. Save the resulting audio clip.

Stereophonic and Multichannel Audio

We perceive the origin of sounds in space based on the differences between what each ear hears and on the differences between sound that reaches us directly and sound that reaches us indirectly (such as sound that reflects off of walls and other surfaces). Stereophonic sound (or stereo), which directs one track of audio to the left ear and the other to the right ear, therefore appears to have much more depth than just monoaural (single track) sound. Almost every type of sound production uses at least stereo sound, from television shows to music CDs.

Beyond stereo sound is surround sound. This combines multiple tracks to give the impression of sound originating from specific locations in space. There are several different standards available for reproducing surround sound, each with a corresponding configuration of speakers, but by far the most common is 5.1 surround. This comprises five speakers in a circle around the listener, with an

Figure 7.5 *Earth © BBC Worldwide Ltd 2007.*

additional low–frequency emitter (LFE or subwoofer) to provide bass. Surround sound is commonly used in theatrical releases, and many home systems now have some form of surround sound capability.

How to Get Stereo from Mono
Making sound into stereo is easy; making it sound like it is stereo is a little bit more involved.

1. Load the mono audio track into a sequencer.
2. Add a second track and copy and paste the mono track into it. Depending on your particular system, you may have to adjust the audio patching so that one track is denoted as the left channel and the other is the right one (some editing systems make this assumption automatically).
 a. At this point, you technically have a stereo soundtrack, but as there is no difference between the two channels, it will still sound mono.
3. The next stage is to artificially introduce subtle differences between the two channels so that it creates the illusion of stereo sound.
 a. Use a comb filter to offset one of the channels by around 50 milliseconds (this will be small enough so that you will register the difference on only a subconscious level).
 b. Use shelving filters to direct different frequencies to either channel.
 c. Pan the audio left and right to give the impression of a moving source (this is particularly effective for shots where there is camera motion).
 d. If your editing system has surround panning capabilities, you can get good results by converting the project to surround sound, using the surround panning tools, and then mixing back down to stereo.
4. Save the new clip.

The M/S Audio Model

A powerful approach to working with stereo audio is to use mid-side encoding. This converts the left and right channels into sound that can be heard in the middle and sound that can be heard at the sides by creating a track with audio common to both left and right channels (forming the mid channel) and a track featuring the differences between the two (forming the side channel). The process originates from recording audio using a combination of a cardioid and a side-facing (figure-8) microphone, but can be replicated fairly well using digital processes.

The benefit to this approach is that rather than panning left to right, you can effectively pan from the center to the sides, processing each seperately from the other, in a way that would be difficult to achieve with a standard stereo mix. For example, you can use this approach to change the perceived distance of a sound from the listener by adjusting the M/S ratio. In addition, it can also isolate specific types of sound, such as isolating dialogue from background noise.

How to Get Surround Sound from Stereo
There are a few approaches you can take to produce surround from stereo.

1. Load the audio into an editor sequencer capable of working with 5.1 surround sound.
2. Depending on the material you have to work with, you can produce a surround mix in a number of ways.
 a. If you have a stereo mix with separate foley elements, you can keep the mix in stereo and surround pan the other elements to match their location in screen space.
 b. If you have separate tracks for each element, you can surround pan them individually to get the desired effect.
 c. If you have a single stereo mix, you can use a combination of low-pass and high-pass filters to separate the audio frequencies and work on them separately. For example, you can redirect low-frequency sounds (such as the rumbling of trucks across gravel) to the LFE channel.
3. Depending upon the capabilities of your sequencer, you may have several options available to refine the sound.
 a. Most systems are able to pan tracks in 2D space (as opposed to just left and right panning available for stereo). This essentially raises or lowers the volume at each speaker relative to the panned position of the track. This can be used to give the impression of the sound being located at a particular point in space. You can also dynamically pan the audio to give the impression of a moving audio source.
 b. There will usually be a separate control for LFE, which determines the amount of audio that is directed to the LFE channel rather than the surround speakers. Naturally, increasing this control will result in more bassy, delocalized sound.
 c. There may be the option to adjust the width of the sound across channels. This causes the sound to be diverted to more of the speakers, resulting in sounds being delocalized. By the same token, by narrowing the width, you make the sound seem to originate from a more specific point in space.
 d. It may be possible to patch sound directly into a specific channel. This can be useful if, for example, you want to patch all dialogue tracks into the center channel.
4. Save the audio. Note that this will usually entail saving it in a surround-encoded format, although you may be able to output a separate file for each speaker channel.

> **TIP**
>
> It's advisable to keep dialogue in the center as much as possible, rather than panning it to match the location of the actors in screen space, or else it can become distracting to the audience.

How to Automate Dialogue Replacement

There are a number of reasons why automatic dialogue recording (ADR) can be necessary, such as audio that is so distorted it is beyond repair, bad

takes, script changes or additions, or even due to wanting to get a different performance from the actor.

The ADR process is not as automatic as its name suggests.

Although there are systems dedicated to ADR, you can recreate the workflow in most editing systems with a little preparation.

1. Load the sequence for ADR into an editor sequencer.
2. If more than one line needs to be replaced, split up the track so that each line to be recorded is separate. You should also remove sections that are unnecessary (you can keep a short amount of footage before the line to be replaced to act as a cue for the actor).
3. Duplicate each clip, positioning the duplicate so it runs immediately after the original. Remove the audio from the duplicate.
4. Cut four beeps, evenly spaced so that the fourth beep occurs immediately where the recorded line is to begin (on the duplicate clip).
5. Remove the fourth beep.
6. With the setup complete and the actor present, mark the first pair of clips to run in a loop and record the actor until the result is satisfactory.
7. With certain systems, you will be able to record directly into the playback system, which will allow you to audition the result right away. Otherwise, you will need to import the recorded audio into the editor and cut it into takes, auditioning each one in turn.
8. Repeat with other lines until you're done.
9. Save each new take separately, and then cut the desired takes into the main sequence. Be prepared to edit more than one take to replace a single line.

> **TIP**
>
> ADR is sometimes referred to as looping, although this actually refers to the process of the actor trying to sync lines against a looped section of audio, rather than trying to speak in a way that ensures continuity with what's on screen.

This approach (and the ADR process in general) can and should be adapted to make the actor most at ease. For example, some actors find the rhythmic beeps distracting (in which case, cut them out); some like to record while listening to their original lines (in which case, paste the audio back into the duplicate clip and give them a pair of headphones); and some prefer to simply work from a script. Likewise, some actors like to be involved in the process of listening back to each take, while others don't.

How to Ensure Audio Continuity
Continuity is only noticeable in its absence, especially in the case of audio.

1. Load an entire scene into a sequencer.
2. Play through the scene, noting any potential problems.

a. Play through it at least once without picture sync. This will ensure that you're able to detect problems that are masked to some extent by action on the screen.

b. Pay attention to level readings, particularly the peak level indicator, which should be fairly consistent across most scenes.

c. If it's a surround mix, you should also listen to it in stereo to make sure there are no obvious problems when it gets mixed down.

3. If the audio levels fluctuate over the course of the scene, refer to the process on page 112 for getting consistent volume.

4. If there are differences in the tone and quality of the sound (but not in the audio levels), use compression and expansion processes to make the tone of different sections match. You may need to apply other filters, such as reverb, to make the audio appear to have originated in a single, specific location.

5. Make sure that background and ambient noise is consistent throughout the scene. For example, if the scene is set in a factory, do the mechanical processes in the background all occur at regular intervals? If not, you may need to replace, trim, or loop sections to make it sound more natural (and therefore, more subconscious). Also, be sure that there are sounds to cover everything that happens on-screen (and off-screen). For example, if someone leaves a room, are there accompanying door sounds, even if we don't see the door?

a. Be sure to avoid looping sounds in a way that sounds artificial, such as the same sound of a barking dog repeated over and over.

b. Occasionally, it's desirable to make background sound inconsistent. For example, when something pivotal is happening (or about to happen) in the foreground, it is common to reduce all other sounds to create an aural focal point.

6. Make sure dialogue is clearly audible at all times.

a. Again, you can make exceptions if it's in keeping with the storyline.

7. Check that the audio is in sync with the picture. Refer to page 114 for specific details on checking the sync.

Chapter 8

Fixing Color Problems

"Too close to the light, just for the thrill of it."
—Moloko

After editing and sound, color is probably the single most important element that can be adjusted during postproduction. Color adds mood and emotion to scenes, and plays a big part in ensuring continuity between shots. But more than that, exceptional color grading gives a sense of artistry to productions. You need only look at recent music videos to witness incredible variety among otherwise similar subjects given by simply changing the color palette.

In digital postproduction, changing the color of footage is easily achievable, and the tools for doing so are highly evolved. However, this doesn't mean that doing it well is easy. In fact, most colorists I've worked with, people whose entire job it is to adjust colors during postproduction, insist that it's something that can never be perfected. I don't doubt that sentiment at all, but the techniques in this chapter will get you at least part of the way there.

Clipping and Crushing

As with audio, every imaging system, whether a film camera, an LCD monitor, or even a human eyeball, has a property known as dynamic range. In technical terms, this is the ratio of the brightest color to the darkest color that the system can reproduce. In slightly less technical terms, it's the point where something becomes pure black or pure white. Our eyes have incredible dynamic range. You can gaze wistfully out of a window on a sunny day into a vista of bright clouds, blue sky, and lush green trees. A camera, on the other hand, might render the view as white mush framed by the edge of a window.

The problem is that once the image has been recorded that way, there is very little you can do to recover the missing detail. Any regions that were recorded as pure white are said to be clipped, and

Figure 8.2 © *Jack James.*

any regions recorded as pure black are said to be crushed. As far as the imaging system is concerned, any clipped regions are pools of solid white, and crushed regions are pools of solid black. It's a little like pushing a snowball against a hot plate: the more you push the snowball, the more of its shape is destroyed. Even if you were to stop this cruel punishment part way through, the snowball could not regain its former shape.

When faced with clipped or crushed footage, the only way to fix it is to go back to a version of the footage before the clipping or crushing was introduced. For example, with digital footage that originated from film, it may be possible to rescan the footage in question using different color settings to better capture the missing details. Or perhaps the material had already undergone a digital color correction that was a little heavy-handed, and so detail can be recovered by adjusting the process and rerendering it.

All too often, this is not an option; but even then there is sometimes a way to recover some of the detail. Certain video formats and digital file formats have provisional headroom: even though regions are displayed as pure white or black, some extra detail is retained beyond these limits (also known as super-white and super-black, respectively).

There will almost always be footage that is crushed or clipped that you just have to deal with. The important things to do are ensure that crushed regions remain pure black (as opposed to a dark

shade of gray), clipped regions remain white, and you don't unnecessarily introduce any clipping or crushing yourself.

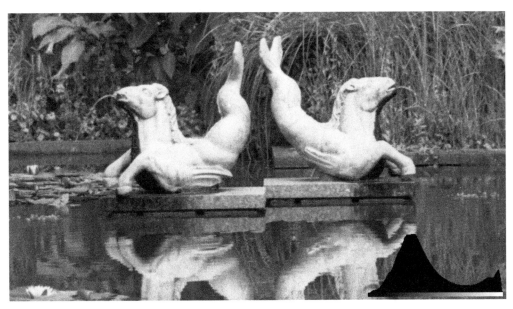

Figure 8.3 *A frame without significant clipping or crushing.* © *Jack James.*

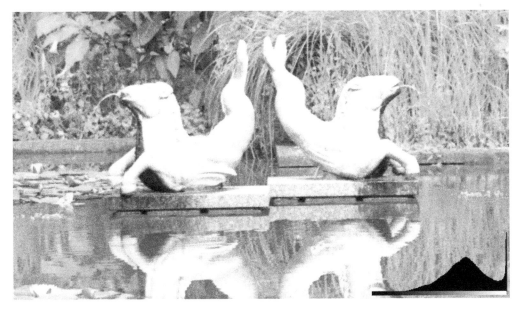

Figure 8.4 *After increasing the brightness of the frame, highlight details are lost. Note the histogram has skewed to the right.*

Figure 8.5 *After decreasing the brightness of the frame, shadow details are lost. Note the histogram has skewed to the left.*

Featured Tools: Video Scopes

Color correction is a very involved and subjective process. It is important, therefore, to take advantage of tools that can help make the decision-making process more objective. The best way to do this is to understand and make use of video scopes, which measure various aspects of a video signal and display them graphically.

There are a variety of scopes available, both as external pieces of equipment and as software-based widgets, and each is used for a different aspect of footage.

Waveform monitors (Figure 8.6) measure luminance in a signal. Use them to check for crushed or clipped signals (the signal will plateau in these cases), as well as regions of headroom in some cases.

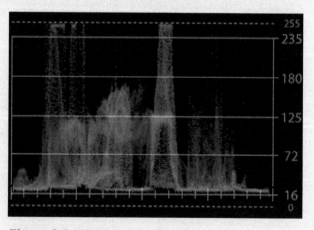

Figure 8.6

Histograms (Figure 8.7) measure the distribution of luminance in a signal. You can use them to check for banding (which will show as little spikes in the graph), overall contrast, and, to a lesser extent, clipping and crushing.

Vectorscopes (Figure 8.8) measure the distribution of chromacity in a signal. You can use these to examine saturation, check for color casts (the signal will appear to be skewed away from the center), and generally check color balance.

Software such as Adobe's OnLocation (www.adobe.com) can replicate the functionality of scopes during a digital shoot, providing valuable feedback when you need it most.

Figure 8.7

Figure 8.8

How to Correct Exposure Issues
Altering under- or overexposed images is not quite as simple as just adjusting the brightness.

Exposure problems are common, and sometimes deliberate. In an effort to capture more sky detail, a cinematographer may deliberately underexpose a shot; likewise, he or she might overexpose a scene in order to get more shadow detail, making the overall image look too dark or too bright, respectively.

Fixing this problem is not as simple as just increasing or decreasing the brightness of the image, as this will inevitably lead to clipping or crushing, or, at the very least, to losing the detail that the cinematographer was trying to capture in the first place (see Figure 8.9).

1. Load the footage and duplicate it.
2. Use curve grading methods on the copy to massage the tonal range into something more desirable.
3. Layer the two copies together.
 a. Use a screen blending mode between the two if the original is underexposed; use a multiply if the original is overexposed.

b. You can also experiment with using different blending modes between the two copies, depending upon the image content.

c. If there are clipped regions in the area, they will have to remain as pure white. Likewise, if there are crushed regions, they will have to remain pure black. Take care not to introduce any clipping or crushing yourself during this process, being sure to check all frames in the finished sequence.

d. You can also experiment with separating the red, green, and blue channels and working on each one separately, as exposure can affect each channel separately, especially in the case of images from a digital video source.

4. Render out the sequence.

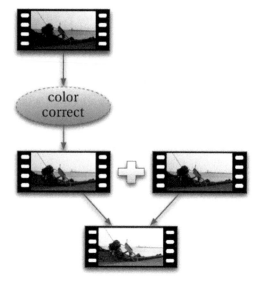

Figure 8.9

Figure 8.10 *In the case of overexposed footage, use a curve like this as a starting point.*

Figure 8.11 *In the case of underexposed footage, use a curve like this.*

Color Calibration

In the same way that you need clear, good-quality audio monitoring equipment when working with sound, when doing any sort of picture work, especially color work, it is essential to use calibrated equipment. Much of the color correction process is highly subjective; you're using your eyes to determine what looks right. Because of this, you need to ensure that the feedback you're receiving is accurate. Otherwise, you might brighten images that look dark when in fact it's just the monitor that's dark (and you've thus made the images too bright).

Color calibration is difficult to get right. I'm not going to delve too far into this deeply complex and depressingly confusing topic here, as there are many things to consider in order to get it absolutely right. Suffice to say that if you perform even basic calibration of your monitors, you'll see the benefits immediately.

Both Mac and Windows computers offer basic color calibration tools that will guide you through the process of creating a profile for your monitor. Bear in mind that these tools will partly depend upon external factors such as ambient lighting, so it's important to try and keep these factors consistent (which is also why so much of postproduction tends to be done in the dark).

On OS X, go to System Preferences ... → Displays → Calibrate. On Windows XP, you'll need to install and run the Color Control Panel Applet PowerToy (available for free from http://www.microsoft.com/prophoto/downloads/colorcontrol.aspx).

On Windows Vista, the applet will already be installed, so just go to Control Panel → Color Settings → Devices → Add.

If you want to get more serious about color calibration, you will need to invest in hardware such as calibration probes and picture line-up generators (PLUGEs).

Color Space

Imaging systems, whether a camera, television screen, or the human eye, can accommodate only a finite number of different colors. For instance, the human eye can see pretty much everything in the spectrum from red to violet, but a video camera is not sensitive to deep reds and greens. The characteristics of the color range and sensitivity of an imaging system are known as its color space (or gamut).

Most of the time, different color spaces overlap with each other, so a specific shade of green will appear the same whether photographed with a digital camera or a film camera, for instance. However, even slight differences in the color spaces between two different imaging systems can result in pictures that look very different, especially when there is a broad range of color in the scene. Colors that don't match up in this way are said to be out of gamut.

Figure 8.12 © *Andrew Francis (www.xlargeworks.com).*

One of the most important tasks in postproduction is ensuring continuity between different output formats. This is especially true of productions destined for theatrical release, which may need outputs for 35 mm film, digital cinema, HD video, and broadcast SD video, each of which have different color spaces.

There are two schools of thought on how to tackle differences in color space. The most common practice is to do all color correction in the color space with the widest range of colors, which will result in an ideal color grade for the production, and then correct for out-of-gamut colors in the color space of each target output format.

An alternative approach is to do the color correction in the narrowest color space intended for output, and then correct for the other outputs. The benefit of this approach is that it maintains better continuity across the outputs (in other words, the results will tend to look the same, irrespective of the output format), but at the cost of flexibility during the color correction process.

> **TIP**
>
> For the most part, humans perceive specific colors in relation to others, rather than on their own merit. A shade of green will appear more saturated if it is surrounded by desaturated colors. For this reason, instead of trying to isolate and correct specific out-of-gamut colors, it is often better to adjust the entire color of the image to give the impression of the desired color.

How to Legalize Colors
If you plan for your work to be broadcast, it is essential that the colors are legalized.

Certain colors don't reproduce well with different broadcast standards (this is particularly true of the NTSC standard, which is often referred to as the Never The Same Color twice standard). Not only can these colors look different than intended, but the problem can also affect other parts of the image. For example, strong red colors can bleed into the surrounding areas during television broadcast, which can quickly ruin picture quality. For these reasons, footage must be legalized before it can be broadcast.

There are many factors to consider when making footage broadcast-safe, but fortunately you'll rarely have to worry about the specifics. Almost all video processing systems (and even a few digital imaging applications) have filters to process and correct the footage for you.

1. Load the footage.
2. Apply a legalization filter appropriate to your target broadcast output.
 a. Some filters allow you to choose from different methods of legalization. Generally, choosing any of them will result in legal colors. However, they may produce perceptually different results. It's worth previewing each setting and comparing for them differences in tone, contrast, and artifacts such as noise and clipping and crushing, and then picking the one that produces the best-looking result.
3. Render out the sequence.

Legalization should be done at the last stage of postproduction, as it degrades the footage somewhat, and it's always worth retaining a copy of the production just prior to legalization, which can be used to make deliverables for other types of output (such as for the Web).

Figure 8.13

TIP

For your production to be suitable for broadcast, you'll also need to pay careful attention to title and action safe regions, and make sure there are no strobing patterns, as these can induce seizures in susceptible television audience members.

Changing Color Space

Working with different formats may entail changing the working color space. This is best done as early as possible in the process, provided the new color space is going to be the primary one, as if it is done later on, it may lead to artifacts. Most systems allow you to change color space transparently, requiring little effort on your part. There are two considerations, though. First, you may need to legalize colors (using the technique given above) to ensure that the converted colors can be reproduced correctly within the new gamut.

The second, and much trickier, part of the problem is that your target color space may vastly differ from that of your primary display device. For example, many film productions that undergo a digital intermediate process use a film color space, which cannot be faithfully emulated using standard digital display devices. These types of production require specially calibrated monitoring equipment, in conjunction with sophisticated color lookup tables (CLUTs), to ensure that the colors seen on the display match those that will ultimately be projected from the outputted film prints.

How to Enhance Tone and Contrast

Tone and contrast are the most prominent features of color in footage, especially in terms of defining characteristic "looks".

1. Load the footage.
2. First, identify the darkest and lightest points in the footage. Scrub through all frames looking for the darkest region, and adjust the color until that point becomes black.
3. Adjust the color until the brightest region becomes white (don't use a brightness operation here, as that will also lift the black level; instead, use curves or levels operations).

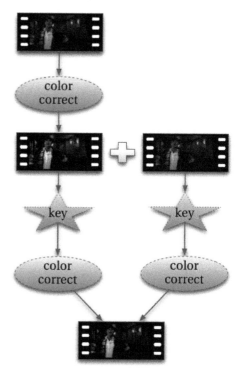

Figure 8.14

4. Duplicate the result and add it as a new layer.
5. Adjust the mid-tones and overall result using curves or levels operations.
 a. Experiment with using different blending modes between the two versions and continue making adjustments until you are happy with the result.
 b. Use keys to isolate specific regions (such as the highlights or shadows on the luminance channel) for greater control.
6. Render the sequence.

Figure 8.15 *A single frame without correction. © Andrew Francis (www.xlargeworks.com).*

Figure 8.16 *After tone and contrast enhancement. © Andrew Francis (www. xlargeworks.com).*

How to Enhance Highlights and Shadows
This technique can be used in combination with almost every other color correction process to give images extra depth.

1. Load the footage.

2. Create keys on the luminance channel for the shadow, mid-tone, and highlight areas.

3. Blur the shadow and highlight keys.

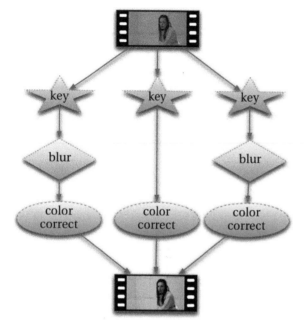

Figure 8.17

Figure 8.18 *A single frame without correction. © Entitled Productions.*

Figure 8.19 *The frame with enhanced highlights and shadows.*

4. Use the keys to selectively adjust the color of each region.
5. Render the sequence.

Color Temperature

Light is rarely pure white. If you film a white sheet during sunset it will probably look slightly pink when you watch it later. The color the light gets recorded as has to do with the color temperature of the light. Higher temperatures tend to be slightly blue, whereas lower temperatures tend to be more red (this is the reverse of how we usually describe colors, that is, we refer to red as being warm and blue as cool).

Different lights (and in the case of sunlight, different times of the day as well) each have a color temperature. When something is photographed, the color temperature of the light source will affect the color of the recorded scene. Most of the time the cinematographer will keep the color under control (for example, by using filters on the camera or selecting a particular type of color-balanced stock), but sometimes there is a resulting color cast on the final footage. For example, if you were to photograph an office interior using daylight-balanced film, you might find that the scene had a green color cast (or tint) to it, due to the color temperature of the fluorescent lights.

Figure 8.20 © *Steve Johnson (www.xhiking. com).*

How to Remove Color Casts

Removing color casts is easy on paper, but can require a great deal of experience.
Although many color casts are caused by lighting or filters, some are actually perceptual. For example, if you take a scene that is predominantly red, it may appear to have a slightly yellow cast over more neutral (gray) areas.

Another point to consider is that color casts may not necessarily be a bad thing. The fact that candle light can cause a yellow cast might add to the mood of the scene.

1. Load the footage.
2. Scrub through it and identify an area that should be neutral.
 a. If possible, take a reading of the RGB values of the neutral area. This will assist you in the correction process, because to make it neutral, the red, green, and blue values should all match (although this will be less helpful in trying to fix perceptual color casts).
3. Adjust the color balance (using whichever tools you have available) until the area in question is neutralized, making sure that the luminance across the image is unchanged.
4. Preview the footage to ensure the results are consistent, making tweaks as necessary.
 a. If the color cast comes and goes during the sequence, you'll need to adjust the correction dynamically to avoid removing one color cast but adding another.
5. Render the sequence.

Figure 8.21

Although the process of removing color casts is not particularly strenuous, it does take a lot of practice to get consistently good results. Some colorists prefer to correct for skin tones rather than neutrals, as this will eliminate most perceptual color casts as well. The process of neutralizing colors must ultimately go hand in hand with the overall process of using color to enhance the mood and style of the production.

Black and White

Working with black-and-white digital footage is not really any different from working with color digital footage. Although you don't have to worry about things like color casts, aspects such as tone and contrast are just as important (if not more so).

> **TIP**
>
> Because balancing colors can be a subjective process, in addition to having a correctly calibrated monitor, it can also help to remove any extraneous colors from your point of view. One of the best ways to do this is to set the colors on your computer screen to grey, with a neutral (albeit not very aesthetic) desktop background where necessary.

Figure 8.22 © *K. Fogle Photography (fogle.kim@gmail.com).*

Although it seems reasonable to assume that it's better to shoot black and white if you plan to finish in black and white, that's not necessarily the case. If you shoot in color, not only do you keep the option of finishing in color later, but you also increase your ability to finesse the black-and-white picture.

The reason for this is that you can use the different colors to isolate and tune color regions during the transition to black and white. For example, if you were to photograph a blue shirt using black-and-white film, it would probably be recorded (depending upon the type of stock used) as white, in the same way that a shirt that is actually white would be. This would make it difficult to differentiate the blue shirts from the white ones later on. If you had shot the scene in full color, though, you'd be able to key the blue prior to conversion to black and white, and save the key for later use.

How to Turn Color into Black and White
Get more control over black-and-white conversions with this technique.
Although it's tempting to use a desaturate filter to remove color from footage, you can get a great deal more flexibility by using the extra information locked away in each of the color channels.

1. Load the footage.
2. Separate the red, green, and blue channels to produce three grayscale sequences.

3. Layer the sequences together, and blend between them until you get a result that you like.
 a. You can try duplicating some of the layers and using blending modes between them to emphasize different regions.
4. Render the sequence.

How to Bleach Bypass
This popular process gives footage a very stylized look.

The bleach bypass is a very stylized look. Originally a chemical process used on productions such as *Saving Private Ryan*, it can be emulated digitally on any footage. The result has more contrast, stronger highlights, and less saturation overall than conventional processing. Essentially, a monochrome copy of the image is superimposed over itself.

Figure 8.23

> **TIP**
>
> For the best quality, and greater flexibility, try to keep footage in color for as long as possible during post-production, converting to black and white only when the other processes (such as noise reduction) have been completed.

Figure 8.24 *The bleach bypass look. © Andrew Francis (www.xlargeworks.com).*

1. Load the footage and duplicate it.
2. Follow the procedure on page 138 for converting the copy to black and white.
3. Take the black-and-white copy and layer it over the original.
4. Use blending modes (such as screen or multiply) between the two layers until you achieve the desired look.
 a. You can also key the luminance channel for the highlights and blur and brighten it to increase the effect.
5. Render out the result.

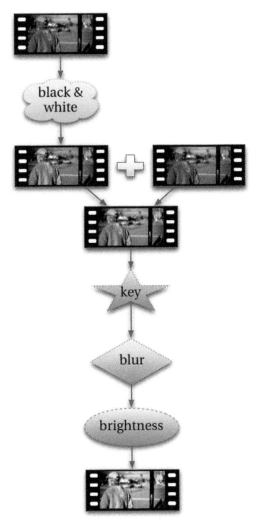

Figure 8.25

Changing Colors

Whenever someone demonstrates a color correction system, they will almost always show off its ability to completely change a color (for example, turning a red rose yellow). In practice, such extreme effects are rarely necessary, but easily performed: simply key the original color to isolate it, and then use the regular slew of color correction tools to alter the isolated region. You may need to combine the key with a garbage matte, especially if the isolated color is present in other parts of the scene.

How to Cross Process

This is another technique adapted from chemical processing that can be used to stylize footage.

Cross processing is another chemical process, caused by putting negative film through the development process for positive (slide) film, or vice versa. The result is a very distinctive, surreal-looking image.

Figure 8.26 *The cross process look. © Andrew Francis (www.xlargeworks.com).*

1. Load the footage.
2. Create keys on the luminance channel for the shadow and highlight regions.
3. Using the shadow key to limit the effect, darken the red channel and brighten the blue channel.
4. Using the highlight key to limit the effect, brighten the red channel and darken the blue channel.
 a. You may also want to apply a blur to the overall highlights to mimic the chemical process.

5. Increase the contrast of the green channel slightly.
6. Tint the entire image slightly yellow.
7. Render the result.

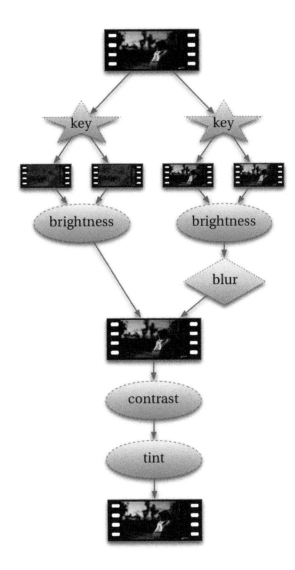

Figure 8.27

How to Blue-Green Transfer
This is the simplest technique to stylize footage, and is surprisingly underused.

A blue-green transfer was a popular technique in the early 1990s, coinciding with the rise of the telecine (film to video) process. It has long since fallen out of use, but it remains a simple yet effective

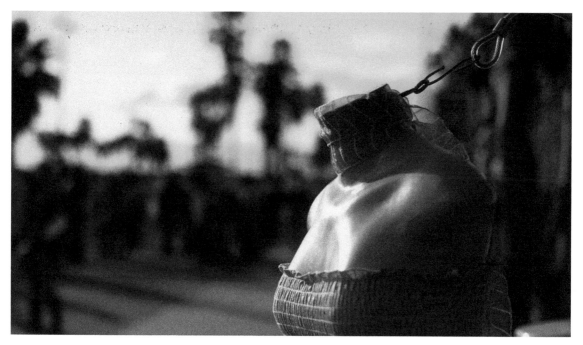

Figure 8.28 *The blue-green transfer look.* © *Andrew Francis (www.xlargeworks.com).*

way to stylize footage. It can be combined with other techniques, or used as a starting point for inspiration.

1. Load the footage.
2. Swap the blue channel with the green channel.
3. Render the result.

How to Boost Vibrance
This is a popular technique adapted from digital photography for adjusting saturation in a more controlled way.

Almost every color correction system has a method for adjusting the saturation in an image. This single control gives rise to a great variety of different ways

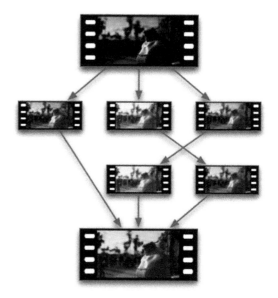

Figure 8.29

to stylize footage, from the hypersaturated reality of shows such as *Pushing Daisies* to the more mono-chromatic imagery of *Sin City*.

The problem with your garden variety saturation control, though, is that it affects all colors equally. So colors that are already saturated can quickly become oversaturated, or vice versa. This technique provides a way to adjust the saturation of footage based on how saturated it already is, making it ideal for working with skin tones, which are not typically very saturated to begin with.

1. Load the footage and duplicate it.
2. Desaturate the copy.
3. Create a difference matte between the two versions (refer to Chapter 2 for the process of creating a difference matte).
4. Desaturate the resulting footage and then adjust the levels so that the color range is from pure black to pure white.
5. Render out the result.
6. Using this new footage as a mask (you may need to invert it) on the original footage, adjust the saturation as desired.

How to Turn Day into Night
This is where colorists get to show their mettle.

Day-for-night shots can be a producer's dream. You save on the additional expense of a nighttime shoot by shooting during the day, and get a colorist to make the shots look like a nighttime scene through careful manipulation of the colors. However, it takes a very skilled colorist to produce convincing results.

This technique is simple enough to follow, but the secret is in the tweaking; it's a classic example of where tools and technical expertise must give way to pure artistry in order to get the best results.

1. Load the footage. If possible, try to get reference material of similar scenes that were actually photographed at night.

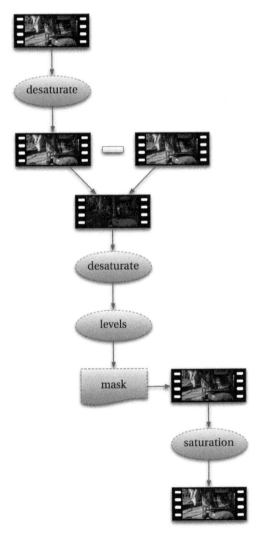

Figure 8.30

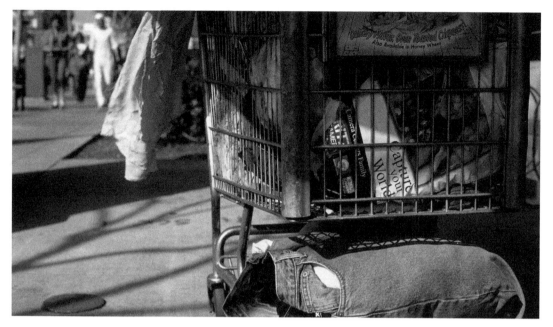

Figure 8.31 *A single frame without correction.* © *Andrew Francis (www.xlargeworks.com).*

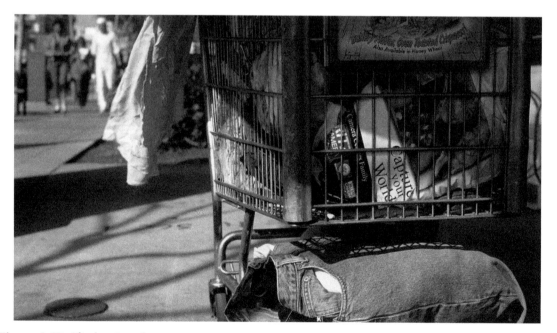

Figure 8.32 *After boosting vibrance.*

2. Desaturate the shot by around 50–75%. We don't perceive color very well in low light, so it is very unusual to see anything saturated in a nighttime scene.

3. Tint the image slightly blue. This produces a basic day-for-night to use as a starting point. You now need to identify certain key aspects of the scene.

 a. What provides the primary light source? Is it the moon, street lights, passing cars, or something else? For light sources like passing cars, you will need to add dynamic color correction to make light appear to move across the scene.

 b. What time of night does the scene take place?

4. Remove anything from the scene that shouldn't be visible at night (such as reflections of the sun, birds, and cars without lights).

 a. Particularly tricky elements to remove may have to be given to a visual effects artist to deal with, or you might be able to crop or otherwise blot them out.

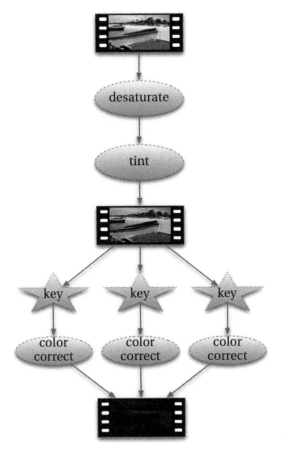

Figure 8.33

Figure 8.34 *A single frame without correction.* © *Andrew Francis (www.xlargeworks.com).*

Figure 8.35 *Day is turned into night.* © *Andrew Francis (www.xlargeworks.com).*

5. Create keys for the shadow, mid-tone, and highlight regions and adjust the color of each to get the desired result.

 a. You'll probably want to exaggerate the darkness of the shadows and mid-tones, adjusting the highlights depending upon the picture content and desired result.

6. Tweak the result until you are happy.

7. Render the sequence.

TIP

For *Band of Brothers,* colorist Luke Rainey broke with tradition, opting to give everything a brown (rather than blue) hue, resulting in some of the best-looking day-for-night footage ever produced.

For a great example of how lighting changes over the course of a night, refer to the work of colorist Larry Field on the television series *24.*

Figure 9.1 © *Paolo Margari (www.flickr.com/paolomargari).*

Chapter 9

Fixing Compositional Problems

"The more I get of you, the stranger it feels."
—Seal

One of the aspects of digital postproduction that seem to get producers the most excited (particularly the ones with a significant background in working with film) is its ability to quickly and easily recompose shots. A medium shot can potentially become a close-up, widescreen footage can be formatted for narrower displays, and images can be blown up from SD video to 35 mm resolution. And all this for far less expense than reshooting.

The reality, of course, is not quite this straightforward. Although digital technology makes all of these things easy, there is still a price to be paid—almost all of these processes can diminish the inherent quality of the original in some way.

The Crop

Sometimes you need to adjust footage to fit a particular frame. For instance, you may need to add high-definition material to a narrower standard definition production. You have two options: you can squash the HD image to fit the SD frame, which will distort it (all your actors will look taller and thinner), or you can crop it, cutting some of the original composition.

What becomes important at this point is the region of interest, that is, the part of the image you want to keep. Most of the time, cropping footage will keep the image centered by default (performing what's known as a center cut-out). Most of the time that produces the desired result, but bear in mind that you can usually combine the crop with repositioning the image, for instance, in the case of cropping HD to fit an SD frame, keeping the top part of the frame and losing the bottom instead.

Figure 9.2 *A frame of HD video. © Andrew Francis (www.xlargeworks.com).*

Figure 9.3 *The frame squashed to fit an SD frame.*

Figure 9.4 *The frame cropped to fit an SD frame.*

Figure 9.5 *The frame cropped and repositioned to fit an SD frame.*

The Letterbox

Crops are useful for a number of situations, but sometimes it's more important to retain the complete, original image, rather than filling the frame. For example, if you need to make an SD reference tape that contains HD elements, you'd better be sure that the whole image is there in case anything important is happening at the sides. In this case, what you need is a letterbox, not a crop.

A letterbox retains the original shape of the footage, typically filling the rest of the frame with black. On the plus side, you get the complete composition, but on the minus side, you get a lot of wasted space in the frame (a letterbox usually implies a reduction in resolution as well, and so will be less detailed than the original).

Figure 9.6 *A frame of HD video letterboxed to fit an SD frame. © Andrew Francis (www.xlargeworks.com).*

Digital Scaling

There are many situations in postproduction that require the picture size of a shot to be changed. Unfortunately, the process of resizing digital images is far from perfect. Intuitively, it should be a very simple process, like using a zoom lens on a camera to get closer to the action, or even like using an enlarger in a photographic darkroom to make the picture fit a bigger page.

Figure 9.7 © *Timothy Lloyd (www.timlloydphoto.com).*

Both of these examples use an optical process that magnifies details that were previously too small to see clearly. With digital images, however, you're limited to what's already there. And because what's already there is just pixels, tiny colored square boxes, when you enlarge a digital image too far, you get … big colored square boxes.

Having said that, this side effect goes unnoticed most of the time. The main reason you don't see scaled-up pixels in digital images very often is that almost every image processing application automatically performs interpolation on the raw data to produce the resized result. This uses any of a variety of algorithms to create detail between the pixels in the original. Very often, this process works well, generating passable results. However, it can also lead to a variety of artifacts and should therefore be avoided whenever it's not needed.

> **TIP**
>
> Refer to Chapter 6 for techniques for removing many of the artifacts that can be caused by digital scaling, such as aliasing.

Figure 9.8 *Close-up of pixels after resizing using nearest neighbor inter-polation.*

Figure 9.9 *Close-up of pixels after resizing using bilinear interpolation.*

Figure 9.10 *Close-up of pixels after resizing using Lanczos interpolation.*

How to Use High-Quality Scaling
Digital photo editing applications often provide more options for scaling footage than video editors.

Most video processing applications are built for speed. There's a trade off between an application's responsiveness and interactivity and the complexity of the processing it can do. It's acceptable to use scaling algorithms on digital video footage, provided that footage will still play back in real time.

Many of these applications, as a result, don't provide much in the way of choice of algorithms for scaling footage. This is a shame because there are a large number of digital image processing applications that provide a great number of different options, each yielding different results. This technique will allow you to leverage the flexibility of image processing applications for digital video footage.

1. Load the footage.
2. Render it as a series of still images at its native resolution (refer to Appendix 1 for more information on this process). Make sure the images are numbered sequentially.
3. Open one of the images in your image processing application.
4. Resize the image to the desired size, trying different methods until you find one that provides the best result.
5. Batch process the remaining images using these settings, again ensuring that the resized files are numbered sequentially.
6. Load the new image sequence into a timeline.
7. Render out the sequence to the desired format.

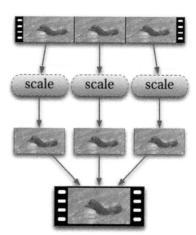

Figure 9.11

TIP

The problems associated with scaling (as well as the potential solutions) apply equally whether you are enlarging or reducing footage. Using different algorithms can produce varying results when making footage smaller, with some producing smoother results and others producing sharper results. Be aware that an algorithm that works very well when scaling footage up will not necessarily be suitable for scaling the same footage down.

Aspect Ratio
The aspect ratio of an image is the ratio of its width to its height. High-definition video has an aspect ratio of 16:9 (which may also be written as a decimal: 1.78), meaning that for every 16 units

Figure 9.12 © *Anna Pearson.*

of width (be it measured in pixels, centimeters, whatever), the height will be 9 units. Standard definition video, on the other hand, usually has an aspect ratio of 4:3 (1.33), although there are widescreen variants of SD that can be 16:9, just like HD.

With film, it gets even more complicated, as the aspect ratio will depend on the gate used during the shoot. This means that the aspect ratio of a strip of film footage might be 1.66, 1.85, or even 2.35. On a given production, it's not uncommon to find footage that has been shot with different aspect ratios for inclusion in the final cut.

With very few exceptions, the aspect ratio of any output format must be consistent. Regardless of how the material was shot, it must be formatted for 16:9 for HD video and usually for either 1.85 or 2.35 for theatrical release. Most of the time, any discrepancies can be resolved simply by cropping the footage to fit. That's fine when working with formats that have a lot of detail, such as 35mm film, but cropping SD video to make it 16:9 can quickly reduce it to something close to VHS quality.

Figure 9.13 *Different aspect ratios.*

Safe Areas

Safe areas are a legacy of old television sets. It was difficult to manufacture televisions that would ensure that the displayed picture would fit exactly within the frame. So many manufacturers overcompensated, with the result that part of the picture was outside of the frame and therefore not visible (but at least their customers didn't complain about part of their screens being blank).

In turn, producers found that the edges of their pictures were being cropped on a large percentage of the audience's televisions. So anything happening at the edge of a frame may or may not have been visible, which was especially problematic for necessary items like text. The solution, therefore, was to define the safe regions, where elements would be guaranteed to be visible regardless of the type of display. Unfortunately, these safeguards are still enforced in the digital era, and therefore require careful checking before output.

For visible action, the safe area is defined as 3.5% of the width and height from the edge, and for titles, 5%. Refer to Appendix 2 for more specifics.

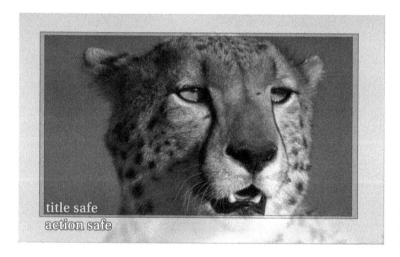

Figure 9.14 *Safe areas within an HD frame. Earth © BBC Worldwide Ltd 2007.*

How to Turn HD into SD
Changing HD into SD requires more than a simple resize.

The following technique assumes you want to fill the SD frame (otherwise, you should just letter-box the footage to retain the entire frame).

1. Load the footage.

a. Ensure that the aspect ratio is preserved. If your application doesn't do this automatically, calculate the new width by multiplying the new height by 16 and then dividing by 9.

b. Ideally, you should use a system that doesn't commit the resizing operation until you render it out, to allow for interactive experimentation.

2. Crop the footage left and right to match the output width. Apply the crop evenly to the left and right to get a center cut-out.

a. If you don't want to use a center cut-out, reposition the frame horizontally before cropping.

b. For a more advanced application of this process, set key frames to dynamically adjust the position and scaling of the frame according to the desired point of interest in the shot (this is known as a pan-and-scan).

c. Make sure you pay attention to action-safe and title-safe regions for the final output composition.

d. If the footage has text that cannot be separated from the picture and cannot be made to be title-safe in the final composition, the chances are it will have to be cropped out completely and then added back on again separately.

3. Render out the final result, using settings appropriate to the output format.

Figure 9.15

How to Turn SD into HD

Turning SD into HD is particularly challenging, as there are many factors to consider.

When trying to give SD video footage the properties of HD video, you suffer from several disadvantages:

- The picture area is much smaller (a single frame of HD can have as many as four times as many pixels as a frame of SD).
- The frame is much narrower. This means it has to be resized to be significantly larger than HD in order for it all to fit in the frame.
- Any noise in the image will be greatly exacerbated.
- If it will be cut alongside actual HD footage, there may be noticeable differences in the picture quality and sharpness between the HD material and the resized SD material.

What this means is that you have far less flexibility in the process of going from SD to HD than you do from HD to SD. This technique tries to retain as much vertical detail as possible, at the cost of distorting the image slightly.

1. Load the SD footage. Make a note of details such as the size (in pixels) of the picture area, the frame rate, and so on. You'll need to compare these with those of your output HD format.

2. You'll probably have to noise reduce (using the techniques in Chapter 6), and it's best to do so before any scaling.

3. Stretch the picture horizontally as much as possible without it being noticeably distorted (I usually find that stretching it to an aspect ratio of around 14:9 (by 16.7%) gives reasonable results).

4. Scale this result (maintaining the new aspect ratio) until it has the width of the HD output format.

 a. Because there will be significant scaling at this point, it's worth referring to the technique on page 154 for using high-quality scaling.

5. Crop the top and bottom of the resized frame to the height of the output HD format.

 a. If you don't want to use a center cut-out, reposition the frame vertically before cropping.

 b. For a more advanced application of this process, set key frames to dynamically adjust the vertical position of the frame according to the desired point of interest in the shot.

6. Follow the techniques in Chapter 3 for improving the sharpness of the final shot.

 a. Ironically, you can add some noise back in at this stage to make it perceptually sharper, as it will appear to give more definition to the (now smaller) pixels.

7. Render out the final result.

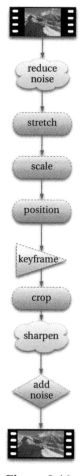

> **TIP**
>
> You may be able to squeeze a few more pixels out of SD footage by utilizing the technique on page 166 for extending framing.

Figure 9.16

Shoot and Protect

If you know ahead of time that you're going to be shooting on a format that has a different aspect ratio from the destination format, you can plan for the difference using a technique known as shoot and protect.

The basic idea is that you compose your shots so that the main action happens within the framing of the destination format (once it has been cropped), but you still shoot the entire frame. Getting this technique to work properly means that you also have to consider how the safe areas will change once the shot is cropped, and so it's advisable to have corrected guides on the viewfinder.

Appendix 2 has a chart showing how to calculate recommended shooting ratios for different formats.

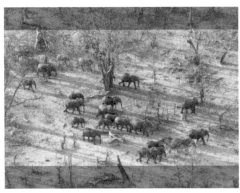

Figure 9.17 *16:9 protected for 4:3. Earth © BBC Worldwide Ltd 2007.*

Figure 9.18 *4:3 protected for 16:9. Earth © BBC Worldwide Ltd 2007*

Pixel Aspect Ratio

Pixels are thought of as being square, and they certainly are for display devices (monitors, digital projectors, iPhones…), but pixels in digital footage are actually rectangular. To better understand the difference, imagine you are building a house. You find an architect to draw up detailed plans, even working out how many bricks you'll need. Like everything in postproduction, something

Figure 9.19 *© Jack James.*

inevitably goes wrong at the last minute, and so on the day you're due to start building, a shipment of square bricks turns up. They're only slightly narrower than they were supposed to be, but your trusty architect does some quick sketching. Using these square bricks, the overall house is going to be narrower by several feet. However, she also points out that you could just order a few more of these square bricks now to end up with the same overall shape. The house won't use regular bricks like you wanted, but at least it will retain her stunning design.

Rectangular pixels exist because they enable a wider image to be packed into a smaller file. In the film world, cinematographers can use anamorphic lenses to squeeze a wider, more panoramic image onto the same area of film. If you look at the negative of film shot in this way, it looks like it's been squashed inward horizontally. The reason you don't see it like that at the cinema is because the projector uses another anamorphic lens to unsqueeze it onto the screen. Exactly the same principle is used in the digital world, with some images squeezed together to use less pixels overall, then automatically unsqueezed for display purposes. Probably the most common example of this is in standard definition widescreen formats. SD frames are almost square (4:3 aspect ratio), but widescreen (16:9) images can be squeezed to fit this frame, meaning the same equipment can be used for both, from the tapes to the editing systems. All that needs to happen to make the process foolproof is for the footage to be adjusted automatically for display so that it look correct when you view it.

In order to determine the shape of a pixel, digital footage has a property known as the pixel aspect ratio, which is simply the width of a pixel divided by its height. So a perfectly square pixel has a pixel aspect ratio of 1.0, and a wide pixel might be more like 1.5.

One of the problems with all of this (other than there being numbers involved) is that sometimes the pixel aspect ratio can mysteriously disappear under certain situations. A particularly common

Figure 9.20 *A group of square pixels (with a pixel aspect ratio of 1.0).*

Figure 9.21 *A group of non-square pixels, such as those found with DVCProHD footage (with a pixel aspect ratio of 1.5).*

Figure 9.22 *Approximating non-square pixels using square ones.*

problem during exports or conversions is that footage that looked fine on one system suddenly looks squashed on another. This happens either because the pixel aspect ratio was not written into the file by the first system, or because the second system has ignored it.

Video and Graphics

Managing the pixel aspect ratio is particularly important when you are importing or exporting graphics. Most digital video footage uses non-square pixels, while most digital photos and graphics use square pixels. Because of this, mixing the two can often result in elements getting squashed and stretched.

In this situation, it may be a good idea to convert all the footage to have a common pixel aspect ratio (for example, of 1.0), stretching it outward rather than squeezing it inward (thus creating new pixels) in order to get the best quality results. You may also see a slight quality benefit by doing this if your footage will be put through lots of processes that may degrade it further.

Appendix 2 lists the pixel aspect ratios of common formats.

How to Remove Objects from Shots

A perfect shot can be ruined by a misplaced boom, but can sometimes be rescued in post.

1. Load the footage.

2. If you're lucky, the object to be removed will be in the foreground. If that's the case, it can be removed using cloning techniques, in which case you can simply render out the result.

3. Otherwise, you'll first need to create a clean plate, removing the obstructing foreground elements. There are a few ways to do this, depending upon the picture content.

 a. Scrub through the footage to find a point where the foreground objects have moved, revealing the background. Clone as much of the background as possible onto a frame that has the object to be removed, as a new layer. You may have to reposition the cloned regions to properly line them up.

 b. Repeat using other frames as a cloning source until the foreground elements are removed.

 c. If necessary, use cloning techniques to refine the clean plate.

 d. Repeat this process for every frame in which the object to be removed is visible. You'll probably be able to use the new clean plate frames as a cloning source, which should make the process a little faster.

4. Once the clean plate has been constructed, mask it so that it only obscures the object to be removed.

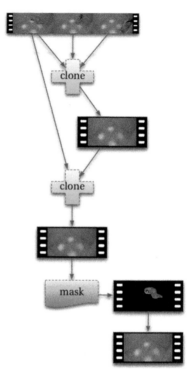

Figure 9.23

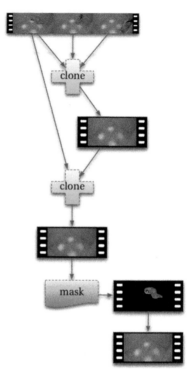

> **TIP**
>
> This is the point where we start to stray into the realm of visual effects, as some of these techniques require a skill set similar to those required for digital compositing. However, I'm only scratching the surface here, and it's well worth learning some compositing skills even if you never intend to use them, as they can be useful for fixing all sorts of problems in postproduction. For example, the skill of match-moving (correctly positioning layered elements with respect to factors such as perspective), though a very deep and complex subject, makes creating and applying clean plates yield much better results.

5. Use cloning techniques to finish the job.
6. Render out the sequence.

How to Censor Objects
The visibility of a commercial brand, or a person who didn't sign a release, needn't mean a reshoot.

This technique is favored in documentary productions more than in other types, as it can be distracting to the viewer, but it can be useful when there are no other options.

1. Load the footage.
2. Mask the area to be censored on one frame.
3. Track the mask to the area across the shot.
4. Dynamically adjust the position and size of the mask so that

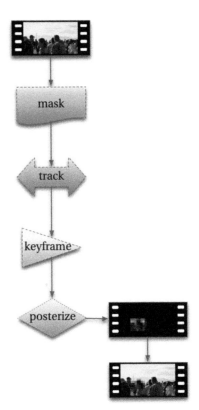

> ### TIP
> You can get different aesthetic results depending upon the type of filter you use to obscure the area in question. For instance, using a heavy Gaussian blur filter produces a much less distracting result.

it constantly obscures the object in question.
5. Apply a filter, such as mosaic, to the masked area across the shot.
6. Render the result.

How to Replace Skies
Turning gray skies blue or adding stormy clouds can dramatically alter the mood of a shot.

Figure 9.24

1. Load the footage. If you want to change the pictorial content of the sky, you'll also need footage of the new sky to be inserted.
2. Key the existing sky. Depending upon the sky itself (whether it's cloudy, for example), this may prove tricky.
3. Use garbage masks to further isolate the sky. Remember to match the final mask to the motion of the camera, using tracking if necessary.
4. Blur the resulting mask.

5. Use the new mask to form the new sky.

 a. Color-correct the original footage, using the mask to limit the extent of the correction to the sky.

 b. Alternately, layer the sky footage over the original footage, constraining it by the mask. You'll need to track the motion of the new sky to the underlying layer if you do this.

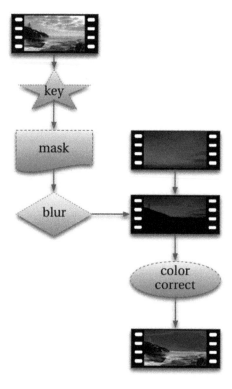

Figure 9.25

TIP

A very simple way to add interest to shots with skies is to create a mask from a gradient, starting from the top of the frame, down to the horizon. Then apply a slight color correction using this mask to get the desired result.

How to Replace Logos
Replacing logos can be a painstaking process, but a real money-saver nonetheless.

1. Load the footage.

2. Follow the directions on page 162 for removing objects to remove the original logo. Don't render anything just yet.

3. You should now have two layers: the original footage and the masked clean plate.
4. Add the new logo onto a new layer.
5. You'll now need to match-move the logo so that it conforms to the movement of the objects in the scene.
 a. Use trackers, particularly multiple-point trackers if possible, as these will aid in the rotation and scaling of the logo as well as the position.
 b. Use warping techniques to ensure the perspective looks correct.
 c. Use cloning techniques where needed to improve the integration with the rest of the scene.
 d. Color-correct the logo to match the lighting of the surrounding region. Pay particular attention to shadows that may fall across the logo, using masked color corrections to simulate shadows where necessary.
 e. Check every frame that the logo is visible in, adjusting as required.

Figure 9.26

6. Mask the logo layer to reveal foreground objects that should appear to be in front of it.

7. Go over the entire sequence with a cloning tool to fix problem spots.

8. Render out the result.

TIP

Software such as Imagineer's Monet (www.imagineersystems.com) can take a great deal of the guesswork and monotony out of the process of replacing logos by using tracking algorithms specifically designed for that purpose.

How to Extend Framing

This will push your system (and your patience) to the limit, but can result in footage that is otherwise impossible to obtain.

The field of digital photography has a technique for creating panoramic images much bigger and more detailed than the camera in question is capable of shooting. The basic idea is that you take multiple photographs of a scene, changing the objective slightly each time (but keeping everything else the same), resulting in a set of images that effectively overlap each other to some degree. You can then stitch these images together and adjust the result so that it's seamless.

In motion pictures we don't usually have the luxury of being able to shoot exactly the same subject from very slightly different viewpoints over and over again, but we do have one main benefit, which is access to lots of images.

1. Load all the available footage for the shot. Try to get as much of what was shot for a given scene as possible, which can include outtakes and different setups.

2. Using the original shot as a point of reference, arrange the footage in layers so as to extend the frame as much as possible.

 a. Reposition, scale, rotate, and warp the footage as necessary.

 b. As a rule of thumb, the greater the difference in camera angle from the original shot, the farther from the center it should be.

 c. Don't agonize about keeping everything in sync, unless there are a lot of foreground objects moving about.

 d. Remember to use frames before and ahead of the current frame, particularly if there is any amount of camera movement in the shot.

 e. You may also be able duplicate layers and then flip or flop them to increase the available area or fill in gaps.

3. Scrub through the footage and keyframe the position, scaling and so on so that the elements don't appear to drift around.
 a. At this point you may discover that choices you made earlier regarding the selection of the additional footage just don't work, and you may have to start over.

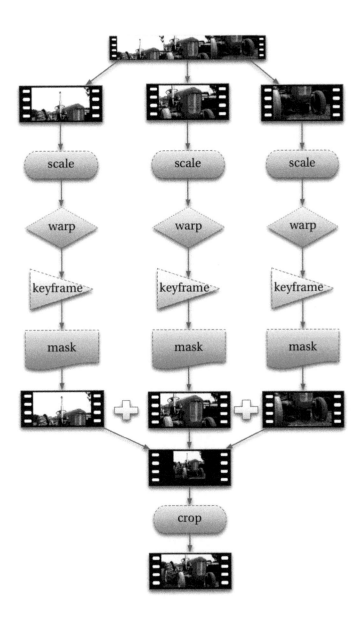

Figure 9.27

4. Depending upon what is happening in the scene, you may have to separate the foreground and background (and possibly in between) elements. Mask the regions in question and copy them to separate layers.

5. Scrub through the sequence again to ensure everything is lining up properly, and make adjustments as required.

6. Crop the composition so far to the desired aspect ratio, making sure there are no gaps at any point.

7. Color-correct the various layers so that they blend together.

8. Use cloning to make all the gaps seamless.

9. Play through the result and render it out.

How to Add Pseudo-Reflections
Simulating realistic reflections is probably best left to an experienced compositor, but this will give the subtle impression of a reflection quite easily.

.Depending upon how you want the reflection to work, this can be a relatively easy process.

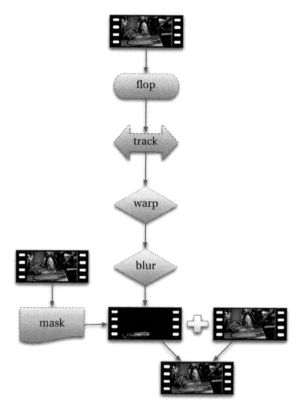

Figure 9.28

1. Load the footage and determine where you want the reflection to occur.
2. Duplicate the footage and mask the region to appear in the reflection.
3. Depending upon where the axis of the reflection is, you will need to flip or flop the result. For example, if the reflection is to appear on the ground, flip the shot vertically; if it's on a window, flop it horizontally.
4. Track the result over the course of the shot so that any camera movement doesn't give it away.
5. Depending upon the perspective of the scene, you may need to warp the reflection to make it look natural.
6. Add an additional mask to the layer, a gradient mapping the distance from the camera across the reflection. For example, for a ground reflection, the mask should start at white on the horizon, reaching black in the foreground. This will need the same tracking data applied to it.
7. Use this mask to control the opacity of the reflection layer. You want the reflection to appear strongest where it is closest to the subject, so the mask may need to be tweaked at this point.
8. Blur the resulting layer to taste.
 a. You can also experiment with using other filters, depending upon the effect you're after.
9. Render the result.

Figure 10.1 *Earth © BBC Worldwide Ltd 2007.*

Chapter 10

"From this time, we're all looking at a different
picture through this new frame of mind."
—Portishead

Almost every production will have at least one shot that has timing issues. Most of the time these are deliberate, such as the case of footage intended to be sped up or slowed down. Sometimes, though, there will be shots that have other problems (such as data corruption), which then become the cause of timing issues such as dropped or duplicated frames. And of course, there are problems that occur during the shoot, such as flicker, which were either overlooked or impractical to control at the time.

This chapter will address many of these types of problems, as well as provide some tips to improve intentional timing changes.

Retiming Footage

Almost every production will have at least one retimed (sped up, slowed down, reversed) shot. This is done for a variety of reasons, such as for continuity, for emphasis, to imply a sense of scale, or for special effect. Traditionally, speed changes were always done in-camera by changing the rate at which the film ran, but these days the responsibility tends to be delegated to postproduction for flexibility.

> **TIP**
>
> The following techniques assume you are retiming footage independently from any audio. For information on retiming audio as well, separate the audio tracks from the footage, and refer to Chapter 7.

The digital realm also offers other possibilities. For instance, it's possible to vary the speed of the shot as it plays. A shot could start sped up, then switch to normal speed, and then slow down toward the end, a process known as time-warping or ramping.

Figure 10.2 Shots of explosions and fire tend to be slowed down to give them more screen time. © Daniel Garcia (dgarcia@focalintent.com).

How to Speed Up a Shot
Almost every editing system can speed up a shot.

1. Load the shot into a new timeline.
2. Set the new speed as a percentage of the original speed. For instance, to double the speed of the original shot, set the speed to 200%.
3. Render the result.

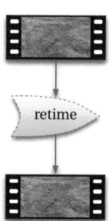

Figure 10.3

If you know the new duration of the retimed shot rather than the percentage (and if your editing system doesn't let you change the speed by specifying a new duration), you can work out the percentage:

[Number of frames (original shot)/Number of frames (new shot)] × 100

If your editing system doesn't let you apply speed changes directly from within its interface, you can do it yourself by manually cutting out frames (using extract or ripple-delete operations) at regular intervals. For example, to double the speed of a shot, cut out every other frame.

> **TIP**
> Most systems will allow you to reverse a shot by setting the speed to −100%.

Figure 10.4 *A sequence at its original speed. Earth © BBC Worldwide Ltd 2007.*

Figure 10.5 *Here the sequence runs twice as fast, skipping every other frame. Earth © BBC Worldwide Ltd 2007.*

Most systems will speed up footage by simply discarding frames at a regular interval. In most cases, this provides good results, with the added benefit that it processes very quickly.

Some software (notably third-party retiming plug-ins) will default to using motion-based interpolation. For speeding up shots, this is unnecessary at best, and at worst will soften the images by simulating motion blur and thus should be avoided (unless this is the effect you're after).

How to Slow Down a Shot
Slowing down a shot convincingly requires considerably more work than speeding it up.

Certain things are best done in-camera, rather than left to be fixed in post. One of the best examples of this is slowing down footage. No matter how well you can do the job of creating slow-mo digitally, it will never look as good as if you'd set the camera to film at a higher frame rate.

The main issue with slowing down a shot is that you must generate frames that don't exist. On top of that, you will sometimes need to reduce the camera motion blur so that the images appear sharper. Many editing systems that give you the option to slow down footage will do so by duplicating frames at a regular interval. In most cases, this method is not sufficient. If your system has a frame-blending method (or better, a motion-estimation option) you should use it and then check for problems. If not, you can get the same results with a liberal application of elbow grease:

1. Determine the points where new frames need to be generated. For example, if you need the shot to run at half-speed (making it twice as long), then you need to insert a new frame every frame.
 a. If the new speed must be less than 50% of the original, then you will need to do the entire process several times, first making it look right at 50% speed and then making further reductions to get to the desired speed.
2. For each new frame to be created, load the frame before and the frame after into an image editor.
3. Combine the two images together using a straightforward blend operation. Depending on the picture content, you may find that different blending modes produce more convincing results.

4. Fix any obvious problem areas, such as double edges, by masking and moving, cloning from the other frames, or warping the affected regions to the correct position.
5. Ensure that the new frame is the same as the other two in terms of overall sharpness, brightness, and contrast, and adjust accordingly.
6. Save the new frame.
7. Insert-edit (or splice-in, or ripple-edit) the new frame into the sequence.
8. Repeat for the other frames to be generated.
9. Play through the new sequence in real time to check for other problems.

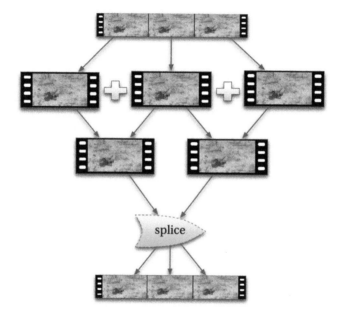

Figure 10.6

Slowed-down shots will almost always look softer than other shots because there is an implied motion blur (unless the shutter was deliberately increased during the shoot). For the sake of continuity, it may be necessary to take steps to try to reduce this blur.

How to Time-Warp Footage
The complex nature of ramping the speed of a shot requires dedicated software.

Time-warped shots tend to be very striking and energetic because they are unnatural; they distort our sense of rhythm,

> **TIP**
>
> If you apply a speed change to a cut sequence (using interpolation or motion-estimation-based algorithms), you'll end up with undesirable soft cuts at each cut point. To prevent this from happening, you must apply the speed change to individual shots rather than to the entire sequence.

and therefore are usually relegated to trailers, commercials, pop promos, or stylized films. However, more subtle applications of time-warping can be used to tweak regular speed changes and make them appear less jarring.

Unfortunately, there is no practical way to time-warp shots manually (unless you want to spend a day with a sheet of graph paper and a calculator). Provided you have access to software with time-warp functionality, the process is very simple:

1. Most systems use a graph-based interface, with the output time running horizontally and the input time (or input speed) running vertically. There should be no sharp angles on this graph as you make changes to it, as these tend to produce visible changes in speed (which may be great for trailers, but not so great for narrative pieces). Gentle curves will produce more subtle results (assuming that's what you're after).

2. Determine the points at which the main speed changes occur. In most cases, these will be the start and end of the shot, and in some cases, the middle, too. Set these points to a good average of what you want to achieve, and preview the output.

3. Make sure the first and last frames of the output are what they should be, and not handle frames. Most systems allow you to change the overall duration of the new shot independently of the first and last source frames, so don't worry too much about the duration at this point (unless it has to be a predetermined length).

4. With an overall speed set, layer slight changes into the sequence that look pleasing to the eye. Be sure to review changes in the context of the previous and next shots in the sequence so that it appears smooth.

5. Render the result.

Figure 10.7

The most important thing about this process is that the result looks right. Don't worry too much about sticking to exact speeds; as long as the first and last frames are set correctly, anything goes!

You may find that this method produces noticeably softer results than the speed-change methods mentioned earlier, or introduces motion artifacts. In this case, you may need to combine this approach with the original speed-change

TIP

It's absolutely crucial to use a system that can process changes quickly and interactively during the initial phase of time-warping footage. Much of the success of the process lies in a creative process of trial and error, making little adjustments and tweaks, so it's essential that you don't spend time waiting for your shot to be reprocessed. Many time-warping systems include a preview or draft mode to aid performance, and these should be used as needed.

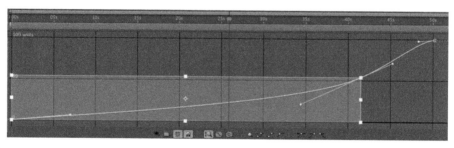

Figure 10.8 *Systems such as Adobe's After Effects allow you to use an interactive graph to adjust time parameters.*

techniques, using blending or masking of problem areas. For example, to increase the sharpness of a sped-up shot, create a new version of the shot using the method on page 172, and then blend the two shots together (for example, layering some of the luminosity of the straightforward speed-up onto the time-warped one), adjusting as necessary.

Removing Duplicate Frames

Duplicated (or "doubled-up") frames are a nasty little problem, mostly because they can be easy to miss until it's too late to fix them at the source.

In the digital world, frames can be duplicated due to several situations:

- One or more frames of an image sequence has been copied twice
- The footage has been retimed
- A de-interlace has not been set up correctly
- A digital filter has caused a render error
- A motion-compressed file has been corrupted

Whatever the cause, we'll assume the damage has been done and you're stuck with it. The problem now falls into two categories:

1. There is a duplicate frame at a regular interval (for example, every three frames).
2. There is no pattern as to where the duplicates pop up (or it only happens once).

Figure 10.9 *Here the frames are duplicated in a repeatable pattern. Earth © BBC Worldwide Ltd 2007.*

Figure 10.10 *In this case there is no particular pattern to the repeated frames. Earth © BBC Worldwide Ltd 2007.*

In the second case, you need to tackle each duplicate frame individually, which can be fairly tedious if there are a lot of them. In the first case, you should be able to fix all the problem frames in one go.

The next question you need to ask is, if you were to remove just the duplicate frames, would the footage run smoothly? In other words, have the duplicates overwritten other frames?

> **TIP**
>
> Duplicate frames can also be created accidentally during an edit. See Chapter 11 for more on that.

Figure 10.11 *In this case, the duplicate frame has overwritten the original frame. Earth © BBC Worldwide Ltd 2007.*

Figure 10.12 *In this case, all the original frames still exist in the sequence. Earth © BBC Worldwide Ltd 2007.*

This can be tricky to determine, particularly if the duplicate frame is on a cut. If the sequence includes audio, then you can check the audio sync. If it's out of sync, then it's likely that all the original picture frames are intact. Another option is to check the shot or sequence length (in frames) against any records you may have (such as an offline EDL). Sometimes, though, you will have to work under the assumption that everything is there and deal with any problems that crop up later on.

In order to remove duplicates, all that needs to be done is to delete the rogue frames and then save the modified sequence. If you know that the duplicates have overwritten other frames, then you instead need to regenerate the missing frames, and then use them to overwrite the duplicate frames.

How to Remove a Single Frame
Removing individual frames is a very straightforward process.

1. Load the sequence into an editing system.
2. If there are any audio tracks, lock them to prevent changing the audio.

3. Cue to the frame to be removed.
4. Mark an in and out point on that frame.
5. Perform an extract (or ripple-delete) edit. This removes the frame and closes the resulting gap in the sequence.
6. Render the sequence.
7. Depending upon the cause of the additional frame, the audio may now be out of sync, so check the rendered output and correct the audio if necessary.

Figure 10.13

> **TIP**
> You should record any changes you make to footage in case you need to refer back to it later. Usually, saving a copy of the timeline or an EDL just prior to rendering will suffice.

How to Remove Repeating Frames
Provided your editing software supports this feature, you can remove repeating frames automatically.

If there is a pattern to where duplicate frames occur, you can use a speed-up operation to remove them all in one go.

1. Load the footage into an editor.
2. Calculate the speed required to remove the duplicate frames:

$$[(\text{Number of sequential frames without a duplicate} + 1)/\text{Number of sequential frames without a duplicate}] \times 100$$

For example, if there is a duplicate frame after every three frames, then your speed will be $(4/3) \times 100 = 125\%$.

3. Apply a speed-change with the calculated value. It's critical that the speed-change uses a drop-frame method (rather than a blend or motion-estimation method); if this is not an option, you'll have to resort to removing the frames manually, one at a time.
4. Render the final sequence.

> **TIP**
> This method only works where there is only one duplicate frame at a time. If the duplicate frames are repeated more than once, you'll need to run this process several times.

Figure 10.14

How to Regenerate Missing Frames
The slow-mo process can be used to replace missing frames.

There are several cases where you may need to recreate frames:

- The original frame has been damaged
- The shot was accidentally sped up
- An editorial or data error has accidentally removed the frame

To regenerate a single missing frame (Figure 10.15):

1. Load the sequence.
2. Save the frame on either side of the missing frame.
3. Follow the technique on page 173 for slowing down a shot to generate the intermediate frame.
4. Cut the new frame back into the shot.

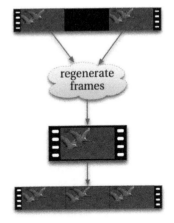

To regenerate concurrent missing frames (Figure 10.16):

Figure 10.15

1. Load the sequence.
2. Follow the steps above to generate the middle missing frame. For example, if there are three frames missing from a shot, this process will give you the second missing frame.
3. Using the newly generated frame, repeat the process as needed to rebuild more frames. For example, you can use the second missing frames along with the two originals to generate the first and third frames from a group of three.
4. Repeat as needed and then cut the new frames back into the sequence.

> ### TIP
> If the original frame exists but is damaged, it is generally better to try to salvage as much of it as possible, perhaps combining a cloning process with this technique, rather than trying to regenerate the entire frame.

If the problem frame is at the beginning or end of a shot (and without any handle frames available), you're pretty much out of luck, although you can try using a motion-estimated speed

Figure 10.16

change. Alternatively, you can extend the previous or next shot by one frame if possible, or, as a last resort, just duplicate the adjacent frame.

Flicker

Synonymous with old motion pictures, flicker can occur for a number of reasons:

- One of the light sources was flickering during the shot
- The frequency of the light source was lower than (or out of phase with) the camera photographing the scene (this is particularly typical when photographing television screens)
- A digital filter or compression method went awry

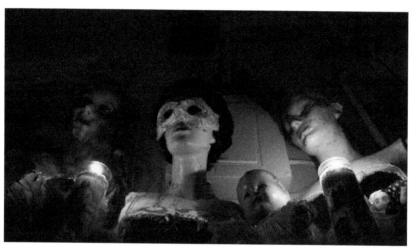

Figure 10.17 *Shooting a scene lit by candlelight can result in flickering images.* © *Doug Bowman.*

In some cases the flicker may enhance the mood of a scene, but in other cases it is undesirable and distracting.

How to Reduce Flicker
Flickering can be diminished using some simple color correction.

Although there is software dedicated to reducing flicker, doing so manually is actually a very simple process. Images flicker because the overall luminance changes very irregularly over a short period of time. Most light sources do not behave this way naturally (with the noticeable exception of fire), and so it is distracting to watch. The process can be reversed to some extent:

1. Load the footage and duplicate it.
2. Apply a desaturation operator to the footage to make it grayscale.

3. Color-correct the footage to equalize it (so that the minimum and maximum values are the same across each frame).

4. Apply a Gaussian blur filter across the footage until there is no discernable detail at all (you may need to apply the filter multiple times to get the desired result).

5. Add another color correction operator, and adjust the midpoint on each frame so that all the frames have the same grayscale value.

6. Copy the adjustments you made back to the original footage.

 a. Some systems allow you to nondestructively layer operations on top of each other. When using such a system, there is no need to copy the changes back; simply deactivate all the operations except for the final color-correction.

7. At this point you may discover that the color component of the footage is still flickering, in which case you should repeat the process without desaturating the footage and adjust the hue on every frame.

> **TIP**
>
> Be aware that you may introduce additional artifacts, such as clipped highlights and crushed blacks, if there is insufficient headroom in the original footage.

8. Finally, tweak the color as needed to maintain continuity between the frames.

9. Render the result.

Figure 10.18

Motion Blur

Motion blur is caused by something moving from one point to another during the time the camera was photographing a single frame. In the image, the movement gets exposed in its entirety, causing a blur. During a shoot, the amount of motion blur can be controlled by changing the shutter: a shutter that is open longer will record more motion (and thus more motion blur), while the reverse is true for a shutter that is open for a shorter time.

Too much motion blur can cause a shot to look soft, while too little can make the motion look stochastic. This is typically exploited for stylistic effect, but on some occasions it becomes apparent that a shot has more or less motion blur than is desired, and must be fixed.

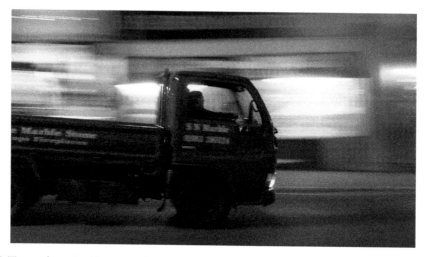

Figure 10.19 *Too much motion blur can stylize a shot or ruin it.* © *Andrew Francis (www.xlargeworks.com).*

How to Add Motion Blur
Simulating additional motion blur can be simple.

1. Load the shot (with handles if possible).
2. Duplicate the shot twice so that there are three copies of the shot layered on top of each other.
3. Slip the second layer backward by one frame.
4. Slip the top layer forward by one frame.
5. Set the blending modes of the layers to screen (you can experiment with other blending modes as well) and reduce the opacity of the top two layers to suit.
6. Render the new version.
7. To increase the effect, run the process again, using the previously rendered output.

Figure 10.20

How to Reduce Motion Blur
Unfortunately, there isn't a foolproof way to remove motion blur, but you can use this technique to at least reduce its impact.

1. Load the footage.
2. Duplicate it so that there are two copies layered on top of each other.

3. Apply an emboss filter to the top layer. Adjust the settings so that the desired details (such as the edges of foreground objects) stand out.

4. Set the blending mode of the top layer to vivid light (assuming your application supports this mode; otherwise, you'll have to experiment with other types), and adjust the opacity so that the details stand out.

5. Unfortunately, doing this will increase the noise of the image significantly, so you now need to use one of the noise reduction techniques from Chapter 6.

6. For best results, combine the new footage with the original using masking and cloning techniques.

7. Render out the sequence.

Figure 10.21

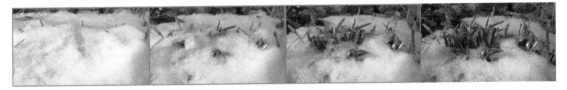

Figure 10.22 *Earth © BBC Worldwide Ltd 2007.*

How to Get Great Time-Lapsed Shots
Getting great-looking time-lapse shots requires combining several techniques.

Time-lapse shots are often simulated using visual effects rather than shot on location, partially because doing so provides greater control over the end result. Time-lapse material created in-camera can suffer from lots of flaws and thus can be visually distracting if not treated properly.

When done right, though, camera time-lapse footage can look stunning, vastly superior to its artificial counterpart. If you have a time-lapse sequence, follow these steps to get the best out of it.

1. Load the footage and play through it, noting all of the issues that are apparent. Generally, it's best to tackle the most obvious problems first.
2. For the motion to be smooth, the first consideration is that all the frames are available (at least to begin with). Time-lapse sequences are created by exposing single frames at a regular interval. If there are frames that were skipped from the sequence, you will need to regenerate them using the technique on page 179.
3. If there are any frames that exist in the sequence but are completely unusable (for example, if someone walked into the shot), remove them and regenerate the frames using the technique on page 179.
4. If there appears to be any camera shake when playing through the sequence at this point, address this next, using the techniques in Chapter 3.
5. If there are any frames that are partly unusable (for example, if a fly landed on the lens), use cloning techniques to fix them.
6. If the sequence appears to flicker, follow the instructions on page 181 to reduce the flicker.
7. If the sequence now appears stochastic, add some motion blur as described on page 182.
8. Color-correct any remaining discrepancies.
9. Retime the sequence as required.
10. Render the result.

Figure 10.23

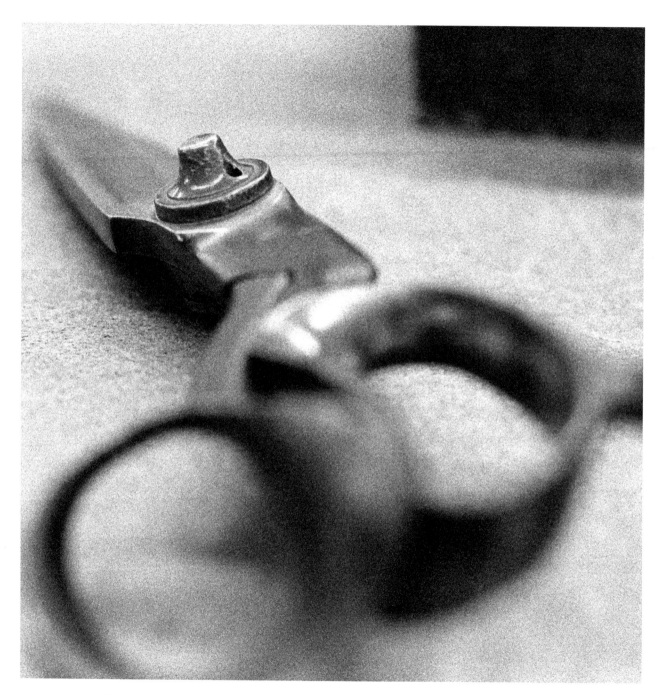

Figure 11.1 © *Andrew Francis (www.xlargeworks.com).*

Chapter 11
Fixing Editorial Problems

"One of these things just doesn't belong here."
—Esthero

The editing phase of postproduction can be a logistical nightmare. There are hours of footage, multiple shots per scene, and multiple takes per shot. If a single frame of a single take is dropped from a production, the consequences can be disastrous. All of this is compounded greatly by the fact that there will inevitably be multiple "final" cuts per production (it's not uncommon to be faced with an edit titled "NEW final final cut 2").

The first part of fixing editorial problems therefore involves developing thorough organizational principles. Some people use notepaper to do this, others use spreadsheets and sophisticated software. However you choose to keep track of things, the most important thing is to be able to develop an intricate knowledge for locating information about any elements of the production (refer to Appendix 1 for some organizational tips).

How to Maintain Continuity
Continuity is one of the basic tenets of editing, but sometimes things can go awry.

1. Load the entire scene into an editing system.
2. Check for shots where the line of action is reversed, for example, a character facing left in one shot is facing right in the next. These can usually be resolved by flopping the shot.
 a. If there are visible logos or other elements that are obviously wrong when reversed, use the technique in Chapter 9 to replace them with those that have the original orientation.
 b. Certain camera angles require flips (along the horizontal axis) rather than flops. Use whichever method seems appropriate.
3. Check for shots where the color is inconsistent, such as two shots of the same subject where one of them is darker than the other. Correct these using the color tools at your disposal.

4. Similarly, check for differences in picture quality. Sometimes they may not be noticeable, other times a very grainy shot might stand out like a glowstick in a dark boardroom. Resolving differences in picture quality is not a simple task. Often you'll be able to improve the visible quality by a marginal amount by following some of the strategies throughout this book, but ultimately you'll have to decide between replacing the low-quality shot and, as a last resort, degrading the quality of the surrounding shots so that the difference is less noticeable.

5. Check for shots where there is duplicate action. For example, in one shot a door may close, and then in the next shot the same door closes again. Depending on the severity of the problem (and how it impacts the main action), these can be resolved by trimming one of the shots. For more extreme continuity errors, it may be necessary to use an alternate take; otherwise, you'll just have to live with it.

6. Check for shots where there is missing action. For example, did someone sit down at a table without first sliding the chair out? Sometimes these types of issues can be resolved by extending a shot or inserting new footage, but sometimes they can prove problematic, especially if the footage does not exist. In the latter case, you can imply that the action happened off-screen. In the example of the character sitting at a table, you could cut to a shot of something else between the character standing and then sitting down, which becomes more convincing if you insert the sound of a chair being slid out during the inserted shot.

7. Save the completed sequence.

Needless to say, any changes to the edit, especially those that involve modifying cut points, should be approved by the picture editor. There are other factors to consider when changing the length of a shot, such as how it will affect audio sync, reel lengths, and the overall production duration. For this reason it is usually preferable to slip edits to minimize the impact of the changes: when extending a shot, trim the adjacent shot, and vice versa.

Figure 11.2

> **TIP**
>
> Careful use of audio can cover a range of continuity errors. If something looks strange (such as the same door closing twice in a row) but doesn't sound strange (we hear the door closing only once), we tend not to notice it. By the same token, ensuring audio continuity is just as essential as ensuring picture continuity, especially in terms of foley, background sound, and dialogue tonality. Refer to Chapter 7 for more on audio continuity.

How to Correct Flash Frames
The easier flash frames are to spot, the harder they can be to remove.

Single frames that stand out from the rest of the frames of a shot in some way are referred to as flash frames due to the fact that when you watch the footage at speed, it will appear to flash on the problem frame. Spotting them is part of the problem; deciding on the best way to remove them is the other part.

1. Load the sequence and identify the problem frame.
 a. Some flash frames are easier to spot if you run the footage slightly slower than real time.
2. Many flash frames are caused by render or editorial errors, particularly if the footage has undergone any previous processing. If that's the case, return to the original footage and re-render it.
3. Some flash frames occur on the last (or first) frame of a shot, and are caused by insufficient footage for the edit. In this case, it may be possible to simply trim the rogue frame, or else slip the entire shot by a frame.
4. Some flash frames can be remedied by color-correcting them to make them match the adjacent frames.
5. In all other cases, cut out the flash frame and follow the procedure in Chapter 10 for regenerating missing frames.

Figure 11.3

Figure 11.4 *A flash frame just before a cut or one after the cut is usually an indication of a color correction that is out of sync with the edit. This can usually be resolved by re-outputting the footage from the color correction system, although it may be symptomatic of a sync problem elsewhere.*

How to Remove Invisible Edits
Though invisible edits are not necessarily problems, removing them is a good practice to follow.

An invisible edit is a point where there is a cut embedded into what appears to be a single shot. For example, after conforming a sequence of three shots from an EDL, you may discover that there appear to be four separate shots (although the sequence itself is correct).

Invisible edits are a symptom of working in the digital realm. It's entirely feasible for an editor to edit two shots together and render them as a single file, which then gets loaded into a different system. Unfortunately, the new system has no knowledge that the new shot is actually composed of two separate shots. This may not cause any issues from a pragmatic point of view but should be corrected nonetheless, as it will help from an organizational perspective.

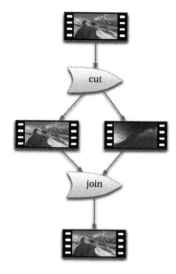

1. Load the footage into an editing system.
2. Cue to the point where the shot changes.
3. Cut the shot at that point.
4. Render out each new element separately.
 a. You'll probably need to recut these two separate shots back into the main sequence, replacing the one with the invisible edit.

Figure 11.5

Soft Cuts

Soft cuts are like invisible edits, except they dissolve into each other, usually over the course of one or two frames. They are typically caused by bad video dubs between different video formats where frames get averaged together. It's not possible to fix these, save for cutting out the frames in question, so unless you have a copy of the original footage, you're stuck with them.

Figure 11.6 *Earth © BBC Worldwide Ltd 2007 A soft cut across a couple of frames in a sequence.*

How to Troubleshoot Dissolves
Fades can be the source of all sorts of problems.

Perhaps the most important thing to note is that you cannot reverse dissolves (or fades, for that matter) once they have been baked into the footage. Dissolves are a destructive process and thus are usually left until the end of postproduction.

The following process deals with problems related to dissolves created within an editing system just prior to rendering.

1. Load the sequence into your editing system and play through the dissolve in question.
2. If the dissolve appears to pop at the beginning or end of the fade, that's a sign that the footage used to build the dissolve is incomplete. For example, a pop at the start of a dissolve indicates that the start of the incoming shot is missing. Separate the two parts of the dissolve and step through each frame to determine where the problem lies. You may discover that there were not enough frames provided to complete the dissolve and will therefore have to recapture the shot with additional handles.
3. Sometimes there are no additional handle frames available to create the dissolve fully. You have a few choices in this case:
 a. Shorten the duration of the dissolve to include just the available frames.
 b. Trim one of the shots.
 c. Repeat frames to generate additional source frame.
 d. Perform a timewarp on the footage to slow it down just at the point where it's missing footage to generate additional source frames.
4. Sometimes the dissolve just inexplicably looks wrong, and it has nothing to do with the timing. In that case, it's likely that the type of fade being used won't work with the material you're using. Most editing systems offer at least a couple of different fade algorithms to use, so try using a different one. For example, try using an additive dissolve rather than a linear one.
5. Save the changes.

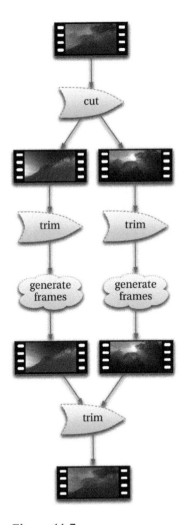

Figure 11.7

How to Create a Custom Transition
Digital systems allow you to create any sort of transition you can imagine.

1. Load the two shots and layer them together so that they overlap as you want the transition to appear.
2. Keyframe the outgoing shot with the process you would like to use, starting from the first frame of the overlap and ending on the last frame of the overlap. Reverse this process for the incoming shot.

 a. To perform a dissolve, simply keyframe the opacity of the top layer. Use different blending modes to produce different effects.

 b. To blur one shot into the other, keyframe the first shot to go from no blur to maximum blur, and the second shot to go from maximum blur to no blur.

 c. To create a white-out transition, color-correct the first shot to go from normal brightness to maximum brightness, and the second shot to go from maximum brightness to normal brightness.

 d. To create a custom wipe, keyframe the size and/or strength of a key or mask so that the first shot starts with no mask and ends up completely masked (the second shot should be on a lower layer and remain untouched, thus being revealed by the animated mask).

 e. You can also create push-wipe type transitions (where one shot appears to push the other) by keyframing the size and position of each layer over the course of the transition.

 f. Experiment with combining different processes.

3. Render the result.

Pull-downs

It is difficult to convert between different formats while maintaining the integrity of each frame due to the differences in the frame rates of the various formats. If you want to output film footage, which runs at 24 frames per second, to NTSC video, which runs at 29.97 frames per second, you can simply

> **TIP**
>
> It's never a good idea to attempt to color-correct material after a fade has been applied. The reason is that you end up applying the same correction to both the outgoing footage and the incoming footage, which means that you can end up with flash frames at the end of the fade, or (particularly if you're using shapes or keys as part of the correction) ruin the other shot's color. If you absolutely must color-correct a fade, use keyframes to effectively fade the effect of the correction in sync with the editorial fade.

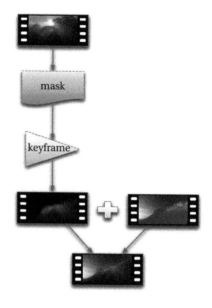

Figure 11.8

192

retime it, which (if you use an interpolative retiming method) can produce smooth playback, but each frame is now different from the original it was created from (and thus the original frames cannot be recreated from the new version).

Situations where you need to preserve original frames but still have playback occur at the correct speed require a pull-down. A pull-down changes the speed of the footage by duplicating fields in a pattern (known as its cadence) so that the sequence as a whole runs longer. This makes it possible to recreate the original footage by performing an inverse telecine (IVTC), which reverses the pattern to restore the original sequence of frames at the original frame rate.

Different pull-down methods may be used for the same conversion, each with varying degrees of smooth playback (see Table 11.1).

Table 11.1 *Different Pull-down Methods*

Original Frame Rate	New Frame Rate	Pull-down	Cadence
24	30	2:3	[AA][BB][BC][CD][DD]
24	30	3:2	[BB][BC][CD][DD][A'A']★
24	30	2:3:3:2	[AA][BB][BC][CC][DD]
24	30	3:2:2:3	[AA][AB][BC][CD][DD]

★Note: A 3:2 pull-down is essentially identical to a 2:3 pull-down, but uses the B-frame as a reference point.

Figure 11.9 *A 3:2 pull-down used to create 30 FPS footage from 24 FPS source material.*

Figure 11.10 *An inverse telecine used to restore a 24 FPS sequence from a 3:2 pull-down.*

There are some loose ends still left to deal with:

- NTSC runs at 29.97 frames per second, so a reverse telecine from 29.97 will result in footage that runs at 23.976 frames per second rather than 24.
- There is no pull-down method to go from film at 24 frames per second to film at 25 frames per second. The common solution is to run the film footage frame for frame and speed up the audio by 4% to compensate for sync problems. Alternately, it is possible to duplicate a field every 12 frames.
- There is no pull-down method to go from NTSC to PAL. The solution is to perform an NTSC-to-film pull-down and run the resulting footage frame for frame and speed up the audio by 4%.

How to Reverse a Pull-down
Telecine judder, when playback is not smooth, is a telltale sign of video that has a pull-down that can be removed.

The addition and removal of pull-downs are usually handled automatically by editing systems, but all too often pull-downs can be burned-in to the footage, requiring a manual inverse telecine to be performed. There are several key pieces of information you'll need to get started:

- The frame rate of the source footage
- The frame rate of the current footage
- The cadence
- The corresponding A-frame

If you don't know the cadence of the footage, you can usually figure it out by analysis:

- Are there two frames or three frames making a single frame?
- Where does the timecode change (this will tell you where the frame boundary is)?

Jot down the pattern across several frames and you should be able to find a matching cadence and pull-down method.

1. Load the footage.
2. If there are invisible edits, remove them using the process above and treat each new clip separately.
3. Separate each field into a new frame (your system may be able to do this automatically):
 a. Retime the footage to 50% of its original speed (without using interpolation).
 b. Perform a cut on every single frame.
 c. If the footage has an upper-first field order, go to the first frame and mask out every odd-numbered line in the image, and do this for every alternate frame. Then go back and mask out every even-numbered line of every other image (do the opposite for footage with a lower-first field order).
4. Ripple-delete any duplicates. For example, if you determine that your footage is using a 2:3 pattern, ripple-delete one of the B-fields (for instance, the third frame counting from the first A-field) and one of the C-fields in the first grouping, and likewise for every other grouping.
5. Swap frames that are now in the wrong order. For example, if the footage has an upper-first field order and there are two upper-first fields next to each other, swap the second one with the field following it.
6. Layer each pair of fields together.
7. Render out the sequence.

Figure 11.11

If you're going to spend any amount of time using this technique, you should learn how to automate the process as much as possible (for example, using tools like AppleScript or Adobe Photoshop's actions). Although the process is conceptually very simple, it is also incredibly labor-intensive, and as much as possible should be done to reduce the time you need to spend on it.

Multiple Pull-downs

It's perfectly common to discover that a sequence contains a combination of shots that contain pull-downs along with those that don't. This can occur for a variety of reasons, such as footage originating from different sources or editing systems incorrectly (or incompletely) applying pull-downs and inverse telecines as part of some other process.

With that in mind, it can be worth returning to the original source material to see if it exhibits the problem, rather than spending much more time trying to undo it.

How to Convert 24 FPS Footage
It's uncommon to work at 24 frames per second, even for film-based projects.

This conversion technique assumes you want to retain the quality of each individual source frame so that it can be reversed later on if need be. In all other cases, simply use a speed change (discussed in Chapter 10) to generate new frames at the desired frame rate.

1. Load the 24 FPS footage into an editing system.
2. Convert it into your working frame rate.
 a. For 23.976 FPS (such as 1080p23.98 HD video), change the frame rate metadata to 23.976 (it may be labeled as 23.98).
 i. If there is an audio component to the clip, it will need to be slowed down by 1% to stay in sync.
 b. For 25 FPS (such as PAL), change the frame rate metadata of the source file to 25. Provided your system does this without forcing the footage to be retimed, you will end up with a clip that has a shorter duration, but every frame will have been preserved.
 i. If there is an audio component to the clip, it will need to be sped up by 4% in order to stay in sync.
 ii. If you absolutely must ensure the same running time, you can apply a pull-down duplicate one frame every second (or better, one field twice every second).
 c. For 30 FPS (such as 1080i60 HD video), apply a 2:3 or a 2:3:3:2 pull-down.
 i. A 2:3:3:2 pull-down will produce smoother playback, but some editing systems may not detect it correctly if it needs to be reversed.
 d. For 29.97 FPS (such as NTSC), first convert to 23.976, as described above, and then apply a 2:3 or 2:3:3:2 pull-down.
3. Render out the result if necessary.

Changing Frame Rate Metadata

Depending upon the specific file format, the base frame rate of a clip is usually stored as a metadata value inside the file. Changing this may be as simple as opening the file and selecting an option to view the file's properties, or by opening the file and resaving it with the new settings. For example, DV files can be opened in QuickTime Pro and the frame rate adjusted by saving the file as a different format. This process should not require re-rendering and therefore can happen quite quickly.

If all else fails, convert the clip to an image sequence using the process in Appendix 1, which can be re-interpreted by loading into a project using the desired frame rate.

How to Troubleshoot Timecodes
Timecodes are often a source of problems, but fixing them early on can prevent bigger problems from occurring later.

One of the most common (and infuriating) problems encountered in video postproduction involves timecodes, from being unable to capture footage from tape due to timecode breaks to not being able to sync shots correctly.

These problems are typically caused by faults on the source tape damaging the timecode track in some way. What makes many of these problems so frustrating is that the audio and pictorial can be completely fine, and yet the editing system will refuse to work with them without producing errors. The good news is that with the right tools, many of the issues can be fixed.

1. If you're unable to even digitize the footage (try using a variety of software and settings to attempt to get the footage digitized), you will need to dub the tape first, and then capture from the dubbed tape.
 a. Jot down the timecode of a frame known to be accurate (for example, a punch-hole or leader frame usually has a specific timecode) at as many points in the tape as possible.
 b. You may need to dub the tape using internal timecode generation (this function is normally labeled as INT on the tape deck) to ensure that a consistent timecode is created on the newly dubbed tape. This will create new timecode that probably has no resemblance to the original, but we'll fix that later.
2. Load the digitized footage into an editing system. Set the start time of the timeline to coincide with the start timecode of the captured tape, and cut the footage in accordingly. For example, if the first frame of bars is known to be at timecode 09:59:30:00, set the start of the timeline to have this timecode, and then cut the footage so the first frame of bars is at the start of the timeline.
3. Do spot checks of specific frames to make sure the timecode of the timeline matches the original frame. Compare any differences between the original tape in a tape deck, as well as any copies

the picture editor has been working with. Trim the footage in the timeline to fix any problems (you will typically need to insert one or more frames of black in problem areas, and very rarely, trim out rogue frames).

 a. If the timecode drifts significantly, it is possible that the footage may need to use a different timebase. Calculate the differences in duration between the timeline and the reference video to see if a simple adjustment to the frame rate can be made.

 b. In the worst case, it may be impossible to correctly re-create the correct timecodes (for example, due to timecode faults during the picture or audio editing stages). In this case you will need to ignore the timecodes completely and rely on eye-matching the shots to get the correct cut points.

4. Render out the timeline.

 a. It is essential that the render settings use exactly the same settings as the original video format, or you will introduce compression or other artifacts.

 b. Make sure the render writes the timeline timecode into the track of the new file. Some file formats do not support embedding timecode tracks during rendering, in which case you may need to use a different format.

Conforming Timecodes

One of the parts of postproduction where ensuring timecode accuracy is critical is when conforming the final picture EDL from source footage. Conforming is normally an automated process that works for the most part by matching reel numbers and timecodes. If they do not match exactly, the wrong frame, or even the wrong shot, will be conformed into the final sequence.

The fact that these mismatches occur fairly often is one of the reasons why it's not merely enough to rely on an EDL from the picture editor. Your eyes become your most useful tools here, and it is far more common to match footage based on an offline reference video than a list of timecodes.

How to Patch Frames
The process of patching frames is simple but is best left until the end of post-production.
Toward the end of postproduction, you're likely to encounter issues for which a quick fix is all that's practical (and if you're being pragmatic, necessary) considering the time available. For instance, if you discover that a dissolve performed at an earlier stage in the process has a flash frame, good practice would dictate that you return to the system where the dissolve was initially constructed, fix the problem at the source, re-render it, and push the new shot through the chain. All of which may not be possible if it has to be fixed in the cut within 5 minutes.

So sometimes you have to fix the problem in place. In the case of the flash frame, that means color-correcting the frame so that the flash is imperceptible, and then cutting the new frame back into

the finished sequence. This process is known as patching, and it usually applies to individual frames rather than clips. It's commonly used to correct flash frames, or film damage noticed at the last minute. Overusing this approach will lead to a finished sequence that cannot be easily adjusted, which is why it is best left until the end of postproduction.

1. Open the finished sequence in an editor.
2. Mark in and out points around the frames to be replaced, and render the region.
 a. If you will be using cloning or similar techniques, remember to include sufficient frames on either side of the problem area as a cloning source or for reference.
3. Load the newly rendered images and correct the problem.
4. Render out the fixed set of frames.
5. Cut the new frames back into the sequence, overwriting the problem ones.

Figure 11.12

EDL Mathematics

Sometimes when working with EDLs, it becomes necessary to perform calculations on the numbers in them in order to make changes outside of an editing system. For example, it is common to take an EDL created for a 25 FPS project and use it to determine timecodes for the equivalent cut points at 24 FPS. The best way to do this is to use a spreadsheet and manually edit the changes there, or you can use software such as Synaesthesia by Surreal Road (synaesthesia.surrealroad.com) to do it for you.

Figure 11.13 *Synaesthesia by Surreal Road.*

Appendix 1

Basic Strategies

Working with digital media can be very daunting. Every time I start a new project, I pretty much have to re-think my approach, due to the fact there will have been so many technological advances and changes since the last one. Disk space for example, will always be cheaper, faster, and more portable than the last time. Almost overnight, a workflow based upon digital tape storage can become redundant, with external disk drives suddenly posing unique advantages over digital tapes. However, there are always certain practices that remain useful, and regardless of the details, the underlying principles are what enable you to make informed decisions on the best course of action.

Digital Assets Management

During digital post-production, you'll generate a *lot* of data. Even if you only work with audio, you'll turn over many gigabytes of sound files and related data over the course of working on a single project. As well as being good at what you do in terms of finding and fixing faults and making improvements, you also need to be good at *how* you do it. If you are well organized, you'll spend less time back-tracking and searching for things, and more time doing the fun stuff.

The first stage to being organized in the digital realm is having a structured approach to managing your digital *assets* (in other words, the media, metadata, reference material, and so on, that are related to the production). You should be comfortable working with the file management tools provided by your operating system (*Explorer* on Windows, *Finder* on the Mac), and employ an indexing system using files and folders that is not only easy for you to follow, but is for others as well (I normally write a short *cheat sheet* at the start of a project which lists how and where to find different elements on disk, primarily suited for other people on the team to comprehend, but which becomes increasingly useful to me as well as the complexity of the project starts to grow).

Naming Conventions

Establishing *naming conventions* are probably the simplest and most logical method to organizing data. The idea is that you define a sort of template structure of files and folders, and then apply the structure to all the data.

For example, a popular method is to use:

/scans/reel#/resolution/frame#.ext

So that frame 1200 from reel 40, scanned at a resolution of 2048 by 1556 pixels becomes:

/scans/040/2048 × 1556/01200.dpx

Instead you could use a variation of this system, perhaps organizing by shot number:

/shot#/tk#/scan/frame#.ext

The important thing is to decide on a convention early on, and be sure to *stick to it*. The absolute worst thing you can do is come up with a system for filing shots and then decide halfway through that it's inferior to another method which you then adopt from that point on. Suddenly you'll find yourself in a less organized state than you would have been without *any* system in place.

Backups

If you haven't been in a situation where you've regretted not making backups (or not making them often enough) you're either doing it already or long overdue for something to go wrong. Seriously, no matter how well-prepared you think you are for problems, something can always happen to test your preparation.

In some cases it's not practical to backup everything, due in part to the sheer volume of data as well as the corresponding time required to manage the backups. On some productions, such as video-based ones, the original source material (i.e., the video tapes) can act as a backup of sorts, because if anything goes wrong with the digitized data, it can always be redigitized. However, this itself can be an easy trap to fall into, as redigitizing footage can take significantly longer than merely copying data, and the digitization process is by no means completely automated (especially in the case of scanning film). In addition, there is a strong argument for only ever digitizing from source once, as it each time can potentially degrade the media.

Ultimately, the most important (and most often overlooked) data to backup can be the project files and metadata used at various stages of the process (such as the editing system projects, compositing scripts, and so on). Although technically these can be recreated, doing so can require every bit as much effort as shooting the scenes in the first place, and given that these files often comprise the smallest volume of data in a project, it seems negligent *not* to back them up as regularly as possible.

As a final point on the subject of backups, you should also consider making *off-site* backups when possible. These ensure that should anything go wrong at the post-production location, you will still have a viable backup. These days, one of the most cost-effective methods for making automated, fast off-site backups can be using an internet-based service, especially for smaller files and metadata.

Version Control

After scheduling regular backups, the most important thing you can do is set up some sort of *version control* system. This is a system whereby you must *check out* files to make changes to them, and then *check in* the changed files. This fulfills several important tasks. First, it allows you to *roll back* changes you've made to previous versions (thus fulfilling the role of rudimentary backup system as well). Second, it prevents two people from independently changing the same footage at the same time, as you cannot check out data which has been checked out by someone else. Third, it provides an audit trail of every change ever made, as everything can be annotated. At a glance, you could look at a single frame and see its entire history, from acquisition to final output. And finally, it provides *authority* on what's considered the final version. At any point, you log into the version control system and there's the latest version.

The concept of version control applies to all digital assets, both in terms of the footage itself, and also project documents, EDLs, and so on. Historically, the disk space requirements of digital productions made version control a luxury no one could afford. Now however, with the cost of disk space per terabyte so low, it's a worthwhile investment that will hopefully become adopted on all manner of productions.

There are many different methods for version control. Many free systems are available, and there are also commercial products that cater specifically for media files, such as Avid's *Alienbrain* (www .alienbrain.com).

Asset Libraries

One of the really good things about analogue systems is that you can easily get a visual reference of what's on them. For example you can place a strip of film on a lightbox, or put a video tape in a player. In the digital domain, this is not quite so straight-forward.

First of all, digital media is not always kept *online*. The amount of data and the non-linear nature of post-production means that it's often necessary to cycle data on and off of different systems. In addition, work may be undertaken at multiple locations, in which case it's rare that one location will have an up-to-date copy of all the data.

Second, there may be issues encountered due to the formats used by digital media. Film scans, for example, tend to be stored as high-resolution image sequences, which are not appropriate for, say, playing back on a laptop.

For all these reasons, it can be worth constructing a virtual asset library, that provides convenient, visual representation of all the media used in the production. Doing so usually involves making low-resolution, compressed copies of the footage and audio (usually to a common format). It need not be sophisticated; in fact, I routinely use the simplest freely available software I can find for this purpose, as it increases the likelihood that it will work on whatever system I need to use it on (you should also aim to use cross-platform software if you're working in a cross-platform environment).

The main aim when building a reference asset library is ensuring that it provides an accurate representation of all the data in the production. This means that any new versions that are created should be added to your library. It may also be worth *burning-in* pertinent data (such as timecodes) to the images to make the reference even more useful.

> **TIP**
>
> Regardless of whether you choose to use an asset library or not, you will often need to create *proxies* for your media. Proxies are copies of the original media but encoded at a lower quality, to allow playback on less powerful display. For instance, it's common to create proxies of film scans for offline editing.

Conforming

A big part of data management in post-production involves *conforming* it all successfully. Conforming is the process of assembling the various elements together to build the *master* version which is then used to produce all the different *distribution masters* (for instance, the DVD and digital cinema masters).

In theory, the conforming process happens once (typically after picture editing has been completed but before color grading begins), and happens automatically. In practice though, the reality of various revisions to the final edit, as well as time constraints, will mean that conforming must be done at several key points. And although much of the process can be automated, supervising the conforming of all the data normally ends up being a full-time job.

Conforming digital video is normally accomplished by matching reel number and timecodes (or clip shot numbers and takes) to an EDL produced from the final (and revised final) offline edit. The key thing to bear in mind when conforming data is that the EDL will rarely have any direct reference to the actual data to be used. For example, the EDL might point you to use *046A take 7*, but this will almost certainly refer to what was *shot*, rather than the latest digital version, which will likely (particularly if you've been using the techniques in this book) have become something else (for example, *046A_tk7_repaired_graded_cropped*) and therefore will not conform automatically. The solution to this problem will depend upon the specifics of your conforming system, but it is

likely you will either have to substitute the source material with the fixed version, or else modify the conform EDL and other parameters to point to the new data instead of the source material, either way requiring a great deal of delicate data management to ensure nothing goes awry in the process.

Conforming digital audio is potentially even more problematic, because there may not even *be* a timecode reference in some cases. However, most audio post-production is done on a single system, and so it may not even be necessary to conform it at all. In addition, a lot of the time the full-quality audio source is used directly (even at the editing stage) and so it may even be possible to output the full-quality, cut-together audio directly from the offline editing system (although this should be considered a worst-case scenario).

Collaboration

The bigger the production, the greater the need collaborate with others. Without a doubt, the most effective tool for collaboration is the Internet, whether used as a communication method or even for scheduling and project management. There are a great number of applications that use the internet for things like synchronization, and these can be incredibly helpful in getting organized.

Even if you're without Internet access, communication is the key to success. If people are working on data in remote locations, there should be a single reference point which is considered the *master* source, or else you run the risk of having a degree of uncertainty over which set of data is correct. Again, this should be combined with a good version control system for the best collaborative experience possible. In fact, one of the best methods for combining version control, off-site backup and still allowing for collaboration is to use a system such as Amazon's S3 storage service (aws.amazon. com) in conjunction with a version control system.

> **TIP**
>
> For the digital intermediate for *Earth*, we made use of the free *Google Docs* to log information related to the final cut and related footage in an annotated spreadsheet that was constantly synchronised between everyone using it. There was no question of whether or not people had access to the most up-to-date information, which simplified things a great deal. Similarly, we used *Google Calendar* with similar results for scheduling events.

Non-destructive Workflows

Non-destructive, or parametric workflows allow changes to be made without committing them (or baking them in) until the end. The basic idea is that all changes, such as color correction and scaling, are stored as metadata rather than actually modifying the source files. The benefit is that anything can be adjusted at any time, but the trade-off is that it requires a lot of computational power

to apply the changes fast enough to enable accurate and real-time playback. In reality, parametric workflows are possible in small pieces. For example, within the context of a paint program, it may be possible to not have to commit any changes you make until the point where you render the new footage out. However, for the editing system to be able to show the changes, the sequence will need to be rendered and reloaded. In general, every time you need to use a different system, you'll probably have to render what you've done so far, at which point it gets baked in. You should therefore strive for a nondestructive approach where possible, and consider every time you render as a sort of milestone (or checkpoint) in the workflow (in other words, a point to schedule a backup).

> **TIP**
>
> In some situations, it may be possible to switch applications without the need to render. For example, the Adobe suite of applications (the same goes for most of the Autodesk and Apple systems as well) allow a great deal of interchange, allowing you, for example, to load a Photoshop Document (PSD file) into After Effects, complete with layers and other properties.

QuickTime Reference Videos

One of the most useful file formats is Apple's QuickTime. Not only does it provide cross-platform support, it also caters for a wide variety of different codecs (and thus, different situations. One of the most useful (and perhaps underused) features of QuickTime is the ability to create reference movies. These are QuickTime movies that point to (reference) other QuickTime movies based upon certain criteria, such as connection speed, CPU power, etc. In practice, the most useful applications of this process are for creating versions for playback on different systems. For example, you could create full-resolution copies of the source footage as single frames, a smaller version for playback on a laptop, and even a version suitable for iPhones, and then a single reference movie to point to each. Depending upon what you're doing, you'll automatically reference the correct version.

> **TIP**
>
> A free utility for creating QuickTime reference movies is available from developer.apple.com/quicktime/quicktimeintro/tools]

Image Sequence Workflows

A very useful workflow to adopt is to use image sequences. The basic idea is that rather than storing a file per clip of footage (as is the accepted method for video editing), a file per frame of footage is stored instead. This method has its roots in film production, as film scans are often stored using this system, but can be applied to any kind of production. To use it, you simply export each frame of footage as a single image. Pay careful attention to how you name the frames. If the original source has a timecode associated with it, it's good practice to name each frame as a number derived from

it's timecode, so that, for example, a frame with a timecode of 01:00:00:01 (at 24FPS) becomes frame number 86401 (remember to pad the numbers with leading zeros as well, making the file-name more like 0086401.tif in this case).

There are several benefits to using a frame-based approach:

- Image editing systems (such as Photoshop) can be used to make quick fixes to frames (rather than needing a dedicated video editing system).
- Footage is better protected from digital corruption (damage will typically only affect a single frame, whereas corruption on a clip file can potentially destroy the entire clip).
- Basic editing can be performed simply by manipulating the files, rather than having to use an editing system (for example, you can simply delete frames to shorten a sequence).
- You can render individual frames in order to fix problems across a frame range, rather than having to render out an entire clip each time.

There are some drawbacks to this approach though:

- The overall volume of data increases dramatically.
- Some systems cannot handle playback of image sequences properly, and even those that can handle playback may suffer some sort of performance hit (you can get around these limitations by using proxies or QuickTime reference movies to some extent though).
- Managing the data becomes much more complicated.

Security

The strengths of digital media can also be its greatest weakness. Working digitally means you can get a perfect copy every time with ease. With video and audio tape, subsequent copies would result in degradation on each copy, as the signal would suffer from *generation loss*, with the *signal-to-noise ratio* decreasing (in other words, there would be more noise introduced) on each copy. With film, an equivalent effect would also apply to each print run of a reel of film, with the added complication that film requires highly specialized equipment and expertise in order to make a copy.

What this means is that it used to be really hard to make a good copy, which, in post-production, is a bad thing. But in terms of preventing a production from being counterfeited, it was actually a good thing. Anyone trying to duplicate a movie and pass it off as the real thing was at a severe disadvantage, as the copies they would produce would almost always be completely inferior to the original, and therefore easily recognized as a fake.

Now however, the situation is markedly different. It's so easy to make a full-quality duplicate of an entire production (in some cases, literally as easy as clicking a button), that protecting the integrity (and investment) of digital assets is more important than ever.

What to Protect

The degree of preventative methods you need to employ (and the level of paranoia you will need to adopt) will depend upon the type of production you're working on. A corporate video will have very different security requirements than an unreleased Hollywood soon-to-be-blockbuster.

The first aspect to consider is the type of elements you need to protect. Consider each of the following: source footage; project files; intermediate files; proxies; audio elements; still images; pre-production material (digital versions of scripts, briefs, storyboards, etc.); and final masters

What you'll probably find is that certain things will never need to be protected from intruders, such as EDLs, because without the context of the footage to go with them, they are largely meaningless. However, some EDLs will carry information related to specific shots in the comments sections, and so the prying intruder (with a lot of time on their hands), the sequence of events of a story being kept under wraps could be revealed through this method; so if you're being really paranoid, it pays to consider every possibility.

The next aspect to consider is how an unauthorized person may gain access to any of these elements: Interception of physical media (for example, getting hold of a DVD sent in the mail); interception of electronic transmission (for example, intercepting emails or satellite feeds); remote access to computer systems (for example, hacking into a computer terminal via the web); and local access to computer systems (for example, having access to a workstation holding digital media).

> **TIP**
>
> There is another aspect of security to consider, which is that intruders may try to cause destruction rather than make copies. It's not unusual for a hacker to break into a system purely to spread a virus, or in some way corrupt or ruin data. Although this can be resolved through a thorough backup policy, the ideal case is to prevent them from doing it in the first place.

How to Protect It

The concept of needing to protect digital assets is by no means unique to the media industry. It's a challenge that is faced by a large number of industries, many of which have a much more critical interest in guaranteeing security (financial and medical institutions spring to mind). The result of this is that there are several different methodologies that can be adopted for use.

Password-Protection

Certain file formats may include a password-protection feature that can prevent access to the contents of the file without supplying the correct password to "unlock" them first. For example, the PDF format inherently supports this type of approach, and so it can be worth routinely password-protecting any files that need to be sent out where there is a danger they could fall into the wrong hands.

The benefit of this type of method is that it can be applied fairly easily, without much technical expertise. However, it may prove unworkable (you wouldn't want to have to supply a password every time you try and access a certain file if you're going to be using it many times in a day. The other problem is that this type of security is often not particularly secure and is therefore more of a deterrent to the average computer user than to someone who actively *wants* to find out what's inside a locked file.

Encryption

A much more sophisticated approach is to use a form of an encryption. Encryption can work in a number of ways, but essentially what happens is that the data to be protected is scrambled in some way so that it becomes meaningless until it is *decrypted*. Typically encryption and decryption requires the use of a digital key of some sort, which is usually in the form of a password (potentially a very long, unmemorable one) but it could also be in the form of a piece of hardware. In very sophisticated cases, the key will be *rolling*, changing over a period of time. Some financial institutions use this method, providing you with a fob which displays the correct key at the press of a button.

Encryption can apply to stored data or transmitted data. For example, you can encrypt an entire disk drive, or part of a disk, or even a single file. There are various (and free) utilities for creating encrypted virtual disks (such as the cross-platform *TrueCrypt*, www.truecrypt.org), which allows you to encrypt any number of files which all become unlocked at once. Encrypting transmitted data becomes a little bit more complex, but in many cases, you may already be using encrypted transmission without realizing it. For instance, certain website transactions (typically those that begin with *https*), are usually encrypted automatically, protecting them from prying eyes. There are other technologies, such as virtual *private networking* (VPN) and *secure socket layer* (SSL) which are built into many applications that provide a form of encrypted transmission as part of what they do.

> **TIP**
> As a final note, it's worth pointing out that there is no substitute for good, structured security policies. If you manage a large facility with frequent visitors, then it should go without saying that you set up a system whereby no-one should be able to gain access to anything they are not authorized to.

Appendix 2

Standard Data Resolutions

The following figures are the industry *accepted* digital equivalents for various analogue formats, and the standard formats for several native digital formats. These are typically derived from the average resolving power of each format, as well as using a number that is easy for computers to work with (any number that is a power of two: 256, 2048, 4096, etc.)

Format	Picture aspect ratio	Standard pixel resolution	Pixel aspect ratio
Apple iPod video	1.33	320 × 240	1.0
Apple iPhone video	1.5	480 × 320	1.0
Sony PlayStationPortable	1.76	480 × 272	1.0
SD video (PAL, DV)	1.33	720 × 576	1.067
SD video (NTSC, DV)	1.33	720 × 486	0.9
SD video (PAL, square pixels)	1.33	768 × 576	1.0
SD video (NTSC, square pixels)	1.33	648 × 486	1.0
DVD video (NTSC, 4:3)	1.33	720 × 480	0.9
DVD video (PAL, 4:3)	1.33	720 × 576	1.067
DVD video (NTSC, 16:9)	1.78	720 × 480	1.185
DVD video (PAL, 16:9)	1.78	720 × 576	1.69

(*continued*)

Format	Picture aspect ratio	Standard pixel resolution	Pixel aspect ratio
Blu-ray	1.78	1920 × 1080	1.0
HD video @720★	1.78	1280 × 720	1.0
HD video @1080 (certain types★★)	1.78	1440 × 1080	1.33
HD video @1080	1.78	1920 × 1080	1.0
DVC Pro HD @59.94i	1.78	1280 × 1080	1.5
16 mm	1.37	1712 × 1240	1.00
Super-16	1.65	2048 × 1240	1.00
"Academy" aperture (2k)	1.37	1828 × 1332	1.00
"Academy" aperture (4k)	1.37	3656 × 2664	1.00
Cinemascope (Squeezed, 2k)	2.35	1828 × 1556	2.00
Cinemascope (Squeezed, 4k)	2.35	3656 × 2664	2.00
Cinemascope (Unsqueezed, 2k)	2.35	2048 × 872	1.00
Cinemascope (Unsqueezed, 4k)	2.35	3656 × 1556	1.00
Full Aperture (2k)	1.33	2048 × 1556	1.00
Full Aperture (4k)	1.33	4096 × 3112	1.00
8-perf "VistaVision" (3k)	1.5	3072 × 2048	1.00
8-perf "VistaVision" (6k)	1.5	6144 × 4096	1.00
Red (16:9, 4k)	1.78	4096 × 2304	1.00
Red (2:1, 4k)	2.0	4096 × 2048	1.00
Digital Cinema (4k)	1.9★★★	4096 × 2160	1.00
Digital Cinema (2k)	1.9★★★	2048 × 1080	1.00

★DVCPRO HD (at 720p60) is actually 960 × 720, with a pixel aspect ratio of 1.33
★★These include DVCPRO HD100 (at 50i), HDCAM, and 1080i HDV formats
★★★Digital Cinema specifications allow for a variety of aspect ratios, but footage must be letterboxed to fit the standard area
This table is kept up-to-date (and annotated) at www.surrealroad.com/research/archives/2005/standard-data-resolutions.

Standard Video Characteristics

The following table lists key characteristics of popular analogue and digital video formats. Figures shown are the maximum supported by the format specification in each case.

Format	Frame rate	Field order	Color sampling	Bandwidth	Compression	Precision
Digital Betacam (NTSC)	29.97	Upper first	4:2:2	90 Mb/s	2.31:1	10-bit
Digital Betacam (PAL)	25	Upper first	4:2:2	90 Mb/s	2.31:1	10-bit
D1 (NTSC)	29.97	Lower first	4:2:2	270 Mb/s	1:1	8-bit
D1 (PAL)	25	Lower first	4:2:2	270 Mb/s	1:1	8-bit
Digital8 (NTSC)	29.97	Lower first	4:1:1	25 Mb/s	5:1	8-bit
Digital8 (PAL)	25	Lower first	4:2:0	25 Mb/s	5:1	8-bit
DV-SP (NTSC)	29.97	Lower first	4:1:1	25 Mb/s	5:1	8-bit
DV-SP (PAL)	25	Lower first	4:2:0	25 Mb/s	5:1	8-bit
DVCAM (NTSC)	29.97	Lower first	4:1:1	25 Mb/s	5:1	8-bit
DVCAM (PAL)	25	Lower first	4:2:0	25 Mb/s	5:1	8-bit
DVCPRO (NTSC)	29.97	Lower first	4:1:1	25 Mb/s	5:1	8-bit
DVCPRO (PAL)	25	Lower first	4:1:1	25 Mb/s	5:1	8-bit

(continued)

Format	Frame rate	Field order	Color sampling	Bandwidth	Compression	Precision
DVCPRO 50	29.97	Lower first	4:2:2	50 Mb/s	3.3:1	8-bit
DVCPRO-P	30p	n/a	4:2:0	50 Mb/s	5:1	8-bit
DVD (NTSC)	29.97	Upper first	4:2:0	9.8 Mb/s	22:1 (MPEG-2)	8-bit
DVD (PAL)	25	Upper first	4:2:0	9.8 Mb/s	22:1 (MPEG-2)	8-bit
Betacam SX (NTSC)	29.97	Upper first	4:2:2	18 Mb/s	10:1 (MPEG-2)	8-bit
Betacam SX (PAL)	25	Upper first	4:2:2	18 Mb/s	10:1 (MPEG-2)	8-bit
HDV @720p	25p, 30p	n/a	4:2:0	25 Mb/s	22.5:1 (MPEG-2)	8-bit
HDV @1080i	25, 30	Upper first	4:2:0	25 Mb/s	22.5:1 (MPEG-2)	8-bit
DVCProHD-100	25, 29.97, 29.97p, 30, 30p	Lower first	4:2:2	100 Mb/s	6.7:1	8-bit
HDD5	23.98p, 24p, 25, 25p, 29.97, 29.97p, 30, 30p	Upper first	4:2:2	250 Mb/s	4:1 (8-bit), 5:1 (10-bit)	8-bit, 10-bit
HDCAM	23.98p, 24p, 25, 25p, 29.97, 29.97p, 30, 30p	Upper first	3:1:1	143 Mb/s	7.1:1	8-bit
HDCAM SR	23.98p, 24p, 25, 25p, 29.97, 29.97p, 30, 30p	Upper first	4:4:4, 4:4:4 (log), 4:2:2	880 Mb/s (4:4:4), 440 Mb/s (4:2:2)	4.2:1 (MPEG-4, 4:4:4), 2.7:1 (MPEG-4, 4:2:2)	10-bit

(continued)

Format	Frame rate	Field order	Color sampling	Bandwidth	Compression	Precision
Blu-ray	23.98p, 24p, 25, 25p, 29.97, 29.97p, 30, 30p	Upper first	4:2:0	40 Mb/s	25:1	8-bit

This table is kept up-to-date (and annotated) at www.surrealroad.com/research/archives/2008/standard-video-characteristics.

Film Dimensions

The following table lists the physical dimensions for various film formats.

Format	Width (mm)	Height (mm)	Aspect ratio
16mm	10.26	7.49	1.37
Super-16	12.52	7.42	1.69
35mm (Academy)	21.94	16.00	1.37
35mm (Cinemascope)	21.94	18.59	2.35 (unsqueezed)
35mm (Full aperture)	24.89	18.67	1.33
Vista-vision (8-perf)	37.71	25.17	1.5

This table is kept up-to-date (and annotated) at www.surrealroad.com/research/archives/2008/film-dimensions.

Common Digital Image Formats

The following table lists key characteristics of common digital image file formats.

Format	Bit depth (per pixel)	Color model	Lossy compression	Lossless compression	Layers	Alpha channels	Embedded timecode	Additional features
Adobe Digital Negative (DNG)	Various	Various	•	•	•	•		Supports all feature of TIFF specification, various metadata
xAdobe Photoshop Document (PSD)	Various	Various		•	•	•		Supports vectors, parametric image operations, color profiles, other metadata
Kodak Cineon (CIN)	30	Logarithmic RGB, linear RGB					•	Can store key numbers, other metadata
CompuServe Graphical Interchange Format (GIF)	8	Indexed RGB						Supports animation, keyed alpha
SMPTE Digital Picture Exchange (DPX)	24, 30	Logarithmic RGB, linear RGB					•	Supports all features of Cineon specification
JPEG	24	Linear RGB	•					

	Bits	Encoding						Notes
JPEG-2000	Various	Various	•	•				Supports color profiles, other metadata
TIFF	Various	Various	•	•	•			Several variants of the TIFF format are available, such as LogLuv and Pixar, allowing for different dynamic ranges, supports color profiles, other metadata
OpenEXR	48	Logarithmic HDR	•			•		Covers 9.6 orders of magnitude with 0.1% precision, can store key numbers, other metadata
Radiance	32	Logarithmic HDR	•			•		Covers 76 orders of magnitude with 1.0% precision
Portable Network Graphics (PNG)	24	Linear RGB	•				•	
Targa (TGA)	24	Linear RGB					•	
Windows Bitmap (BMP)	8, 24	Linear RGB						

This table is kept up-to-date (and annotated) at www.surrealroad.com/research/archives/2008/common-digital-image-formats.

Common Digital Audio Formats

The following table lists key characteristics of common digital image file formats.

Format	Bit-depth (per sample)	Sampling rate (kHz)	Channels	Lossy compression	Lossless compression	Embedded metadata
PCM Wave (WAV)★	∞	∞	∞			
MPEG Layer-3 (MP3)	∞	48	2	•		•
Vorbis (OGG)	∞	200	255	•		
PCM Audio Interchange File Format (AIFF)★	∞	∞	∞			•
Free Lossless Audio Codec (FLAC)	32	1,048.57	8		•	•
Advanced Audio Coding (AAC)	∞	192	48	•		
Microsoft Windows Media Audio (WMA)	24	96	8	•	•	•
Dolby Digital AC-3 (AC3)	16	48	6	•		
Dolby TrueHD	24	96	14		•	
Digital Theater System Coherent Acoustics (DTS)	24	48	6	•		
DTS-HD Master Audio (Stereo mode)	24	192	2		•	

(continued)

Format	Bit-depth (per sample)	Sampling rate (kHz)	Channels	Lossy compression	Lossless compression	Embedded metadata
DTS-HD Master Audio (Multichannel mode)	24	96	8		•	

⋆Wave and AIFF are container formats that are used in conjunction with various audio codecs, which may impose limits on each property.

This table is kept up-to-date (and annotated) at www.surrealroad.com/research/archives/2008/common-digital-audio-formats.

Safe Areas

The following table lists safe areas for different aspect ratios.

Aspect ratio	Horizontal action safe	Vertical action safe	Horizontal title safe	Vertical title safe
16:9	3.5% from edge	3.5% from edge	5% from edge	5% from edge
16:9 protected for 4:3 (4:3 center cut-out)	15.13% from edge	3.5% from edge	16.25% from edge	5% from edge
4:3 protected for 16:9 (16:9 center cut-out)	3.5% from edge	15.13% from edge	5% from edge	16.25% from edge
1:1.85	3.5% from edge	3.5% from edge	5% from edge	5% from edge
1:1.85 protected for 4:3 (4:3 center cut-out)	16.57% from edge	16.57% from edge	17.65% from edge	5% from edge
1:1.85 protected for 16:9 (16:9 center cut-out)	5.3% from edge	5.3% from edge	6.7% from edge	5% from edge

This table is kept up-to-date (and annotated) at www.surrealroad.com/research/archives/2008/safe-areas.

Index

Index

Index